British Landscape Watercolours 1750–1850

British Landscape Watercolours 1750–1850

Jane Munro

The Herbert Press
in association with the Fitzwilliam Museum

Copyright in the text © 1994 Jane Munro and the Fitzwilliam Museum

Copyright in the photographs © 1994 the Fitzwilliam Museum

First published in Great Britain 1994
by The Herbert Press Limited, 46 Northchurch Road, London N1 4EJ
in association with the Fitzwilliam Museum, Cambridge

House editor: Julia MacKenzie
Designed by Pauline Harrison

Set in Granjon
Typeset by Nene Phototypesetters Ltd, Northampton

Printed and bound in Great Britain by BAS Printers Limited,
Over Wallop, Hants

A CIP catalogue record for this book is available from the
British Library.

ISBN 1–871569–70–2

Front cover: Samuel Palmer (1805–1881), *The Magic Apple Tree*
Back cover: John Sell Cotman (1782–1842), *Postwick Grove*

Contents

Preface

The Fitzwilliam Museum acquired its first British landscape watercolours in 1816 from its Founder, Richard, 7th Viscount Fitzwilliam. The next notable addition, if we overlook the rare grey wash landscape drawings by George Romney given by the artist's son in 1818, was Ruskin's noble gift of twenty-five watercolours by Turner in 1861. Apart from these foundations the Fitzwilliam Museum's watercolour collection is essentially a twentieth-century creation, still in the process of development. Its remarkable quality and extent are the result of benefactions. Some three-quarters have been given or bequeathed to the Museum, and almost all the purchases have relied on funds given for this purpose. Notable are the bequest from Sir Rowland Henry Biffen, received in 1949, and the benefaction from Lord Fairhaven, received in 1948, devoted to watercolours and English landscapes. The Graham Robertson bequest of 1949 was combined with the Biffen contribution to pay for the room which bears his name and where constantly changing displays of drawings and watercolours are shown. T. W. Bacon's gift in 1950 of seventy-two watercolours was a further outstanding postwar event.

Because watercolours suffer from over-exposure to light the Museum has to ration their display. The exhibition of which this book is a record is thus a very special event, as the Adeane Gallery is allowing the Museum to show no less than 147 of its finest British landscape watercolours, a far more representative group than can be exhibited in the Graham Robertson Room, and a much larger number than have been shown together since 1983.

Support for the exhibition has come from the Papworth Trust, to which the Fitzwilliam Museum is deeply indebted. This partnership is no accident. The Papworth Trust promotes all aspects of disabled integration within the wider community, while the Fitzwilliam Museum is placing a high priority on the improvement of disabled access to its own galleries. We are also grateful to two generous friends of the Museum, who wish to remain anonymous, for supporting this book.

The exhibition has been selected and arranged by Jane Munro, Senior Assistant Keeper of the Department of Paintings, Drawings and Prints, who has also written this book, and David Scrase, Keeper of the Department. Others within the Museum whose support has been invaluable include Camilla Boodle, Andrew Morris, Andrew Norman, Elizabeth Orton, Margaret Clarke, Roger Stretch, Bryan Clarke, Nick Burnett, Richard Farleigh and Thyrza Smith.

We are extremely grateful to Mr & Mrs G. A. Goyder and to the Keynes Family Trust, for the loan of superb watercolours by J. R. Cozens and Samuel Palmer. A key role has been played by the Fitzwilliam Museum Trust, and in particular by two Trustees, Nigel Chancellor and Hugh Duberly, to whom we are deeply indebted. And outside the Museum help and assistance has been forthcoming from Duncan Robinson, Raymond Lister, Francis Greenacre, Sheena Stoddard, Kim Sloan, Norma Watt, Richard Duncan-Jones, Henry Hurst, Carlo Knight, Scott Wilcox, Andrew Wyld and the staff of the British Museum Print Room, and of the Rare Books Room, Cambridge University Library. We thank them all.

SIMON JERVIS
Director
Fitzwilliam Museum

Foreword

The Papworth Trust, based at Papworth Everard in Cambridgeshire, is a national charitable organisation dedicated to enabling disabled people to acquire the social, residential and vocational skills which will empower them to live fulfilled and integrated lives. Key features of the Trust's work are its individual assessment, training and rehabilitation programmes which provide employment and living skills for hundreds of people from across the country. Combined with a range of sheltered and independent housing, personal care services and commercial business divisions, the Trust continues to take the initiative in meeting the requirements of disabled people in a rapidly changing world.

Supporters and funders of the Fitzwilliam Museum will know that one of its prime goals is to improve access to its collections. As the exhibition, of which this book is a record, opens, the Museum is embarking on a programme to provide ramps and lifts for wheelchair users together with properly adapted facilities. This project has attracted substantial external funding, and we hope that the exhibition will help attract the substantial further support which is needed, if the Museum's carefully planned strategy is to be fully implemented.

The Papworth Trust welcomes the opportunity to join with the Fitzwilliam Museum in promoting this important exhibition of British Landscape Watercolours and with the task of permanently improving access to the Museum for disabled people.

Nigel Chancellor
Chairman
The Papworth Trust

Introduction

'Every artist must, to a certain degree, obey his master
the public ... two-thirds of mankind, you know, mind more
what is represented than *how* it is done'

Francis Cholmeley to John Sell Cotman, *c*.1809[1]

It is impossible to know whether, when Richard, 7th Viscount Fitzwilliam
acquired the two magnificent views of Italy by John Robert Cozens which
form the basis of the Museum's collection of British landscape water-
colours, he would have counted among the implicitly indiscriminate
majority of whom Cholmeley warned Cotman. In subject matter, style and
medium Cozens's watercolours stand out in a collection otherwise remark-
able for its Italian and Dutch paintings of the sixteenth and seventeenth
centuries, and 'almost unrivalled'[2] collection of prints. No record of their
provenance prior to entering Lord Fitzwilliam's collection survives, and
the paucity of information regarding his life and presumed Grand Tour
prevents even the vaguest hypothesis as to his contact with the artist or his
known patrons. Of the distinction of the Founder's taste, however, there is
no doubt. Lord Fitzwilliam was respected as one of the most discerning
collectors and connoisseurs of his day, said to have spent the last twenty
years of his life 'in almost complete seclusion, not seeing even his former
most intimate friends and absorbed in the pursuits of high taste and
learning'.[3] During his frequent visits to London from his home at
Richmond, in Surrey, he was avidly courted by dealers such as William
Buchanan, who wisely kept abreast of his latest acquisitions and the price
he gave for them.[4]

Of the 144 paintings bequeathed to Cambridge University on the
Founder's death in 1816, few are landscapes, and the thirty or so drawings
in his collection, by an international group of artists including Panini,
Bernard, Clérisseau and Zucchi, are for the most part drawings of Roman
monuments or architectural *capricci*. An examination of the contents of his

'princely'[5] library – which on his death contained both printed books and albums of engravings – is more revealing of his taste in landscape. He owned accounts of journeys to all four continents of the world, from Iceland to India, the North Pole to Botany Bay, and numerous guides to the Continent, in particular to Italy, including a number of impressive seventeenth-century volumes on the architecture and monuments of Rome, such as Giuseppe Vasi's *Monumenti sagri e profani della 4 età di Roma* (1690), Giovanni Battista Falda's *Le fontane di Roma* (4 vols, ?1675), and Giambattista Nolli's *Nuova Pianta di Roma* (1648). In 1806 he acquired an album of superb impressions of the *Collection ou suite de Vues Pittoresques de l'Italie*, by the German artists A. C. Dies, J. C. Reinhart and J. Mechau, published as a volume, with Italian titles, in Nuremberg in 1798. Of all the views of Italian subjects in his collection these come closest to Cozens in date and in their concentration on the luxuriant nature of the Italian countryside, although for Cozens's poetic lyricism they substitute minute description and picturesque incident.

Lord Fitzwilliam's large collection of books on British landscape suggests a voguish taste for the Picturesque. He acquired almost complete sets of the works of fashionable travel writers such as Thomas Pennant and William Gilpin, as well as publications of engravings after works by leading landscape painters and topographical publishers of the day, including Paul Sandby, John 'Warwick' Smith, William Byrne, and Thomas Hearne, in many of which he is listed as a subscriber. From publications such as William Angus's and William Watts's *The Seats of the Nobility and Gentry in Great Britain* (1779–86; 1787–97), both of which he acquired in 1801, it is clear that he shared a taste for estate portraiture common among his aristocratic contemporaries, and around 1806 he commissioned from William Ashford (1746–1824), later President of the Royal Hibernian Society, a series of six views in oil and twenty-nine in pen and grey wash of his own estate at Mount Merrion in Ireland.[6] Although Cozens's watercolour views of Italy differ enormously in mood and breadth of vision from these charming, but comparatively prosaic views of the landscape, it would be misleading to make too emphatic a distinction on grounds of their technique alone. To early nineteenth-century eyes, Cozens's use of a restricted palette of blues and greys gave his landscapes an effect reminiscent of 'mezzo-tinto prints thinly washed with colour',[7] a quality which is worth bearing in mind not only in terms of Lord Fitzwilliam's eminence as a print connoisseur, but also in the light of the popularity of the large hand-coloured etchings of Rome and its environs by artists and engravers such as Louis Ducros (1748–1810), Giovanni Volpato (1732–1803),

Francesco Piranesi (*c*.1758/9–1810) and Louis-Jean Desprez (1734–1804), among Grand Tourists in Italy in the 1780s.[8] Equally, it should be noted that however unique in the context of the Founder's collection, his acquisition of these specific views of Italy was in itself far from unusual; in fact, the views of Lakes Nemi and Albano were among the most popular in the artist's repertoire.[9] As one critic noted in the 1830s, Cozens's romantic sensibility was perfectly in tune with that of his day, and his drawings, 'replete with the principal attributes sought by English amateurs – breadth and aërial perspective, with a space residue for the imagination to speculate upon'.[10]

Clearly, in the case of Cozens, the suggestion that a landscape artist was compromised by the demand for topographical accuracy was at best a half-truth. Patrons, Lord Fitzwilliam included, bought into a style as much as an image, and some, as today, could see their 'investment' in an artist soar. While fickle connoisseurs such as William Beckford, who sold his entire collection of Cozens's watercolours in his own lifetime, tired quickly of their original enthusiasm, others, notably the 2nd Earl of Dartmouth, lived to see the wisdom of their patronage given due recognition, albeit after the artist's death. That landscape painters themselves attached growing significance to the assertion of a distinctively personal style is neatly illustrated by the contrast between two artists at either end of the chronological span of this exhibition. While Jonathan Skelton sought his patron's approval of his developing landscape style in regular letters from Italy during the late 1750s,[11] John Linnell dismissed the suggestions that a painting of his should have been derived from anything other than his own imagination with the irascible retort, 'Madame, I am not a topographer!'.[12]

Undoubtedly, much of this change in attitude can be accounted for by the greater prominence given to both landscape and watercolour painting during the first years of the nineteenth century. While informal gatherings of painters such as the 'Sketching Society', the 'Epic and Pastoral', and later the 'Academy' at Clipstone Street continued to provide important forums of artistic exchange inside and outside the capital, the foundation of the Society of Painters in Water-Colours in 1804 and its first exhibition the following year did much to accelerate public appreciation of the medium. For the first time watercolourists – or at least the sixteen 'valiant Trojans'[13] who participated in the first exhibitions – could show their works independently of oil paintings in the more sympathetically-lit rooms of no.20, Lower Brook Street. The extraordinary attendance figures – 12,000 paying visitors in the seven-week duration of the first exhibition,

rising to 23,000 in 1809[14] – is proof enough of the popularity of the 'new' art form, but also speaks for the pleasures of exhibition-going. At least by the 1820s, when the initial novelty value (and crowds) had diminished somewhat, a visit to the rooms of the Society of Painters in Water-Colours provided 'a place for investigation and reflection',[15] where visitors could respond to the more intimate nature of watercolour painting, undisturbed by the ritualistic glamour and dazzle of Royal Academy openings.

A number of journals gave regular coverage to the Society's exhibitions, none more extensively than the *Somerset House Gazette*. Its reviewer, William Henry Pyne (1769–1843), who wrote under the pseudonym Ephraim Hardcastle, was among the earliest members of the Society, and consequently *parti-pris*; however his series of articles on 'The Rise and Progress of Water-Colour Painting in England', published during the winter of 1823 to 1824 (in which he memorably compared watercolour's cremona violin to the rich coloratura of oil painting's organ) did much to foster appreciation of the special qualities of the medium, and provided an analysis of its development which has formed the basis of many twentieth-century accounts.

Despite the growing recognition of watercolour as an independent art form, there was little corresponding improvement in the financial lot of its practitioners. Even in the Society's most successful years, sales from its exhibitions – divided equally between its members – were insufficient to provide painters and their families with an adequate income, and the situation deteriorated after 1812, when the number of sales decreased dramatically. As Roget suggested, this was due in large part to the economic depression in the wake of the French and Peninsular Wars,[16] but it also reflected the comparatively low prices commanded by water-colour landscapes. In order to ensure at least a modest living, watercolour painters almost invariably turned to teaching and topographical work. Many of the artists represented in this exhibition – Towne, Girtin, Varley, Cox, Cotman, DeWint, Harding and Ruskin among them – worked as drawing masters for most of their careers; the majority of them, too, hated it. From Thomas Jones's rejection of the idea of 'degrading' himself as a drawing master at a boarding school,[17] to Cotman's complaints of the 'sorry drudgery' of his teaching responsibilities at Norwich and London, the notion that the artist was enduring a necessary evil is recurrent throughout much of the nineteenth century. It is difficult not to sympathize with the disillusionment of painters of Cotman's calibre at having to resort, through financial necessity, to filling the leisure time of a bored provincial lady or gentleman by teaching them how to execute, with

minimal effort, a gratifyingly realistic landscape to add to an already 'abundant cargo of graphic inanity'.[18] The temptation to invent systems which would be simple to follow and produce a pleasing end result, without overtaxing one's pupil, must have been immense, and many, indeed, succumbed. William Payne is among the most vilified of method-makers, although at the beginning of the nineteenth century Edward Dayes had already foreseen the downfall of British draughtsmanship in the fashionable, but to his mind, sloppy systems taught by Alexander Cozens. He recommended the prospective student to exercise extreme care in selecting a drawing master: above all he should beware of having 'his time wasted with gew-gaws and trash, beneath the dignity and attention of rational beings'.[19] By no means all drawing masters were dissatisfied or unscrupulous, however: Harding, Cox and Varley all produced pupils of distinction and influential drawing manuals, some of which were admirably methodical and (though their prose often disguises it) highly original in approach.[20] Even so, professional practitioners were right to perceive the seeds of watercolour's downfall in its growing popularity as a polite art. William Henry Pyne recognized the independent merits of the vigorous, 'apparently careless' handling of John Glover (1767–1849) and William Payne, but saw that in the less gifted hands of the amateur, it became no more than a vehicle for 'a display of their showy talents, without the fatigue of study'.[21] By 1859, John Ruskin could justly attribute the surfeit of undistinguished work at Old Water-Colour Society exhibitions to the popular demand for a dashingly-executed watercolour, and to the support of amateurs who, 'concern themselves with art without being truly interested in it; and … enjoy being taught to sketch brilliantly in six lessons'.[22]

Topographical work – the 'what' Cholmeley so disparaged – continued to be a mainstay of the landscape artist's existence. The numerous antiquarian and topographical publications which flourished at the end of the eighteenth century, such as *The Copper Plate Magazine* (later known as *The Itinerant*), *The Antiquarian and Topographical Cabinet*, *The Monthly Mirror*, and Brayley and Britton's *The Beauties of England and Wales*, provided regular employment for Girtin, Dayes, Turner, and Hearne as well as a host of more pedestrian draughtsmen, the quality of whose work amply justifies Cholmeley's concern. Some, notably Thomas Hearne, were amateur antiquarians in their own right, with the financial astuteness to explore the advantages of closer involvement in the mechanics of publication, and in the process did much to raise the quality of such work. By the 1820s the re-opening of the Continent to travellers injected much-needed

new blood into the genre; as one commentator wearily explained: 'We had begun to tire of the endless repetitions of Tintern Abbey from within, and Tintern Abbey from without, and the same by moonlight, and twilight, and every other light in which taste and talent could compose variations to the worn-out theme. So with our castles – old Harlech, sturdy Conway, and lofty Caernarvon, have every year, of late, lost a century at least of their antiquity, by being so constantly brought before us.'[23] A new wave of publications, known collectively as the 'Annuals', responded to this topographical *ennui*, and the best of them – such as Jennings's *Landscape Annual*, and Charles Heath's *Picturesque Annual* – were conscious of the advantage of employing artists of reputation to provide paintings or watercolours for engraving; as Heath bluntly confessed, their principal *raison d'être* was to 'ransack the portfolio of an artist of genius on his return from abroad'.[24] This was certainly the view of the Edinburgh publisher Robert Cadell, who recognized that by securing the services of Turner to provide illustrations for the *Prose Works* of Sir Walter Scott (1834–6) he would immediately more than double its subscribers.[25] A growing number of landscape artists took control of the translation of their work into print, but none so expertly or so sensitively as Turner. As John Gage has recently shown, Turner's ability to understand colour as a function of light and shade rather than as 'hue-contrasts' enabled him not only to achieve remarkable subtlety in his use of the black and white medium, but also to use his experience of engraving to broaden his understanding of the technical and expressive potential of oil and watercolour.[26] While his commissions for engravings demanded certain concessions as regards verisimilitude, Turner's deliberate flouting of conventional topographical representation in other media aroused considerable criticism; as Henry Crabb Robinson remarked in 1825, the public was only alienated by his artistic licence: 'If he will invent an atmosphere and play of colours all his own why will he not assume a romantic name … men like realities and like to be reminded of them.'[27] To advocates of 'pure' watercolour, too, Turner's highly original manipulation of the medium amounted to a corruption of its most valued properties of transparency and luminosity; the critic of the *Annals of the Fine Arts* in 1820 spoke for many when he advised the artist to return to his less extravagant earlier style, 'and keep nearer their truth [rather] than to run riot … after a thousand yellow fantasies and crimson concerts'.[28]

How a watercolour was painted, in the strictly technical sense of which pigments, supports and degree of finish were legitimately described as such, became a contentious issue in the artistic community as the

century progressed. The debate arose partly from the growing number of colours and papers being made available to artists through technological advances, but was also part of a broader discussion between those practitioners of the medium who wished to assert the special aesthetic qualities of transparent watercolour, and those who wished to emulate the more powerful effect of oil paintings by using opaque pigment and varnishing with copal. At the Society of Painters in Water-Colours, matters came to a head in 1813 when a number of painters broke away from the original Society to form the Society of Painters in Oil and Water-Colours, whose members, as their title implies, were prepared to exhibit works in the two media alongside one another, a direct contradiction of the reasons for forming the original society. This decision was itself reversed in 1820, when those in favour of watercolour's independence re-grouped as the 'Old Water-Colour Society', assuming the role of guardians of the transparent wash. The factionalization which took place during the first thirty years of the Society's existence was symptomatic of the difficulty in establishing watercolour's place in the artistic hierarchy, and of its attempt to be recognized as something more than merely 'convenient for the decoration of English rooms'.[29] By mid-century, the extent to which it had succeeded – at least in stark financial terms – may be judged by John Frederick Lewis's resignation as President of the Old Water-Colour Society in 1858, on the grounds that he found watercolour, 'thoro'ly unremunerative ... no rest and such little pay'.[30]

During the first part of the nineteenth century, artists' colourmen were quick to respond to the growing popularity of watercolour among professional and amateurs, and produced a number of materials which were intended to cater specifically for their needs. James Whatman and Winsor and Newton developed a range of papers of various roughness or 'tooth', which allowed painters to exploit the luminosity of the white ground by leaving the paper to sparkle as highlights through loose washes of colour, as well as a variety of smooth and tinted papers favoured by Turner and Harding.[31] Some artists – Girtin and Cox, for example – sought out unusual papers which suited their individual expressive purposes; others, such as Samuel Palmer adapted readily available materials – in his case a 'London Board' manufactured especially for flower painters – for use in landscape painting.[32] A new range of pigments – including Emerald Green and French Ultramarine, which came on to the market from the 1820s – to some extent replaced the fugitive, vegetable-based colours such as indigo, whose fading has so dramatically affected the colour balance in many of Girtin's watercolours. Although a number of

colourmen combined a scientific knowledge with a genuine concern to improve the range and permanency of the medium, there were many less scrupulous. Practising artists and teachers, in particular, deplored their tendency to encourage the use of a wide range of colours. Temperance in colour, 'as in all things'[33] was in Dayes's view essential for the beginner; while almost half a century later, John Ruskin determined, if appointed Chancellor of the Exchequer, to impose 'a tax of twenty shillings on all colours except black, Prussian blue, Van Dyke brown and Chinese white'[34] in order to discourage the pernicious practice. As a result, there emerged something of a moral high ground in retaining an independence of the new pigments and finishes promoted by colourmen. David Cox's biographers, for example, were keen to establish his adherence to traditional materials, noting that, throughout his career he spurned the 'glaring, glittering, dangerous inventions so much in use these days'.[35] Increasingly, the debate came to focus on the legitimacy of admitting bodycolour or opaque white gouache to watercolour. To those who defended 'pure' watercolour, even the 'tipping of a seagulls' wing' was an offence, but there were also many who took a more conciliatory stance. One of the most influential teachers of the nineteenth century, J. D. Harding, painted in both 'pure' colour washes and with bodycolour, but was motivated to promote the use of lead pencil, chalk and Chinese white by the increasing sloppiness he detected in watercolour painting. Beginners were too eager, he wrote, to succumb to the sensual allure of colour, and to sacrifice, 'every solid and future advantage ... at the shrine of present gratification'.[36] In the most important of his drawing manuals, particularly *Elementary Art*, which appeared in 1845, he emphasized the need for disciplined mastery of line and the cultivation of powers of observation before proceeding to explore the sensual charms of watercolour. Bodycolour in his view, and especially the much-maligned Chinese white, precluded the need to resort to the 'bungling practice' of sponging out or scraping to obtain highlights, and compensated for the thinness of transparent colour by introducing depth rather than opacity of colour into shadow.[37] Many of Harding's views were adopted by his pupil John Ruskin, who by 1859 considered 'the sponge and handkerchief' to have been the ruin of watercolour painting.[38] Although he was able to appreciate the intuitive genius of watercolourists such as Cox and DeWint, Ruskin also championed the highly-wrought work in bodycolour of William Henry Hunt and John Frederick Lewis, and remained convinced that 'the greatest things to be done in art must be done in dead colour'.[39] However, Ruskin's most useful contribution to the debate was perhaps his timely perception that the

formal qualities of watercolour – be it transparent or opaque – had come to be valued more highly than the emotional truths which it was capable of expressing. The evaluation of *how* a watercolour was painted, had, in other words, come to replace *what* – in a sense more than strictly topographical – it set out to represent, leaving the medium impoverished, 'a kind of Potted Art, of an agreeable flavour, suppliable and taxable as a patented commodity, but in no wise a *Living* art'.[40] As a painter and draughtsman himself, Ruskin was sensitive to qualities of execution, but aware that invention, an understanding of the underlying laws of nature, and the expression of some higher visual 'truth' were the painter's real concerns: if, as artists we were 'incapable of such reflection as shall make us know, in the depths of those glens and in the cry of the … waves of the beach, their true connection with the thoughts, the joys, and sorrows of men, we shall never paint one leaf nor foam wreath rightly'.[41]

NOTES

1. Quoted Martin Hardie, *Water-Colour Painting in Britain*, II, London, 1967, p.84

2. 'Fitzwilliam Collection of Paintings, at Cambridge', *Library of the Fine Arts*, IV, London, 1832, p.178

3. Ibid., pp.177–8

4. Hugh Brigstocke, *William Buchanan and the 19th Century Art Trade: 100 letters to his agents in London and Italy*, London 1982, p.296; and letters 20, 30, 42, 50, 51, 60 and 70.

5. *Library of the Fine Arts*, as n.2, p.178. A manuscript inventory of the Founder's collection of Printed Books and Manuscripts, drawn up in March 1816 by Messrs Payne and Foss survives in the Museum Archives 9, no.760501.

6. Nos 445, 447, 462, 464, 466, 467 and 3933 (the album of drawings). For a discussion of the problems of dating and pairing of these, see J. W. Goodison, *Fitzwilliam Museum Cambridge Catalogue of Paintings, Volume III, British School*, Cambridge 1977, p.6

7. Ephraim Hardcastle (William Henry Pyne), *Somerset House Gazette*, v, 1823, p.65. See also Edward Dayes, who considered their 'great breadth in chiaroscuro' to compensate for deficiencies in draughtsmanship (*The Works of the late Edward Dayes*, London, 1805, p.324).

8. See, *Images of the Grand Tour, Louis Ducros 1748–1810*, exh. cat., Kenwood, The Iveagh Bequest and tour, 1985–6, pp.11–12, 20–23

9. Ten versions of the Founder's view of Lake Nemi and eleven of Lake Albano have been recorded. See pp. 46 and 48.

10. *Library of the Fine Arts*, III, London, 1832, p.10

11. See Brinsley Ford (ed.), 'The Letters of Jonathan Skelton written from Rome and Tivoli in 1758', *Walpole Society*, XXXVI, 1960

12. Richard and Samuel Redgrave, *A Century of British Painters*, London, 1866 (repr. 1981), p.386

13. *Frazer's Magazine*, June 1830, p.534

14. John Lewis Roget, *A History of the 'Old Water-Colour Society's Club'*, London, 1891, I, pp.203, 244

15. *Magazine of the Fine Arts*, I, 1821, p.115

16. Roget, op.cit., p.268

17. A. P. Oppé, 'The memoirs of Thomas Jones', *Walpole Society*, XXXII, 1951, p.15

18. 'Hints to Amateurs in the Study of Landscape', *Library of the Fine Arts*, II, 1831, p.280

19. Dayes, op.cit., p.260

20. See Peter Bicknell and Jane Munro, *Drawing Masters and their Manuals*, exh. cat. Fitzwilliam Museum, 1987, pp.28–30, 31–40 and 111–15

21. *Somerset House Gazette*, I, no. IX, 6 December 1823, p.133

22. E. Cook and A. Wedderburn (eds), *The Works of John Ruskin*, London, 1903–12, XIV, p.246

23. *Somerset House Gazette*, II, no. XXX, 1 May 1824, p.48

24. Heath's *Picturesque Annual*, 1832, unpaginated

25. 'With his pencil, I shall insure the subscription of 8,000, without, not 3,000' A. L. S. Cadell to Sir Walter Scott, quoted Anne Lyles and Diane Perkins, *Colour into Line. Turner and the Art of Engraving*, exh. cat., London, Tate Gallery, 1989, p.71.

26. John Gage, *J. M. W. Turner 'A Wonderful Range of Mind'*, London and New Haven, 1987, pp.75–96.

27. Quoted Gage, op.cit., p.30. Crabb Robinson referred to Turner's painting of the *Harbour of Dieppe* exhibited at the Royal Academy in 1825 (Butlin and Joll, 1984, no.231).

28. *Annals of the Fine Arts*, 1820, p.421

29. Ibid., p.66

30. Cook and Wedderburn (eds), op.cit., XIV, p.73

31. See Marjorie B. Cohn, *Wash and Gouache: A Study of the Development of the Materials of Watercolor*, exh. cat., Cambridge, MA, Fogg Art Museum, 1977. For an account of paper used by Turner, see Peter Bower, *Turner's Papers A study of the manufacture, selection and use of his Drawing Paper 1787–1820*, exh. cat., Tate Gallery, 1990. In the third edition of *Elementary Art* (1846), Harding referred to the wider range of tinted papers being produced by firms such as Smith and Alnutt at the beginning of the 1840s.

32. See Raymond Lister, *The Letters of Samuel Palmer*, II, Oxford, 1974, pp.52ff. That Palmer's motivation for using the thicker London or 'Bristol' board was also motivated by his wish to ensure the permanency of the pigment is evident from an inscription on a drawing of 1865: 'Never let drawing on London board be thinned by removing paper from the back. This drawing would be unchanged *after three centuries* if the frame were in a folding case with a door – & unnecessary exposure to light avoided. see missals in B.Museum' (see Raymond Lister, *A Catalogue Raisonné of the Works of Samuel Palmer*, Cambridge, 1988, no.646).

33. Dayes, op.cit., p.308

34. Cook and Wedderburn (eds), op.cit., XV, p.150n.

35. N. Neal Solly, *Memoir of the Life of David Cox*, London, 1873, p.171

36. J. D. Harding, *Lessons on Art*, London, 1849, p.vi

37. J. D. Harding, *The Principles and Practice of Art*, London, 1845, p.152

38. Cook and Wedderburn (eds), op.cit., XIV, p.247

39. Ibid., XV, p.138

40. Ibid., XIV, p.122

41. Ibid.

British Landscape
Watercolours 1750–1850

Richard Wilson 1713–1782

The Grotto at Posillipo
Black and white chalks on blue-grey paper, laid down on card 284 × 423 mm
Inscribed in graphite on mount: *Grotto at Posillipo*; and, in brown ink, lower right: *B*; inscribed verso, upper right: *25*
Bought, 1954 PD.1–1954

Wilson began his career as a portraitist, but turned to landscape during his stay in Italy from 1750 to *c*.1756, probably due to the encouragement of Francesco Zuccarelli (1702–88) and Claude-Joseph Vernet (1714–89). After his return to London he became a founder member of the Royal Academy, and in 1776 took up the post of Librarian there.

This is one of a group of at least sixty-eight drawings of Italy commissioned from Wilson around 1753 by William Legge, 2nd Earl of Dartmouth (1731–1801), probably through the antiquarian and dealer Thomas Jenkins (1722–98). The drawings were greatly admired by artists and connoisseurs at the beginning of the nineteenth century, but disappeared for over a century until less than half the original group was found in a cupboard in Palsull House, Wolverhampton in 1948 (see Ford, 1948, pp.337–45). This is the only drawing of the surviving group to depict the Neapolitan coast. Wilson was a firm advocate of black and white chalks for landscape sketches; according to Thomas Jones, his pupil from 1763 to 1765, he 'did not approve of *tinted* Drawings … which he s'd hurt the eye for fine colouring' (*Memoirs*, p.9).

The 'grotto' at Posillipo, also known as the 'Crypta Neapolitana' is in fact a tunnel built in the middle of the first century AD, which extended through tufa rock from east to west, linking Naples with Pozzuoli. Wilson's view of the imposing western entrance was painted by many of the next generation of British, French and Swiss artists who travelled to the region, including Thomas Jones. Despite being lit from above by a number of very small diagonal apertures in the roof, the tunnel was a dark, malodorous and 'extremely disagreeable' passage, illuminated by the feeble light of a roadside shrine halfway through. However, unlike the surrounding Neapolitan countryside, which was overrun with banditti (see p.35), it was not dangerous; as William Byrne observed, 'It ought to be noticed as reflecting honour on the national character, that no one ever meets with insult in this long gloomy passage' (11, 1796, pl.55).

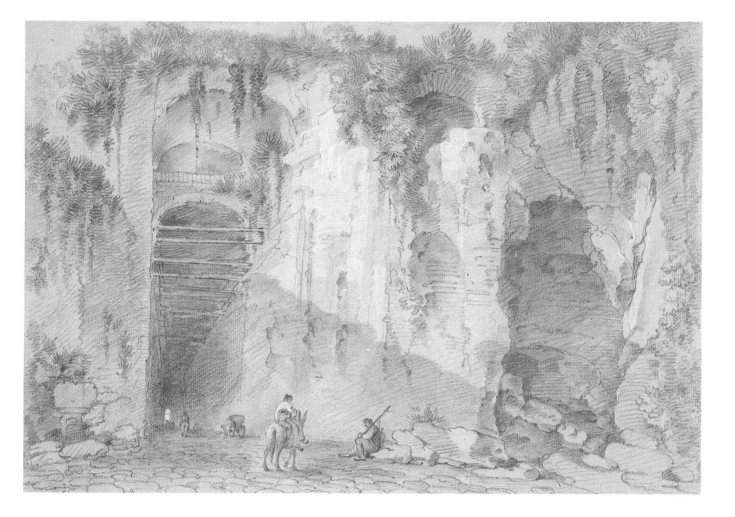

Alexander Cozens 1717–1786

A wood
Grey wash on toned paper, laid down
146 × 200 mm
Signed in ink on the mount, lower left: *Alex'.
Cozens*
Numbered in graphite in the centre: *13*, and, on
the verso of the old mount: *54*
Bequeathed by Sir Edward Marsh, KCVO, CB,
through the National Art Collections Fund,
1953 PD.10–1953

Cozens's greatest contribution to landscape
painting was as a drawing master and
inventor of highly original 'systems' of
landscape composition. The son of Peter
the Great's master-shipbuilder, he was
educated in England, and spent three years
in Italy, from 1746 to 1749. On his return
to England, he taught at Christ's Hospital
and at Eton, and acquired a number of
private patrons, including William Beck-
ford (1760–1844), who described him as
being, 'very Happy, very Solitary, and
almost as full of Systems as the Universe'
(Oppé, 1952, p.34).

This rapidly-executed ink drawing was
made in association with Cozens's first
treatise on landscape composition, *Essay to
Facilitate the Inventing of Landskips*, pub-
lished in 1759. Briefly summarized, the
method recommended in the *Essay*, and in
Cozens's later publications was to make a
casual 'blot' in brown or black ink using a
fully-loaded brush, which would then be
transferred (and reversed) by pressing a
second piece of paper against it, an adapta-
tion of a technique popularly used by
French eighteenth-century artists to make
counterproofs from chalk drawings. From
these 'great splashes of brown' (Sloan, 1986,
p.35), he would then work up a landscape
composition entirely of his own imagina-
tion, using blue and grey blots for the
mountains and sky. The aim of this
unconventional method of teaching was, as
the title suggests, to liberate the student's
powers of invention, but also to equip him
with a technical facility which would allow

the direct expression of his imaginative
ideas. Highly systematized though he was,
Cozens's published methods are anything
but systematic in presentation, and the
opacity of his text laid it open to accusa-
tions of artistic quackery by more conven-
tional drawing masters such as Edward
Dayes, who designated him 'Blotmaster-
General to the town' (*Works*, 1805, p.325).
Despite this, his methods had an important
influence on a number of artists, including
Constable, Wright of Derby (see p.31), and
Romney, whose rare landscape drawings
have the appearance of a 'rude' sketch writ
en large (pp.32–3).

Landscape with a dark hill
Brown wash and graphite over aquatint on
paper, laid down 222 × 293 mm
Signed in brown ink on the mount, lower left:
Alex'. Cozens.; etched, upper right: *16*
Bequeathed by Sir Edward Marsh, KCVO, CB,
through the National Art Collections Fund,
1953 PD.7–1953

This drawing is an elaboration of the
aquatint blot which appears as plate 16 in
Cozens's *New Method*. Over the darker ink
of the printed blot, Cozens has added
graphite outlines and brown wash to
distribute masses, light and shade, trans-
forming the original 'rude and unmeaning'
shape into a more fully evolved landscape.
In the Appendix to his *New Method*,
Cozens provided a list entitled 'Descrip-
tions of the various Kinds of Composition
of LANDSCAPE'. No.16 is given as an
example of 'an extensive country with no
predominant part or object. The horizon
above the bottom of the view.' As Kim
Sloan has shown, Cozens's various land-
scape compositions were intended to
generate a specific emotional reaction in
the viewer, in this case possibly, 'Liberty
curiosity grandeur [and] admiration'
(Sloan, 1986, p.57). All four drawings by
Cozens in this exhibition are laid down on
washed mounts of his own design.

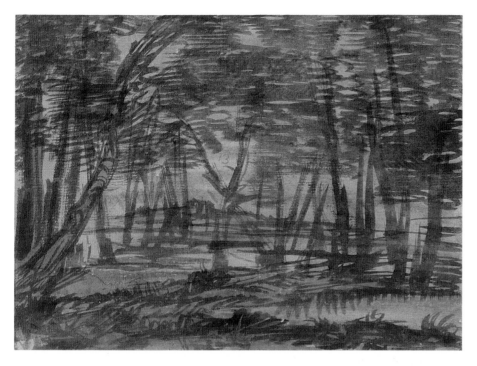

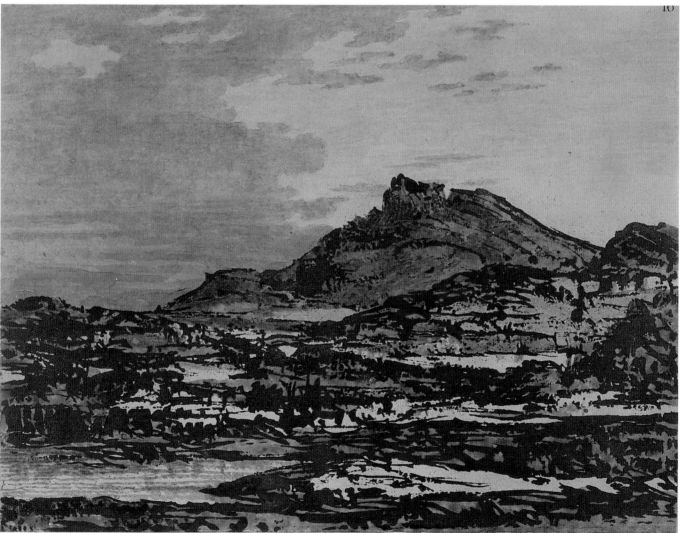

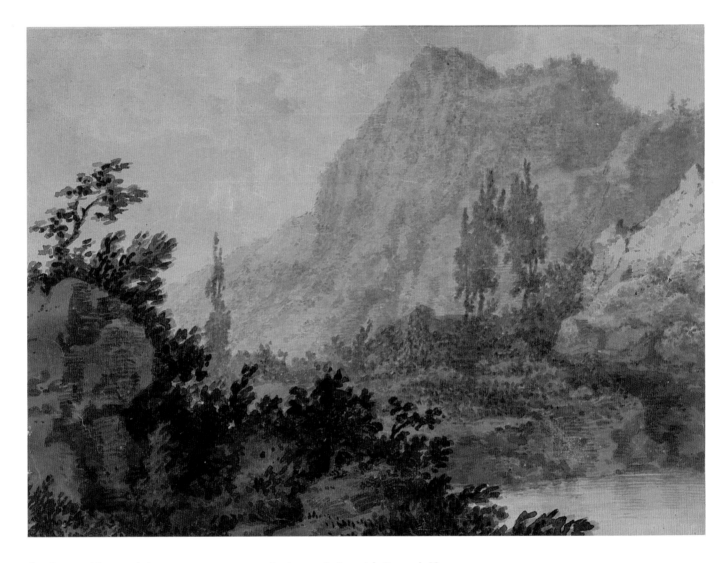

Landscape with a wooded crag
Grey and black wash on tinted paper, laid down
219 × 302 mm
Signed in ink on the mount, lower left: *Alex'*
Cozens
Numbered in graphite, upper right: 59 (over
'30' ?), and, on the verso of the original mount:
74
Bequeathed by Sir Edward Marsh, KCVO, CB,
through the National Art Collections Fund,
1953 PD.8–1953

This drawing and *Landscape with moun-
tain and wooded valley* were made in the
1780s in association with Cozens's *New
Method of Assisting the Invention in Drawing
Original Compositions of Landscape*, 1785–6,
the last of his published treatises, and his
most elaborate exploration of the 'blot'
method invented over thirty years earlier.
Both are examples of fully-evolved land-
scape compositions worked up from one of
Cozens's blots. This drawing was engraved
in mezzotint in reverse by William Pether
(1731–95) as plate 42 of the *New Method*;
another drawing worked up from the same
blot is in the Oppé collection.

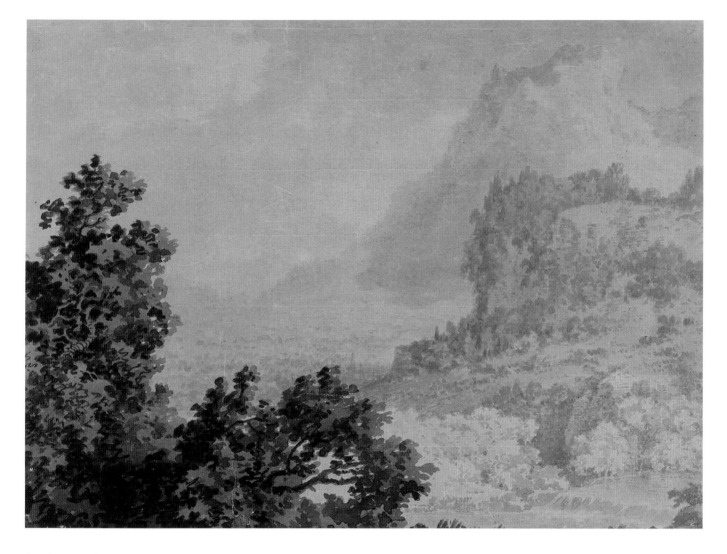

Landscape with mountain and wooded valley
Black and grey washes on tinted paper, laid
down on a wash mount 216 × 301 mm
Signed in ink on the mount, lower left: *Alex'.*
Cozens
Numbered in graphite, top right: *69*
Bequeathed by Sir Edward Marsh, KCVO, CB,
through the National Art Collections Fund,
1953 PD.9–1953

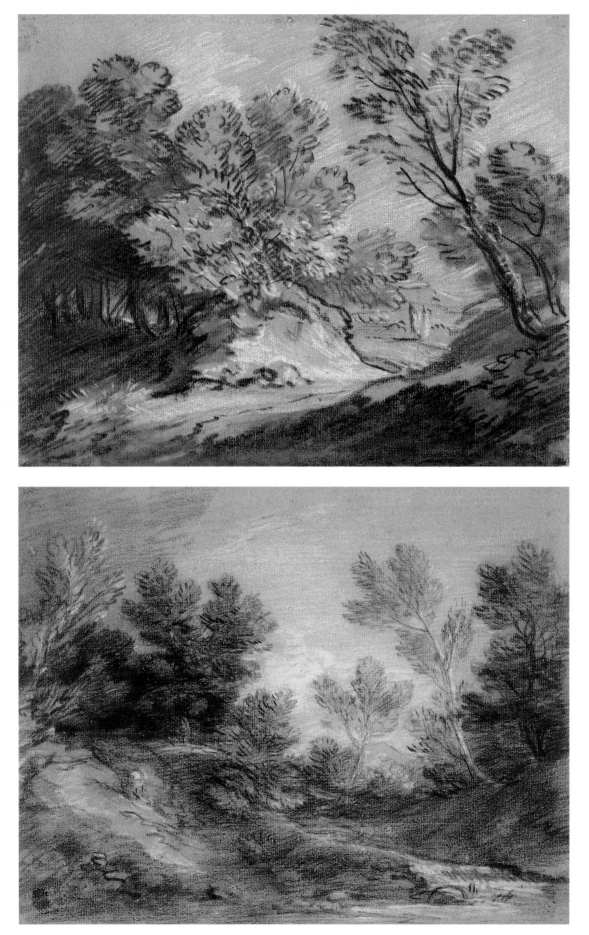

Thomas Gainsborough 1727–1788

Wooded landscape with distant mountain
Black and white chalk on blue paper
260 × 315 mm
Given by the Friends of the Fitzwilliam
Museum, 1919 no.975
Hayes, I, 554

During his residence at Bath, Gainsborough's technique as a draughtsman was extremely varied. He liked to work by candlelight and in a range of media which included wash, watercolour and chalk, with considerable amount of white in the highlights. According to Edward Edwards, his methods were far from conventional; some drawings, he wrote, 'were

executed by a process rather capricious, truly deserving the epithet bestowed upon them by a witty lady, who called them moppings. Many of these were in black and white, to which colours were applied in the following manner: a small bit of sponge, tied to a bit of stick, served as a pencil for the shadows, and a small lump of whiting, held by a pair of tea tongs was the instrument by which the highlights were applied' (Hayes, I, p.24).

John Hayes dates this drawing to Gainsborough's late Bath period, and points to the influence of Gaspard Poussin (1615–75) in the treatment of foliage.

A woodland stream
Black and white chalk on grey paper
251 × 322 mm
Bought, 1953 PD.28–1953
Hayes, I, 607

Gainsborough drew mainly for relaxation, and generally subjects of his own invention. According to Joshua Kirby, who knew Gainsborough from the 1750s, he owned, 'a great many sketches of Trees, Rocks, Shepherds, Ploughmen, and pastoral scenes, drawn on slips of paper, or old dirty letters which he called his *riding school*' (Hayes and Stainton, 1983, p.2). This landscape is drawn with a summary brilliance characteristic of Gainsborough's late style.

Paul Sandby 1730–1809

Wooded lane with travellers resting
Black chalk, brown and grey wash on paper, laid down 218 × 284 mm
Bought, 1972 PD.15–1972

Sandby was trained in the traditions of cartographic representation, and, with his brother Thomas, worked for the Board of Ordnance in Scotland during the late 1740s. In 1752 he returned to London from Edinburgh, and quickly established a reputation as an artist and drawing master. Although he was credited from the beginning of the nineteenth century with being one of the key figures in liberating watercolour from the status of a 'tinted drawing', he worked in a variety of media (see p.31), and his most pioneering work is arguably as a printmaker (Robertson, 1985, p.11).

This drawing is thought to have been executed during the 1790s. John Hayes has drawn attention to similarities with the Dutch-inspired work of Thomas Gainsborough (II, pl.275), although the combina-

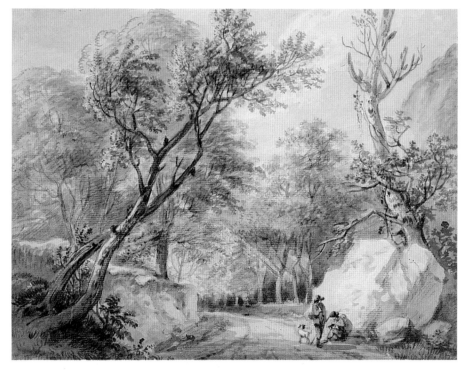

tion of media and the chalky opacity of the ink wash also invite comparison with drawings by William Taverner (1703–72),

over a dozen of whose Italianate landscapes Sandby acquired at the sale after the latter's death.

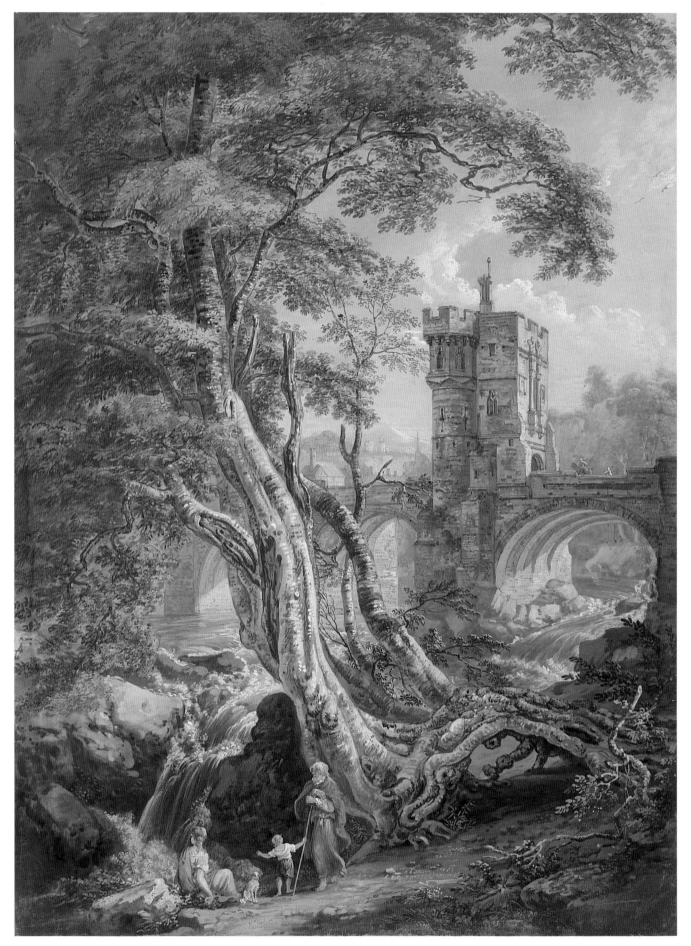

View of the Old Welsh Bridge, Shrewsbury
Bodycolour, watercolour and black ink over
traces of black chalk on paper, laid down on
card 625 × 467 mm
Bought, 1976 PD.8–1976

Sandby worked in bodycolour throughout
his career. He may have become familiar
with the medium as a child in Notting-
ham, where the Verelst family of Dutch
painters were producing large-scale flower
pieces in bodycolours, but he also knew,
and was variably influenced by, the
Flemish-based tradition of James
'Athenian' Stuart (1713–88) and the group
of gouache landscapes by the Italian
painter Marco Ricci (1676–1729), acquired

by George III in 1764, and still in the Royal
Collection.

The Old Welsh Bridge at Shrewsbury
was one of Sandby's favourite subjects.
Between the early 1770s and 1806 he
painted at least twelve versions of the
subject in a variety of media, and from a
number of different vantage points. Most
are painted on a large scale and in a
horizontal format which allowed Sandby
to encompass the arches of the bridge and
the human activity on the river. This view
is at once more dramatic in composition,
and more fantastic in its combination of
pictorial elements, and may have been
intended for exhibition.

The picturesque qualities of the time-
ravaged oak tree were highly recom-
mended by authors such as Uvedale Price
and William Gilpin. According to Gilpin,
it also added a distinctively English quality
to the landscape: 'The oak of no country
has equal beauty: nor does any tree answer
all the purposes of scenery so well. The oak
is the noblest ornament of a foreground;
spreading, from side to side, it's tortuous
branches and foliage, rich with some au-
tumnal tint' (*Observations ... of Cumber-
land and Westmoreland*, 1, 1786, pp.8–9).

The medieval gatehouse, known as the
'Mardol Gate', was demolished in 1782; the
bridge between 1795 and 1798.

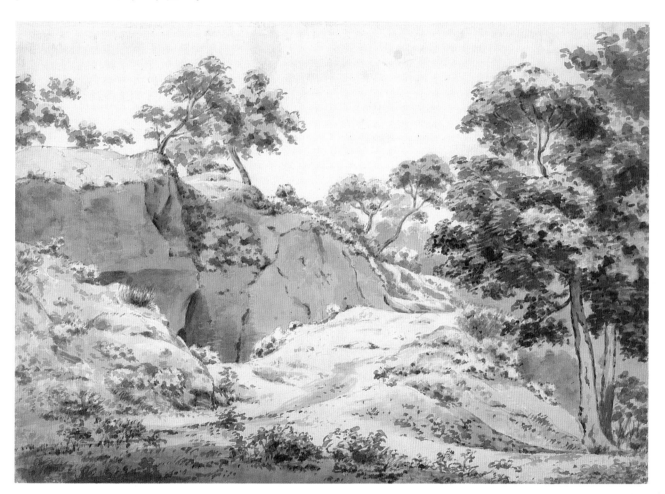

Joseph Wright of Derby 1734–1797

Rocky landscape
Graphite and grey wash with white highlights
on paper 385 × 537 mm
Bought, 1971 PD.46–1971

Wright had little regard for watercolour,
which he considered 'better adapted to the
amusement of ladies than the pursuit of an
artist' (Oppé, 1919–20, p.102), and prefer-
red monochromatic media such as grey

wash and black chalk for his drawings.

This impressive landscape is thought to
have been executed during a tour which
Wright made to France and Italy in 1773
with his former pupil, Richard Hurlestone,
and the painter John Downman (1750–
1824). Smaller grey wash views of Nice
and the surrounding countryside – dated
December 1773, and closer in style to the
delicately-painted contemporary land-
scapes of John Downman – are in Derby

Museum and Art Gallery, Rhode Island
School of Design and the Oppé collection
(see Nicholson, 1968, p.90). The bolder
character of this drawing may derive from
Alexander Cozens's system of 'blot' land-
scapes, which, as Kim Sloan has shown, he
probably knew from the latter's earliest
treatise on the subject, published in 1759
(Egerton, 1990, nos 74, 75; see p.24).

Wright is better known as a portraitist,
and painter of scenes by artificial light.

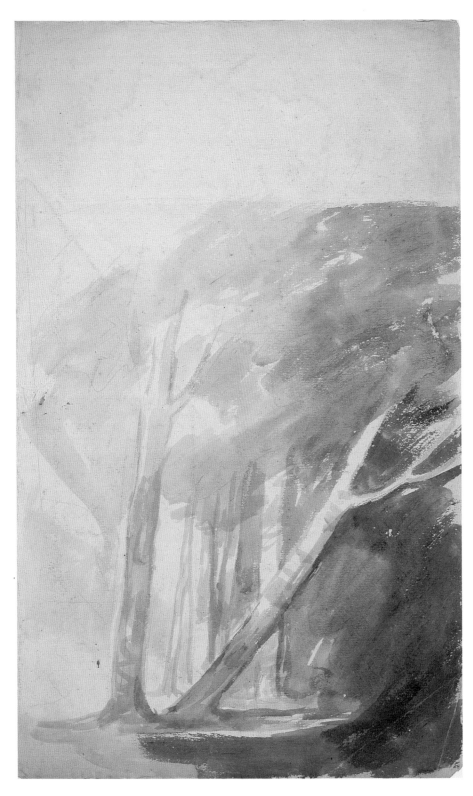

George Romney 1734–1802

Landscape sketch
Graphite and grey wash on paper 520 × 323 mm
Given by the Revd John Romney, 1818 LD.43

Landscape played only a minor role in
Romney's *oeuvre*, but as these studies
suggest, he was eminently aware of its
expressive potential. According to his son,
the Revd John Romney, who gave the
Museum the majority of its substantial
collection of Romney drawings in 1818,
Romney developed a taste for landscape
from studying prints by seventeenth-
century Dutch masters such as Berchem
and Wouwermans during a nine-month
stay in York in 1765: 'no sooner was he at
liberty to direct his own studies, than he
began to make copies from them in oils
and colours, and to form compositions of
his own invention. These, like vernal
flowers, which bloom in uncultivated
wastes … captivated by a certain natural
simplicity, and excited interest, as being
precursors of a more refined production.
They were blossoms of those bright and
sunny hours, when the mind, disengaged
from portraiture, and brooding over its
own imaginings, brought into visible exist-
ence the creations of fancy' (1830, p.23).

His most important landscape painting
in oils, *Landscape with figures*, was one of
twenty paintings sold at lottery in Kendal
in 1762, the proceeds of which enabled him
to set up in London, leaving his wife and
two children in Cumberland. Rediscovered
by his son only in 1798, it is said to have
been a fanciful recreation in the manner of
Watteau of a boating excursion on one of
the Lakes; its present location is unknown.
Like it, these landscape sketches owe more
to the imagination than to reality, and may
have been intended as scene paintings, or
as the background to one of his subject
paintings. As Patricia Jaffé has pointed out,
the breadth and speed of execution is
characteristic of Romney's drawings of the
mid to late 1790s (Jaffé, 1977, p.56).

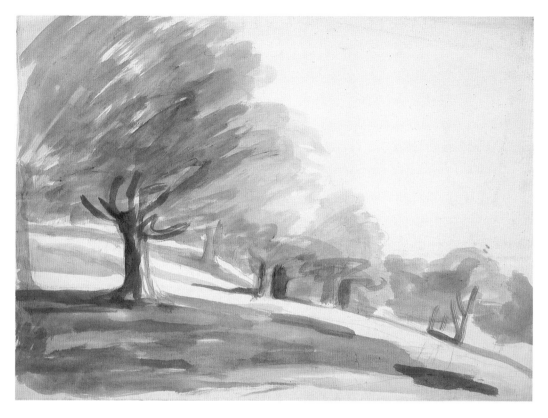

Wooded landscape
Black chalk and grey wash on paper
390 × 540 mm
Given by the Revd John Romney,
1818 LD.42

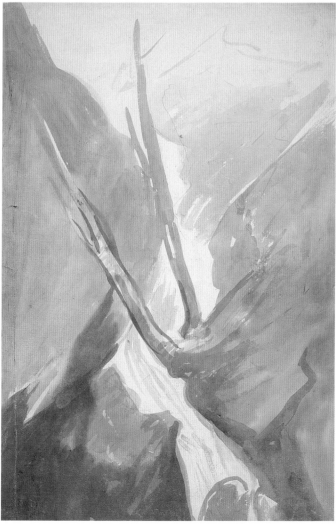

Mountainous landscape
Graphite and grey wash on paper
548 × 360 mm
Given by the Revd John Romney,
1818 LD.41

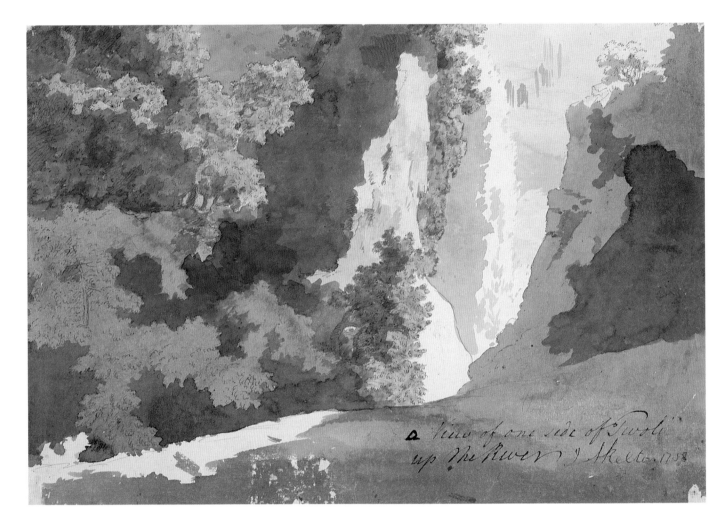

Jonathan Skelton c.1735–1759

Tivoli
Watercolour, grey wash and graphite on paper
264 × 375 mm
Signed, dated and inscribed in brown ink,
lower right: *a view of one side of Tivoli / up the
River J Skelton 1758*
Given by A. E. Anderson, 1926 no.1163

This freely-painted watercolour was
discovered in 1986, when the sheet was
lifted from its mount; the recto depicts a
more conventional topographical view of
the east end of the town of Tivoli in pen
and grey wash. Skelton visited Tivoli in
April 1758, and returned there in late
summer of the same year, when he stayed
in apartments in the Villa d'Este. In a letter
of 20 August 1758 to his patron William
Herring, Skelton claimed that he had 'not
for years been in such happy composure of
spirits' (Ford, *Walpole Society*, XXXVI, 1960,
p.55) and, like Thomas Jones (see p.42),
found the thickly wooded slopes, waterfalls
and rocks reminiscent of 'the most noble
Romantic wildness of Gaspard Poussin'.
On several occasions, he recorded painting
out-of-doors in both oils and watercolours,
but noted a preference for the latter, which
did not 'shine on the picture' in the strong
Italian sun (ibid., p.51).

Little is known of Skelton's life or
training before he left for Italy in 1757,
although dated examples of his work in the
three years prior to his departure show him
working in a picturesque manner, and
with a low-toned, sometimes monochrome
palette. In Italy, Skelton endured repeated
allegations of espionage for the Jacobite
cause, which hampered the sale of his
work; 118 drawings remained in his
possession at the time of his death in
January 1759.

Other views of Tivoli are in the Victoria
and Albert Museum, the British Museum
and Birmingham City Art Gallery.
Another sketch of the lower part of the
falls at Tivoli, executed with a comparable
freedom of handling, is in the Tate Gallery.

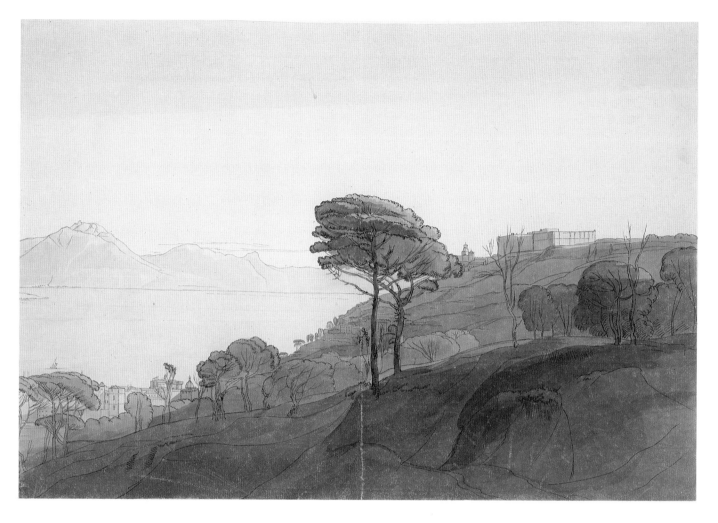

Francis Towne 1740–1816

A view from Naples
Pen and ink, grey wash and watercolour on
paper 320 × 467 mm
Inscribed in brown ink, verso: *N⁰ 1 taken at
Naples / Distance mont Lactarius of the antients /
the Bay of Naples Sᵗ Martini & Castle Sᵗ Elmo /
Francis Towne* and *Naples March 17ᵗʰ 1781*
Given by Percy Moore Turner, 1932
no.1621

Towne spent just over a year in Italy, from
1780 to 1781. He visited the Naples area in
March 1781, where he met up with Wil-
liam Pars and Thomas Jones, the last of
whom, having visited the area on three
previous occasions, offered to act as
cicerone for the short duration of his stay.
Towne's visit was punctuated by the type
of tiresome – and often dangerous –
incidents which bedevilled the eighteenth-
century traveller in Italy. Not two weeks
after his arrival (and three days after this
watercolour was painted) he was threat-
ened at knife-point by two 'gigantic
Troopers' (*Memoirs*, p.102) and, some days
later, on an excursion with Jones to the
Salvatoresque countryside on the road to
Sta Maria de' Monti, east of Naples, they
were set upon by a group of banditti –

'Towne started back as if struck by an
electric Shock, [and] with a most solemn
face, adding with a forced smile, that
however he might admire such scenes in a
picture, he did not relish them in Nature'
(*Memoirs*, p.105).

This view is taken from the northern
district of Naples on a road in the vicinity
of Capodimonte. As Francis Hawcroft has
observed, this is a study for the right-hand
side of a panoramic view of Vesuvius and
the Bay of Naples, executed in 1785, after
Towne's return to England (Whitworth
Art Gallery; see *Travels*, no.97, p.88).

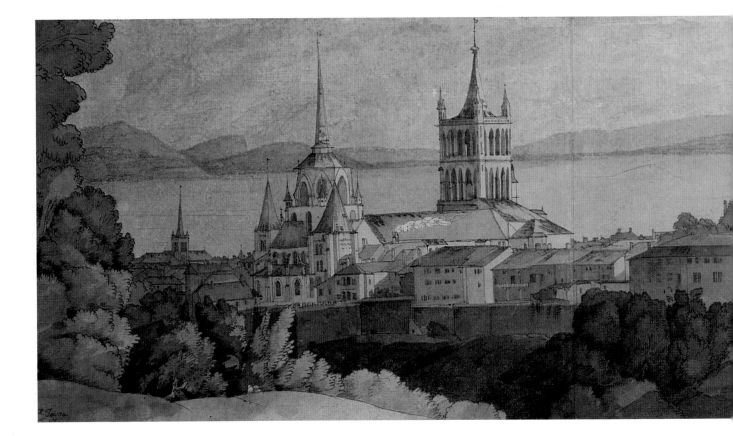

View of Lausanne
Graphite, pen and ink and watercolour on two
sheets of paper, joined together 242 × 905 mm
Signed and inscribed in ink, lower left: *F. Towne
/ delt. Nº. 11*; signed, inscribed and dated by the
artist on the verso of the old mount: *Nº. 11 A
View taken above the Town of Lausanne / looking
over the Lakes of Geneva, towards / Mount Jura
with the Town of Morgues & / Sᵗ Prex, by Francis
Towne / Septʳ 10ᵗʰ 1781 / Evening sun coming over
mount Jura*
Given by the Friends of the Fitzwilliam
Museum, 1928 no.1483

Drawn by Towne on his return from Italy
with 'Warwick' Smith in 1781. Although
Towne dated and numbered the majority

of his views of Swiss lakes, the inscriptions
are far from systematic, and make an
accurate reconstruction of his itinerary
through the Italo-Swiss mountains impos-
sible. The watercolours of the Alps which
he painted on this visit, the majority of
which are in the Oppé collection, are among
the most startling and direct depictions of
mountain scenery of the period. By com-
parison, this view of Lausanne, painted
over one and a half sheets of a sketchbook, is
more conventional in its panoramic format.

In 1805, Towne took the unusual step of
organizing a retrospective exhibition of his
views of Italy, Switzerland and the Lakes
at a room in Lower Brook Street, London.

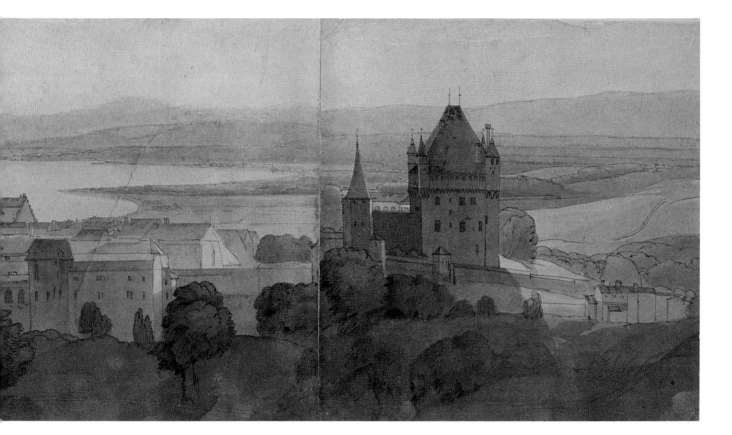

A wooded landscape ?Devon (p.38)
Pen and black ink on paper 343 × 244 mm
Signed, dated and inscribed in black ink, verso:
*N°.1. A Scene at / Indinowle / August the
26th.1788 / Morg light from the left hand / From
12. till 1 o clock / Francis Towne*
Given by the Friends of the Fitzwilliam
Museum, 1923 no.1091

After Towne returned from Italy in 1781,
he divided his time between Exeter and
London and made summer sketching tours
to other parts of England in the 1780s and
1790s, before settling in London in 1800.
The precise location of this view, and the
following drawing, has proved impossible

to identify from the inscription.

Of the two, this view is slightly lighter
in tonality, presumably in order to com-
municate the greater intensity of the light
at midday. Although Towne's fastidious
recording of the physical conditions under
which his views were painted would seem
to suggest a searching naturalist spirit, he
was, as this drawing shows, highly selective
in the information he chose to record.
Trees, foliage and undergrowth are drawn
in a form of artistic shorthand, using a
restricted palette of monochromatic grey
washes to render depth and shadow.

A wooded landscape (p.39)
Pen and black ink with grey wash on paper
343 × 242 mm
Signed, dated and inscribed in black ink, verso:
*No.3. / Indinowle / August the 26th 1788 / light
from the left hand / from 1 o clock till 2 / Francis
Towne*; and, in graphite: *Indenold*
Given by the Friends of the Fitzwilliam
Museum, 1923 no.1093

This and the other watercolours by Towne
illustrated here, came from the collection
of the descendants of the lawyer and poet
John Herman Merivale (1779–1844), who
inherited Towne's estate on the death of
the artist's executor in 1825.

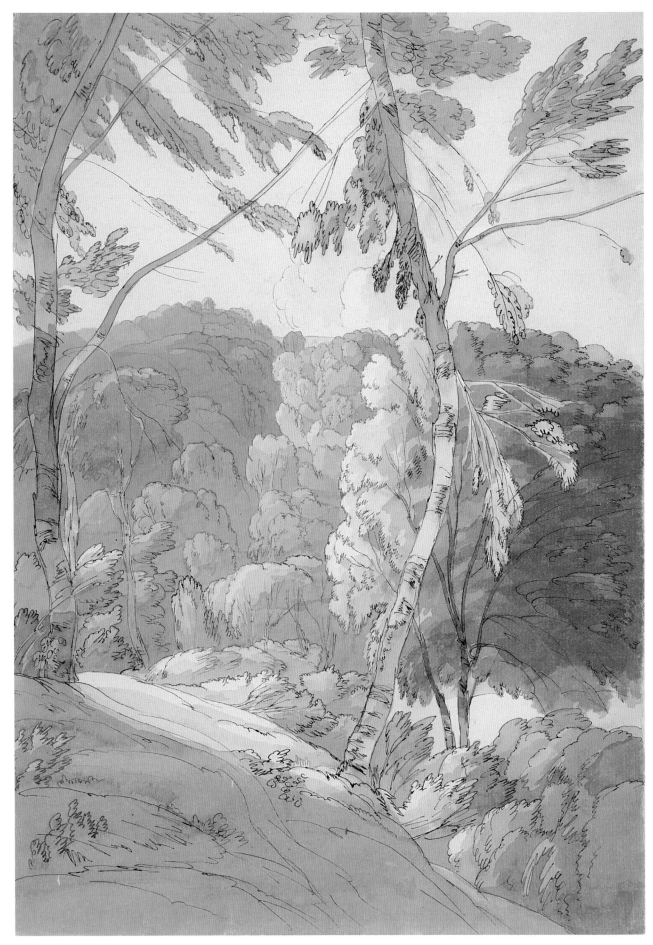

FRANCIS TOWNE

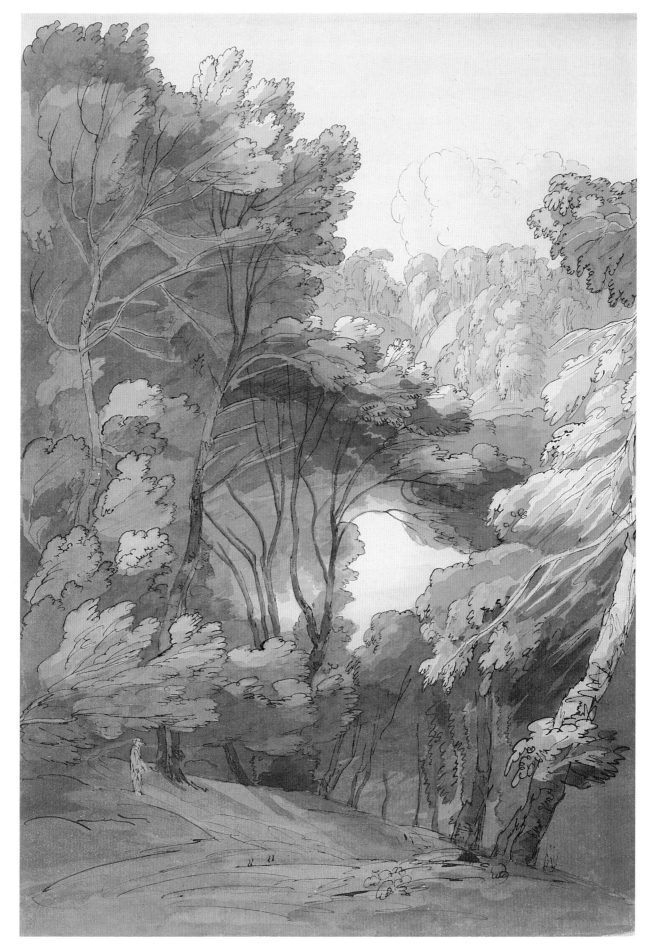

39

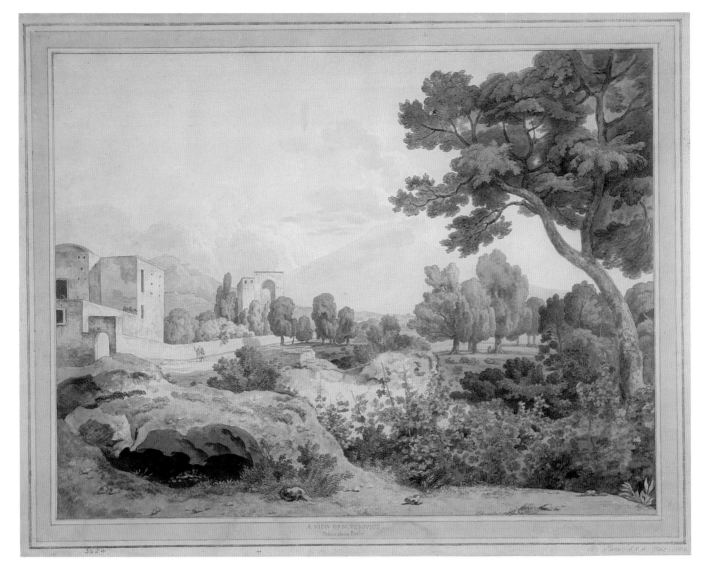

William Pars 1742–1782

View of Vesuvius from above Portici
Black chalk, watercolour, pen and black ink on
paper 432 × 630 mm
Inscribed in ink, below the drawing (the
original wash mount forming part of the sheet):
A View of Mount Vesuvius taken above Portici
Given by the Friends of the Fitzwilliam
Museum, 1936 no.1963

Pars travelled to the Naples area at least
twice, once in 1780 in order to make a copy
of Titian's famous *Danaë* at Capodimonte,
and again in the late spring and summer of
1781. On both occasions he made several
painting expeditions with his friend
Thomas Jones, including one to Portici
and up Mount Vesuvius on 15 June 1781 in
order to sketch 'about the french hermi-
tage near the bottom of the great Cone'
(*Memoirs*, p.105).

The lower slopes of the volcano were, as
Jones noted on a later visit, filled with
'beautiful Vineyards and villages, & Groves
of Fruit & Forest Trees, and interspersed
with handsom Churches and Convents'
(*Memoirs*, p.124), and it is this luxuriant
countryside rather than the smouldering
volcano which Pars has made the subject of
the present view.

The washed border mount of this
drawing was painted by Pars, who, like the
majority of his British and Continental
contemporaries, exercised considerable
care over the presentation of finished
watercolours and prints. These were, after

all, the works presented to Grand Tourists
such as Lord Fitzwilliam's cousin, the 10th
Earl of Pembroke, who visited Pars's studio
'under the Arco del Argina' in September
1779. Apart from arranging a blessing by
the Pope, visiting British artists' studios
was a favourite pastime on a Sunday in
Rome, when it was otherwise 'impossible
to see anything a Key is required to open,
as the bearers are either at their Devotions
or Pleasures on the Sabbath. The Churches
are full of People, so that though entrance
of them is not forbid, yet within Progres-
sion it is. For these reasons we visited some
of our English Artists who being Heretics
were sure to be found at home' (*Pembroke
Papers*, 1939, p.272).

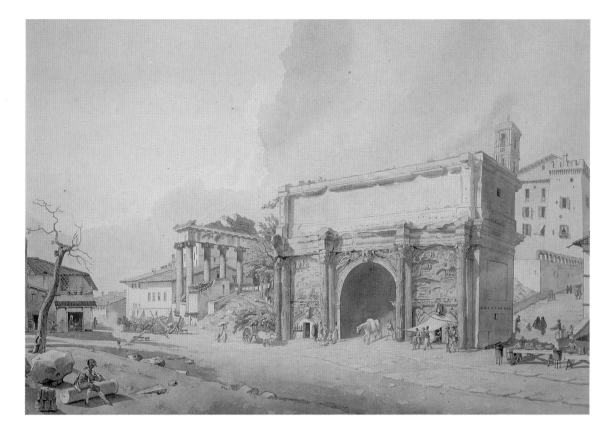

The Arch of Septimus Severus and the Temple of Saturn in the Forum Romanum, Rome
Watercolour over graphite on paper
370 × 557 mm
Bought, 1958 PD.62–1958

Like Richard Wilson, Pars's initial training was as a portrait painter, but from the age of twenty-two he was employed mainly as a travelling draughtsman. In 1764, he accompanied Richard Chandler and James Revett to Greece and Asia Minor, and four years later travelled with Lord Palmerston to Italy via Switzerland, where they had the good fortune to be escorted through the Alps by the geologist Horace Bénédict de Saussure (1740–99).

In 1774 Pars was awarded a grant of £60 for three years by the Dilettanti Society, in order to allow him to continue his studies in Rome. He left for Italy the following year and remained there until 1782, when, though 'a robust, hearty fellow' he died of 'dropsy of the breast', contracted from standing in a waterfall while sketching in Neptune's Grotto at Tivoli (Whitely, 1928, II, p.344).

For most of his seven years in Italy, Pars was resident in Rome. The view in this watercolour looks westward along the Forum to the Campidoglio, with, on the right, the Ionic columns of the Temple of Saturn and the Arch of Septimus Severus before its base was excavated and the two smaller side arches restored.

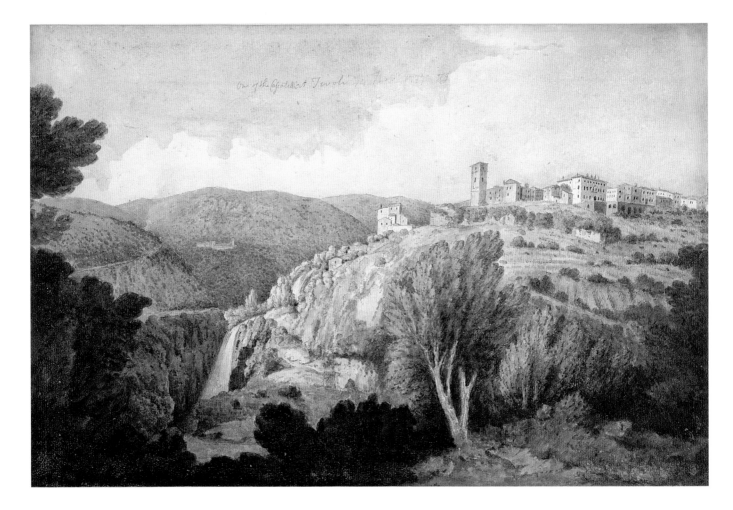

Thomas Jones 1742–1803

View of the Grand Cascatelle at Tivoli
Graphite and watercolour on paper
272 × 412 mm
Signed, dated and inscribed in graphite upper
centre: *One of the Cascatelli at Tivoli: 14 Nov[r].
1777 T.J.*; inscribed in graphite, upper right:
viny[d] / viny[d] / vineyard
Bought, 1961 PD.15–1961

Jones wrote extensively and enthusiastic-
ally in praise of Tivoli and its surrounding
countryside following his first visit there in
November 1777: 'Tivoli is a large Town
situated in the most romantic manner on
the extremity of one of those branches or
ribs of the Appenines which tends toward,
and approaches nearest the city of Rome …

This country … seems formed in a peculiar
manner by Nature for the Study of the
Landscape-Painter …– At Tivoli – the
foaming Torrents rush down the Preci-
pices into the deep Abyss with a fearful
noise and horrid Grandeur' (*Memoirs*,
p.66).

Francis Hawcroft has identified this
view as taken from the slopes of the
northern bank of the River Aniene, look-
ing southeast towards Mount Catillo
(*Travels*, p.50). It depicts the Grand Casca-
telle towards the northern end of the town,
with the campanile of the Cathedral rising
prominently behind. As in most of his
views of the town, Jones's chief concern is
to evoke something of the 'romantic

manner' of the setting, an effect he
achieves by assuming a low viewpoint to
emphasize the precipitous rock face and
luxuriant vegetation.

The 'French looking artifice' arising
from the use of an intense blue in some of
Jones's watercolours of Tivoli, has been
plausibly explained by Gowing as his
attempt to rival the decorative bodycolour
vedute being produced by foreign artists for
the tourist market (Gowing, 1985, p.37).

A pupil of Richard Wilson, Jones spent
seven years in Italy from 1776 to 1783. He
exhibited little after his return, and in
1789, on the death of his brother, gave up
his artistic career to run the family estate at
Pencerrig in Wales.

Thomas Hearne 1744–1817

The South Gate, Yarmouth
Graphite and watercolour on paper
189 × 249 mm
Signed and dated in brown ink, lower centre:
T.Hearne 1792
Given by the Friends of the Fitzwilliam
Museum, 1926 no.1174

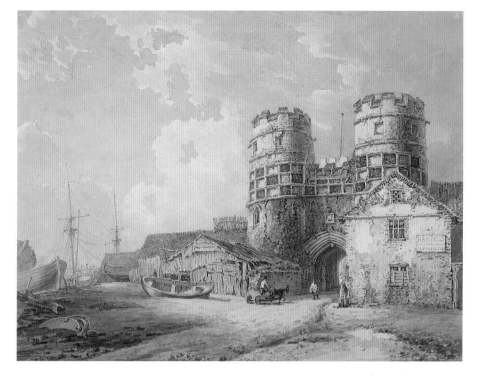

Like many watercolourists of the period, Hearne began his artistic career as a printmaker's apprentice. In 1771 he travelled to the West Indies, where he worked as a draughtsman to Sir Ralph Payne, Governor of the Leeward Islands, and after his return to England in 1775, he rapidly acquired a reputation as one of the leading antiquarian topographical draughtsmen of the day.

This drawing was engraved by William Byrne and John Sparrow as plate 5 of the second volume of the *Antiquities of Great-Britain*, published jointly by Hearne and Byrne in 1806. Sets of engravings for the first volume were issued at intervals of approximately three to six months from 1778 until 1786, when fifty-two engravings were bound and sold as a volume. Nothing further was published until 1796, when sets of four engravings were once again issued, at first annually, and then, due to Hearne's failing health, biennially; the completed second volume appeared in 1806. As David Morris has shown, Hearne's financial and conceptual involvement in this ambitious project was considerable (1989, pp.24–51). For the first volume he owned half-shares in the plates and impressions, and compiled the historical texts which accompanied each print. According to the letter-press which accompanied the plate after this drawing, dedicated to the Mayor and Corporation of Yarmouth: 'the North Gate was erected at the expence [*sic*] of those who had been employed in the shocking office of burying the dead in the time of the plague, by which they had gained great sums.'

Saxon capitals in the walls of the Church of the Hospice of St James, Dunwich
Watercolour over graphite on paper
176 × 259 mm

Inscribed in brown ink, verso: *Saxon Capitals in the Walls of the Church / of the Hospice of St. James. Dunwich. 1786*
Given by Sir Frank Brangwyn, 1943 no.3204

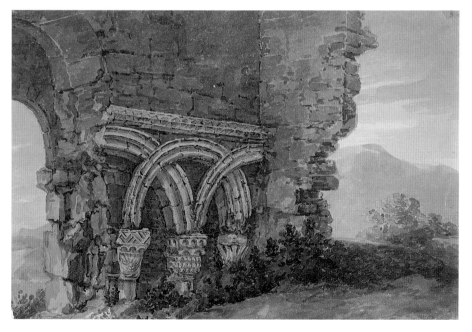

Most of Hearne's best work was produced as a result of picturesque tours made in the 1770s and 1780s, largely to gather views for the *Antiquities of Great-Britain*. On the whole these were complete topographical compositions, such as *The South Gate, Yarmouth*, but occasionally he devoted his attention to isolated details of architecture or nature. In this watercolour, the crumbling texture of the ruined masonry is realized with great delicacy, using a limited range of tones and a network of small, patiently-applied brushstrokes. The immediacy with which Hearne has confronted his subject is unusual in his work; however his aim is not to jolt the viewer's sensibilities, as Girtin or Turner might have done (see *Lindisfarne Abbey* (p.61), *Christ Church, Oxford* (p.63)), but rather to present his subject with a minimum of picturesque trappings.

Another view of the ruins of St James's is in the collection of Harrow School.

John 'Warwick' Smith 1749–1831

View of Ariccia near Albano
Watercolour over traces of graphite on paper,
laid down on a wash mount 302 × 444 mm
Inscribed on old mount: *Holy Sepulchre (?) at
l'Arrizie (?)*
Bought, 1962 PD.3–1962

The son of a gardener, Smith was born in
Cumberland, and throughout his life
gathered patrons with enviable ease. As a
boy he was taken up by Captain John
Gilpin, who gave Smith his first drawing
instruction, and set him up as a drawing
master at Whitehaven. Through the
Captain's son, Sawrey, he met Sir Henry
Harper, at whose Derbyshire seat he came
to the notice of his most influential patron,
George Greville, 2nd Earl of Warwick,
around 1773. Lord Warwick was himself
an accomplished amateur artist, and after
seeing some of Smith's drawings of Mat-
lock, paid for him to go to Italy from 1776
to 1781.

This view remained in the collection of
the Earls of Warwick until it was sold at
auction in 1936. The cupola of Santa Maria
dell'Assunzione, built by Bernini between
1662 and 1664 is just visible above the trees
in the park of the Palazzo Chigi on the left.
A watercolour of Ariccia by Smith's friend
and sketching companion Francis Towne,
viewed from a similar angle and dated
1781, was bequeathed by the artist to the
British Museum in 1816.

Santa Casa, Loreto
Watercolour over graphite on paper
308 × 444 mm
Inscribed, signed and dated in brown ink,
verso: *La Santa Casa, Loretto. / John Smith 1806*
Bequeathed by F. H. H. Guillemard, 1933;
received, 1937 no.2289

This watercolour was painted in 1806, the
year in which Smith became a member of
the Society of Painters in Water-Colours,
and some twenty years after his return
from his second and final visit to Italy, in
the company of Lord Warwick. Of the 159
watercolours which he exhibited at the
Society between 1807 and his death in
1831, the majority were views in Italy; this
distant view of Loreto is loosely related to
an engraving after an earlier drawing,
published as the final plate of the second
volume of Smith and Byrne's *Select Views
in Italy with Topographical and Historical
Descriptions in English and French* (1796).

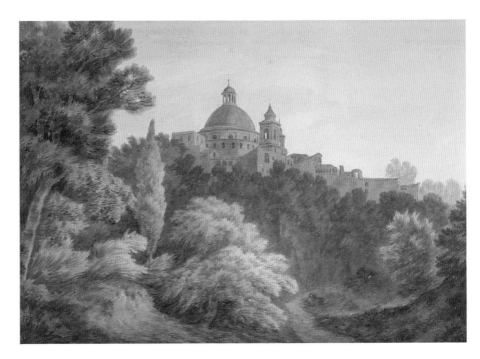

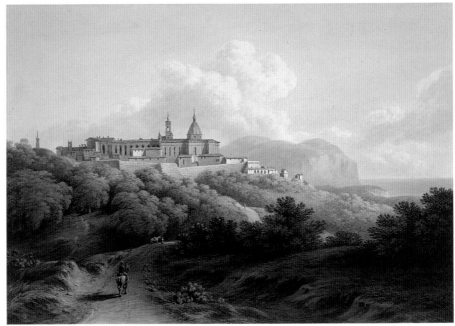

View near Braithwaite's Farm in the Lake District
Watercolour on paper, laid down on a wash mount 344 × 510 mm
Signed and dated in ink, lower right: *J. Smith 1791*
Inscribed in graphite on mount, upper centre: *General View from M^r Braithwaites. No. 8* (*Braithwaites.* reinforced in pen and ink)
Bought, 1970 PD.2–1970

After his return from Italy with Francis Towne in 1781, Smith settled in Warwick, and made sketching tours in Wales and the Lake District. The number '8' of the inscription identifies this as one of a group of one hundred watercolours commissioned by John Christian Curwen of Workington Hall, Cumberland, and painted between 1788 and 1792. Curwen owned considerable estates in the Lake District and appears to have made a point of patronizing local artists. The land known as Braithwaite's near Lake Windermere belonged to the Brathay family until 1788, when it was sold to a Mr Law. It later became the property of the Birmingham banker Charles Lloyd, who held regular social gatherings attended by such literary luminaries as Coleridge, Wordsworth and De Quincey. 'No. 7' in the series, inscribed 'Braithwaite's Farm, Cumberland', was sold at Sotheby's in 1988 (10 March 1988, lot 51).

A selection of these views was engraved and published in parts, without title or text, in 1791, 1793 and 1795.

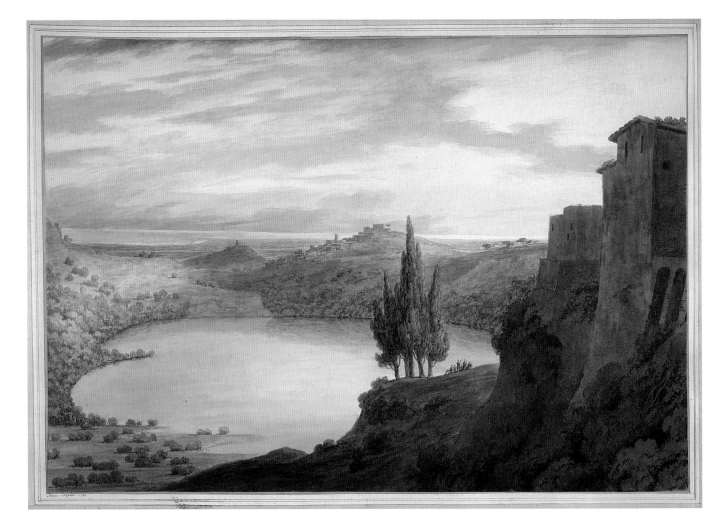

John Robert Cozens 1752–1797

Lake Nemi
Graphite, ink and watercolour on paper, laid
down 427 × 624 mm
Inscribed in blue ink on the mount, lower left:
John Cozens, 1788.; and, on the verso of the
sheet, in ink: *Lake of Nemi*
Founder's Bequest, 1816 no.3464
Bell and Girtin 140 iii

Lake Nemi, a volcanic lake in the Cam-
pagna sixteen miles southeast of Rome,
was one of the most popular sights on the
Grand Tour of Italy. Known as the
Speculum Dianae, or 'Mirror of Diana' due

to the perfect reflections of the moon on
the surface of the lake, it was painted by
most of the British artists resident in Rome
at the end of the eighteenth century,
among them Jones, Wilson, Pars and
Towne, and was one of Cozens's favourite
subjects. Nine other versions of this com-
position are known – in addition to those
listed by Bell and Girtin, two further
watercolours identified by Hawcroft are in
the Toronto Art Gallery and in the collec-
tion of Mr Bruce Howe, USA (1971, p.18).

From a sketch of Lake Nemi and the
town of Genzano in the Soane Museum it
appears that Cozens was working in the

area in April 1777; the inscription on the
verso of this watercolour, and the date 1790
on other watercolours of the subject,
suggest that he was producing finished
repetitions for over a decade after his visit.

Cozens's view is above all a landscape of
mood, and, to judge from the number of
surviving versions of the composition, one
which was highly attuned to the sensibili-
ties of the day (see p.13). An overwhelming
sense of tranquility is induced by the
restful palette of greys and soft blues, and
by the controlled progression through the
landscape, from the foreground shadow to
the shimmering Mediterranean beyond.

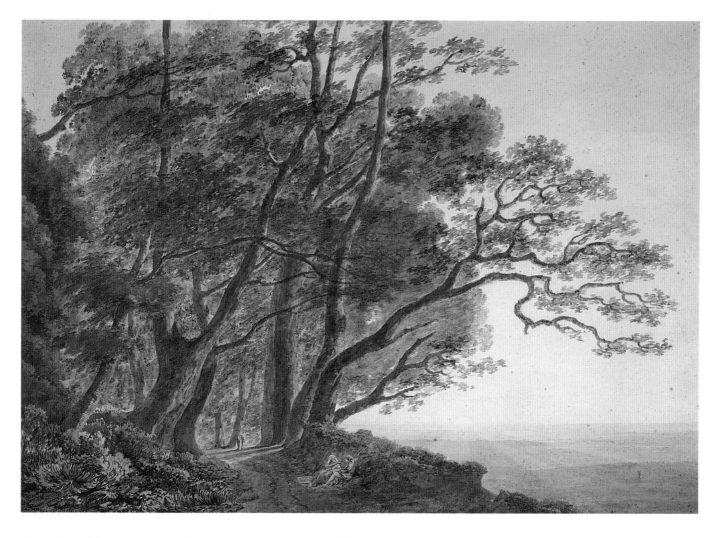

The Galleria di Sopra above Lake Albano
Watercolour over graphite on paper, laid down
450 × 642 mm
Lent by Mr and Mrs G. A. Goyder
Bell and Girtin 154 ii

A tunnel-like avenue of ilex which ran along the southwest edge of Lake Albano, the Galleria di Sopra was painted by Cozens on several occasions and in four different formats. This is one of the compositions which Wilton dates 1778 and describes as type 'c', an unfinished version of which at Yale Center for British Art he relates to another unfinished view in the

Oppé collection (Wilton, 1980, p.41). Although each of the versions differs in viewpoint and degree of finish, they share a common emphasis on pattern and effects of light, created by placing the tree trunks and branches well above the level of the horizon, with no more than a glimpse over the distant Roman Campagna. As Francis Hawcroft pointed out (*Travels*, p.47 under no.49), Cozens may well have derived his interest in describing the outline and character of different types of trees from his father, whose book, *The Shape, Skeleton and Foliage of Thirty-two Species of Trees for*

the use of Painting and Drawing appeared in 1771. John Robert published his own set of soft-ground etchings and aquatints of fourteen varieties of trees, without text or title-page, in 1789.

A fourth version of this composition, now in the Williamson Art Gallery, Birkenhead, was given by Sir George Beaumont to John Constable in 1814; it may be to it, above all, that Constable referred, when he wrote that 'Cousins was all poetry … the greatest genius that ever touched landscape' (Beckett, 1970, p.67, n.7).

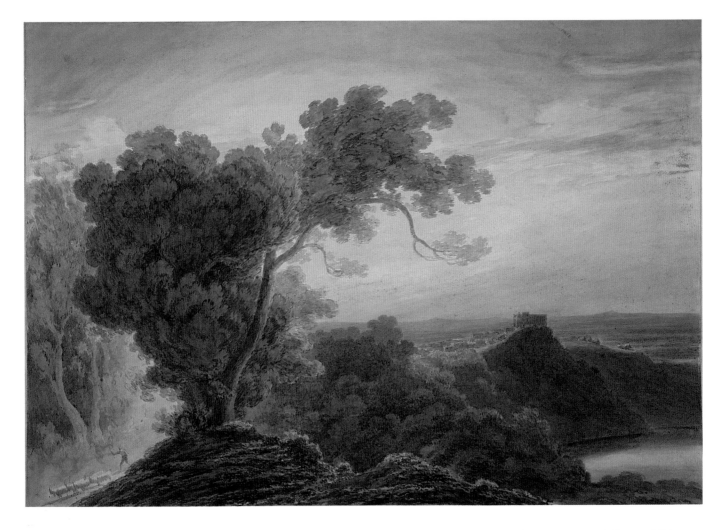

Castel Gandolfo and Lake Albano
Graphite and watercolour on paper, laid down
436 × 627 mm
Inscribed in brown ink on the mount, lower
left: *John Cozens*; and, verso: *Castel Gondolfo
|sic| on the Lake of Albano*
Founder's Bequest, 1816 no.3465
Bell and Girtin 147 i; C. F. Bell, 1947, p.9

The view shows Castel Gandolfo on the
northern rim of Lake Albano, the papal
palace begun by Carlo Maderno (1556–
1629), but later much extended.

To eighteenth-century landscape artists
and travellers, this view would have been
familiar from paintings by Claude Lorrain
(1600–82), the recollection of which may
well have influenced Cozens in his choice
of a twilight scene and inclusion of goat-

herd and flock. However to an even
greater extent than Claude, Cozens's view
invites contemplation of the seemingly
infinite horizon which led Thomas Jones
to describe the region in 1776 as a 'Magick
Land' (*Memoirs*, p.55). Joseph Addison,
who visited the area earlier in the century,
considered the boundless vista one of the
most delightful he had ever seen: 'There is
nothing at *Albano* so remarkable as the
Prospect from the *Capucin's* Garden ... It
takes in the whole *Campania*, and termi-
nates in a full view of the mediterranean.
You have a Sight at the same time of the
Alban Lake, which lies just by in an Oval
figure of about seven Miles round, and, by
reason of the continu'd Circuit of High
Mountains that encompass it, looks like the

Area of some vast Amphitheatre. This,
together with the several green Hills and
naked Rocks, within the Neighbourhood,
makes the most agreeable Confusion
imaginable' (1736, p.218).

Francis Hawcroft has listed ten other
versions of this subject, in the Whitworth
Art Gallery, the Tate Gallery, the Ashmo-
lean Museum, Leeds City Art Gallery, two
in the Yale Center for British Art, and
others in private collections. The dating of
the group is problematic. Although Haw-
croft's divisions into 'mood types' such as
mysterious, decorative and pastoral makes
useful aesthetic distinctions between the
different versions, there is no reason to
assume that they correspond to distinct
chronological groups.

The Villa d'Este, Tivoli
Watercolour over traces of graphite on paper
368 × 531 mm
Given by A. E. Anderson in memory of his
brother, Frank, 1928 no.1493
Bell and Girtin 139 ii

Bell and Girtin list two other versions of
this subject, one in Aberdeen Art Gallery,
dated 1778, and a smaller, later version
(1780) in the collection of Sir Thomas
Barlow, Bt.

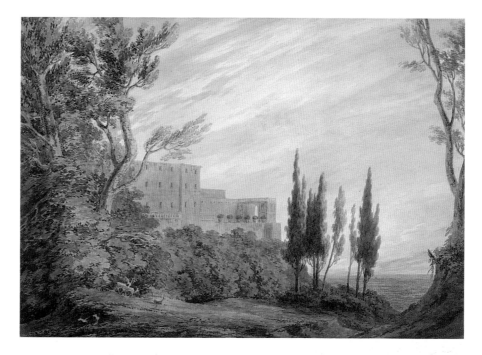

Pays de Valais
Graphite, Indian ink with point of the brush
and blue and grey wash on paper, laid down
332 × 522 mm
Bought, 1965 PD.6–1965
Bell and Girtin 12 v

This watercolour, probably painted be-
tween 1780 and 1785, is based on a sketch
made by Cozens during a trip to Switzer-
land in 1776 in the company of Richard
Payne Knight. The composition appears in
the album of '28 sketches by J. Cozens of
views of Italy, 1776–78' now in the
Soane Museum, with the inscription
*Approach to Martinach Pais de Vallais August
30-1776*. That it was a particularly popular
view in Cozens's repertoire is evident from
an inscription on the verso of the sketch,
which lists the names of eight patrons who
ordered finished watercolours of the
subject, probably after Cozens's return to
London in 1779. Other versions of the
subject are with Thomas Agnew and Sons,
London, and in the Yale Center for British
Art, Leeds City Art Gallery, Birmingham

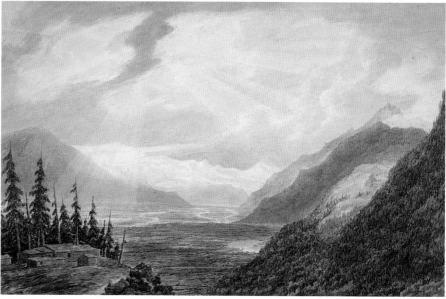

City Art Gallery (two watercolours);
another in the collection of the National
Trust, Stourhead, is the only one of the
group whose provenance can be traced
with certainty to Cozens's original list of

commissions. Andrew Wilton has sug-
gested that the relatively dark colouring of
the Fitzwilliam and Stourhead water-
colours indicates that they were the first to
be drawn (1980, p.150, under no.135).

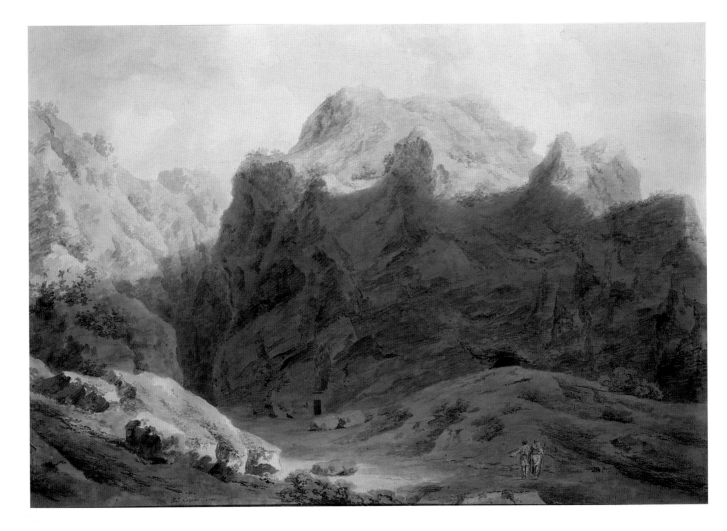

The Chasm at Delphi
Watercolour over graphite on paper, laid down
642 × 920 mm
Signed and dated in ink, lower left: *Jn°. Cozens
1790*
Lent by Mr and Mrs G. A. Goyder
Bell and Girtin 436

Few watercolours by Cozens survive from
the 1790s, and none on this imposing scale.
This drawing was worked up from a
sketch made by the architect James Stuart
'under the direction of a traveller who had
recently visited the spot', and was engraved
as plate x in volume IV of Stuart and
Revett's *Antiquities of Athens* (1816). Its
colouring shows Cozens at his most som-
bre and grand.

In the Farnese Gardens, Monte Palatino
Indian ink, point of the brush and watercolour
on paper 258 × 373 mm
Inscribed in brown ink, verso: *In the Farnesina
Gardens / Mont Palatine / Rome / BY COZINS*
Bought, 1965 PD.5–1965
Bell and Girtin 358

One of a number of drawings of Roman
subjects executed *c*.1783 for William
Beckford of Fonthill, whom Cozens
accompanied on the latter's third visit to
Italy in 1782. Unlike others in the series, it
appears to have been based on a composi-
tion of his father's, known in two versions:
one, dated 1746, formerly in the collection
of A. P. Oppé; the second in the British
Museum (1867.10.12.45). As Kim Sloan has
pointed out, the handling of paint in this
watercolour is closer to the more loosely-
painted version in the British Museum, one
of a group lost by Alexander Cozens on his
way back from Italy, and subsequently
discovered by John Robert in Florence in
1776 (1986, pp.14–15).

Although Beckford was a friend and
pupil of Alexander Cozens, his relation-
ship with John Robert seems to have been
far less cordial. Correspondence between
Beckford and Alexander Cozens suggests

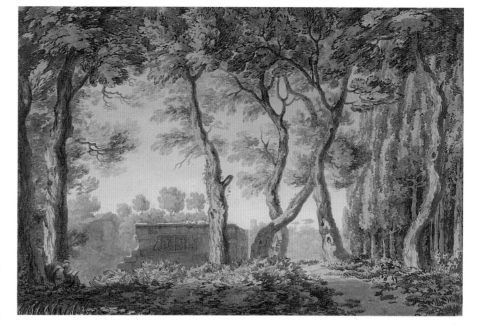

the former's dissatisfaction at the late
delivery of promised drawings, while
Thomas Jones may have echoed something
of Cozens's relief when he wrote that his
friend was 'loosed from the Shackles of
fantastic folly and caprice' (*Memoirs*, p.114)
after the eccentric and demanding Beck-
ford left Naples for Marseilles at the be-

ginning of September 1782. Significantly,
Beckford disposed of nearly one hundred
of Cozens's watercolours at a sale during
his own lifetime (Christie's, 10 April 1805,
at which this was described as 'a brilliant
and highly finished drawing'), and failed
to subscribe to a fund to support Cozens
during the mental decline of his last years.

Hubert Cornish 1757–1832

Visiting the cataract at Dol-y-Melynen
Graphite and watercolour on paper
227 × 316 mm
Bought, 1985 PD.265–1985

Nothing is known of Cornish beyond his
name and the dates of his birth and death.
From his surviving watercolours, it ap-
pears that he toured England, Ireland and
Wales; a number of views of Wales, dated
August 1809, were sold by a descendant of
the artist at Christie's, 14 June 1977.

The cataract at Dol-y-Melynen, one of
three waterfalls near the town of Dolgelly
in North Wales, was much frequented by
tourists in search of the picturesque. One
of these, the Hon. John Byng, later 5th
Viscount Torrington, who trudged across
'stoney and boggy woodland' to visit the
falls in July 1784, proclaimed them the
finest he had seen: 'At every turn the
foaming stream tumbles over massive
rocks, with much uproar, and this con-
tinues for a quarter of a mile, to the great
water-fall which exceeded every thing I

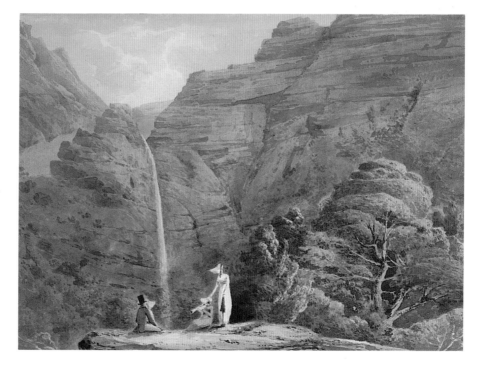

had seen. The torrent is very wide, and
very rapid, sending up surf, and smoke to a
great height … Think of the lucky rain

that fell in the preceding night which
swell'd the cascades in their utmost glory'
(Bruyn Andrews (ed.), 1934, I, p.149).

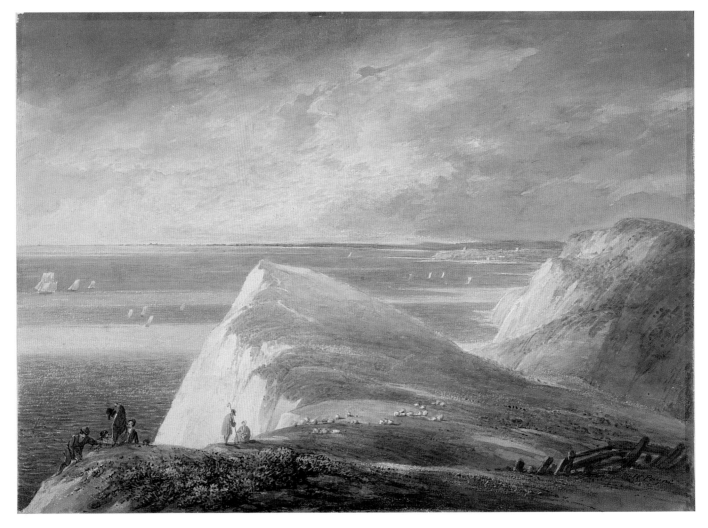

William Payne 1760–1830

Shakespeare's Cliff, Dover
Watercolour on paper, laid down 304 × 425 mm
Signed in ink, lower right: *W. Payne*; inscribed
in ink, verso: *Shakespear's Cliff. Dover*.
Bequeathed by Darcy Kitchin, 1939 no.2372

Payne was born in Exeter, and was first
employed as an engineer in Plymouth
Dockyard. By 1790 he was in London,
where he exhibited views of the southern
coast of England, particularly in Devon
and Cornwall, at the Royal Academy and
British Institution, and later at the Society
of Painters in Water-Colours. He enjoyed
enormous popularity as a drawing master,
though professional colleagues accused
him of promoting sloppy methods of
watercolour painting at the expense of a
proper understanding of technique: 'How
many waggon-loads of woven elephant
and imperial [paper sizes], ye gods! were
consumed by amateur artists in the reign of
King George the Third … in practising the
elegant art of drawing – à-la-Payne!'
(*Library of the Fine Arts*, II, 1831, p.365).

He is best-remembered today for the
grey pigment composed of indigo, crimson
lake, and ivory black, which bears his
name.

Landscape with travellers and a waterfall
Watercolour over graphite on paper
471 × 324 mm
Bought, 1958 PD.57–1958

The handling of paint in this watercolour
is considerably more vigorous than the
preceding watercolour, and demonstrates
something of the spirit and dexterity for
which Payne was much admired in his
own lifetime.

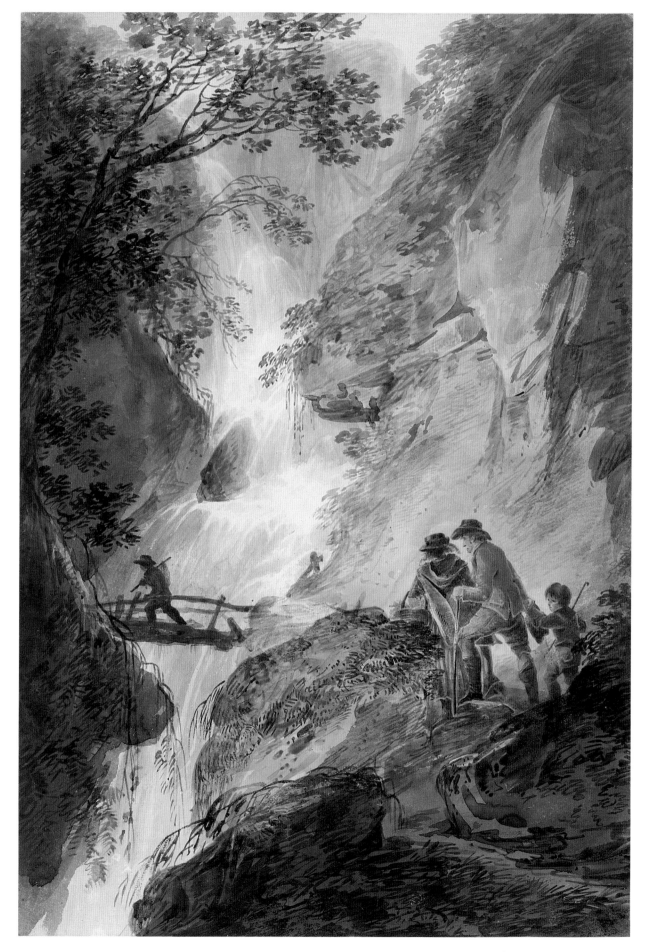

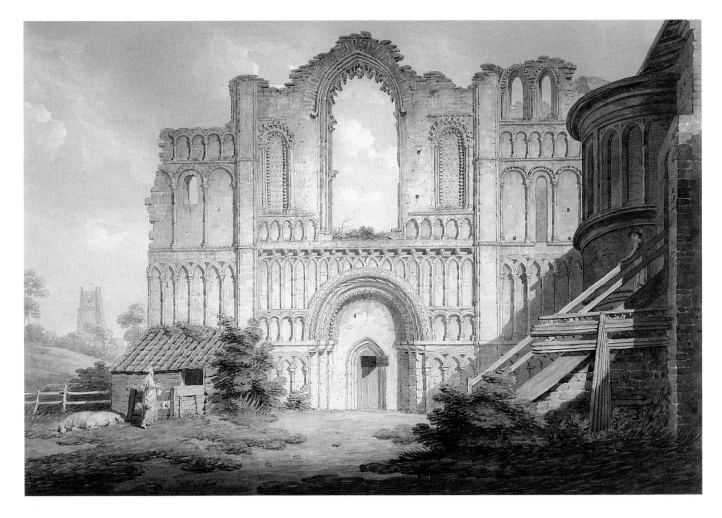

Edward Dayes 1763–1804

The West Front of Castle Acre Priory Church, near Downham, Norfolk
Watercolour and graphite on paper
271 × 398 mm
Signed and dated in ink, lower left of centre:
1796 (?) E Dayes
Bought, 1958 PD.56–1958

Dayes was one of the leading topographical artists of the day. Until 1780 he studied under the miniature painter and mezzotint engraver William Pether (1738–1821), and was later employed as a drawing master to the Duke of York. He contributed drawings of the antiquities of Great Britain to a large number of the topographical publications which appeared at the end of the eighteenth century, and between 1801 and

1803 he published in the *Philosophical Magazine* a series of *Essays on Painting*.

Another view of Castle Acre Priory, now in the Cecil Higgins Museum, Bedford, was published posthumously in the *Antiquarian and Topographical Cabinet* for 1808, and, as Duncan Robinson has remarked, the highly-finished nature of this drawing suggests that it, too, may have been intended for translation into print (1982, no.35).

Although Dayes is often considered to be a picturesque draughtsman *par excellence*, he regretted the trend among his contemporaries to treat subjects which were both 'disgusting' and 'unsightly', and to seek irregularity at the expense of beauty: 'We must give up our understanding [of the picturesque] if we call that landscape *fine*

which represents dirty rugged grounds, scrubby bushes, poor scraggy and ill-formed trees, shapeless lumps of antiquity, and muddy pools; peopled with gipsies and vagabonds, dirty beggars, clothed with rags, their heads decorated with filthy drapery, skins like tanned leather, and their employ disgusting; and these accompanied with poor and old cattle, or nasty swine on filthy dunghills' (*Works*, 1805, p.225). Accordingly, in this watercolour, the landscape is pleasingly unkempt, the swine attractively pink, and the swineherd both pretty and gainfully employed.

It is worth noting that much of the striking effect of this watercolour is due to Dayes's avoidance of his own precept 'never to be nearer the building ... than twice its elevation, or length' (ibid., p.287).

John White Abbott 1763–1851

Trees in Peamore Park, Exeter
Pen and ink and watercolour on nine pieces of
paper, laid down on a wash mount
431 × 355 mm
Signed in ink with monogram and dated, lower
left: *JWA 1799*
Inscribed by the artist on the verso of the
mount: *Peamore – 1799. Given to John Abbott,
March 1. 1832*
Bought with a contribution from the Victoria
and Albert Museum Grant-in-Aid, 1980
PD.42–1980

An apothecary and surgeon by profession,
Abbott was a gifted amateur, whose
watercolours emulate those of his master
Francis Towne in style, if not in strength of
effect. He was born in Exeter, and lived
there for most of his life, although dated
drawings (like Towne he habitually in-
scribed his drawings with place and date of
execution) show that he made sketching
tours to Scotland, the Lake District,
Lancashire, and perhaps also to Derbyshire
and Yorkshire. His contemporary fame
was due almost entirely to his oil paintings,
which he exhibited to great acclaim at the
Royal Academy from 1793 to 1805, and
again in 1810 and 1822.

This view of Peamore Park, three miles
south of Exeter, is one of Abbott's most
impressive productions. While the flat
washes and powerful sense of structure
owe much to Towne, the feathery handling
is characteristic of White Abbott's less
assertive hand, which Oppé has aptly
described as having, 'the air of somewhat
lady-like embroidery' (1925, p.77). The
drawing is made up of nine sheets of paper,
joined together and laid down on a wash

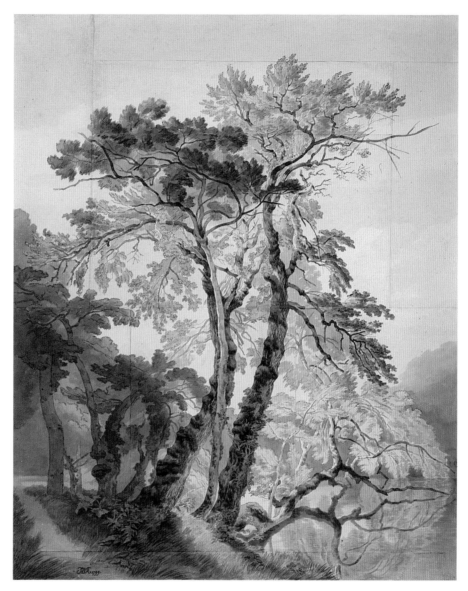

mount. As Martin Hardie has suggested,
Abbott may have preferred this mosaic-
like structure for practical reasons, small

sheets of paper being easier to manipulate
when sketching out of doors (Hardie, 1967,
I, p.127).

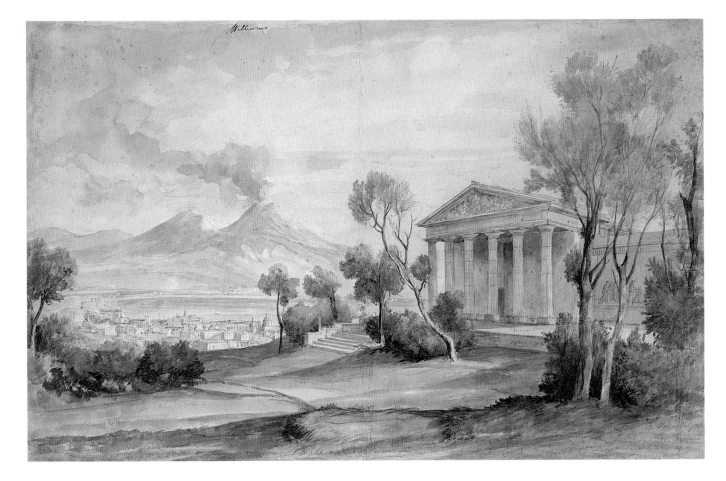

Hugh William Williams 1773–1829

*The Villa Saliceti, Naples below and Vesuvius
in the distance*
Graphite and watercolour on paper
430 × 673 mm
Signed or inscribed in ink, upper left: *Williams*;
inscribed in graphite, lower centre: *Naples*, and,
lower right: *Villa Dalgeté / Pediment yellow with
various t [ones?] / of pink / – frieze … of [8]
different tones / 7 June Naples …. against orange
?grey pink / … pink ….*, and with other colour
notes
Bought, 1985 PD.255–1985

The orphan son of a Welsh sea captain,
Williams was born in Maldon, Essex, and
brought up in Edinburgh, where he

became a pupil of the portrait painter
David Allan (1744–96). He made regular
tours throughout Scotland, and in 1811 to
1812 published a small group of engravings
of Highland scenery. In 1816 he travelled
to Greece and Italy, and in 1820 published
an account of his journey, *Travels in Italy,
Greece and the Ionian Islands*. He held a
one-man exhibition of his works in 1822,
some of which were published as engrav-
ings in *Select Views in Greece* (1827–9).

Williams arrived in Naples in January
1817, and from the inscription on this
drawing it would appear that he spent
around six months in the area. This view
appears to have been painted from the hills

to the north of Naples, perhaps above
Pozzuoli, an area favoured by the Romans
for the construction of sumptuous country
villas. The neo-classical villa, inscribed
'Dalgeté' by Williams, has been identified
by Carlo Knight as the Villa Lucia, built
by the architect Francesco Maresca and
formerly known as the Villa Saliceti.

Williams's visit to the Continent and
exposure to the works of contemporary
foreign painters made him acutely aware
of British supremacy in watercolour
painting. This is one of his most luminous
works, exhibiting a freshness and sponta-
neity which distinguishes it from his earlier,
consciously picturesque, views of Scotland.

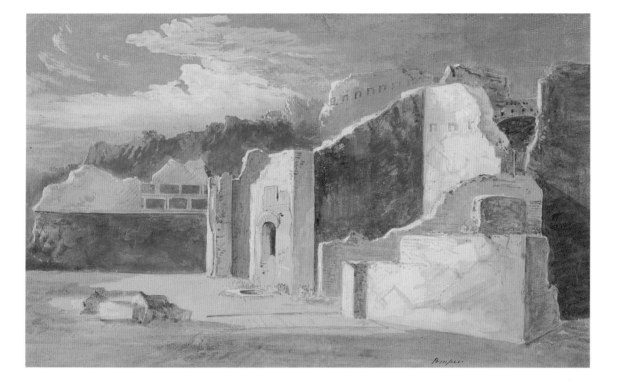

Pompeii
Bodycolour over traces of graphite on paper
245 × 400 mm
Inscribed in ink, lower right: *Pompei*, and in
graphite, centre, with colour notes
Bought from the Goodison Fund, 1988
PD.16–1988

Excavations at Pompeii were started in 1748, and energetically continued (mostly by the French) in the first fifteen years of the nineteenth century. Williams visited the ruined city in January 1817, and, in the published account of his travels, expressed astonishment at the sight of recently-excavated household objects and skeletons 'as fresh as the day of their burial'. Like Goethe, who visited the site in 1787, he was especially impressed by the overall 'compactness and … smallness of scale' (1987, p.198); the effect of the whole was, he wrote, 'indescribable … the houses are generally very low, and the rooms are small, I should think not above ten feet high … The walls of the houses are often painted red and some of them have borders and antique ornaments, masks and imitations of marble … one *woman's* apartment was adorned with subjects relating to love' (1820, II, p.118). Other British artists, such as Thomas Uwins (1782–1857), who visited the site some eight years after Williams, reacted more prudishly to the amorous subject matter of the wall-paintings: 'Such licentious things are found painted in the walls … and … in the more durable material of marble, that the Neapolitans, who are not particularly nice in these matters, prevent strangers coming in where they are at work for fear of some discovery that would be revolting or disgusting' (Uwins, 1858, p.250).

Thomas Girtin 1775–1802

Edinburgh, the Castle Rock
Watercolour over graphite on paper, laid down
on a wash mount 168 × 218 mm
Signed in black ink, lower right: *Girtin*

Inscribed in graphite on the verso of the mount:
*Nottingham Castle – – not at all – it's Edinburgh
Castle – – J.C.S.*
Given by the Friends of the Fitzwilliam
Museum, 1927 no.1187
Girtin and Loshak 38

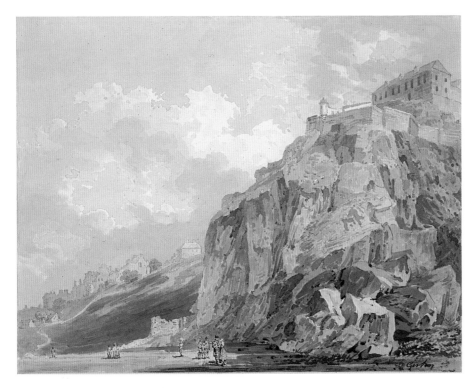

This watercolour came from the collection of the wealthy linen-draper and anti-quarian James Moore (1762–99), and was probably executed around 1793, from a sketch made by Moore on his Scottish tour of 1792. Both the style and colouring show the influence of Edward Dayes, to whom Girtin was apprenticed from 1788, and who also produced watercolours of Scottish subjects for Moore. As Susan Morris has pointed out, most of Girtin's work until 1794 was based on drawings by other (often inferior) artists which he 'translated' for topographical publication, a practice not uncommon at the time (1986, p.11). The delicate painting of the tiny figures may also owe something to Dayes, who also worked as a miniature painter, and had strong views on the subject of appro-priate picturesque staffage (see p.54).

The mount on which the paper has been laid is original, and was added before Girtin began painting.

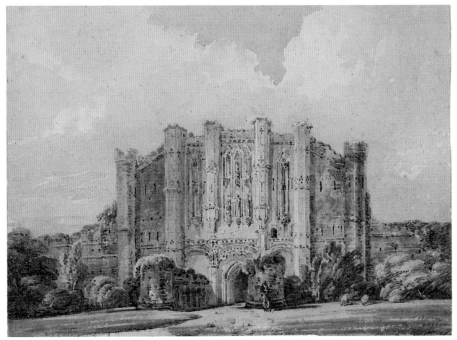

*The West view of Thornton Abbey,
Lincolnshire*
Graphite and watercolour on paper
197 × 269 mm
Signed in ink, lower right: *Girtin*
Bought, 1966 PD.52–1966
NOT IN Girtin and Loshak

This watercolour is one of ten views by Girtin engraved by Bartholomew Howlett for *A Selection of Views in the County of Lincoln*, published in 1801. Girtin appears to have visited Lincoln in 1794 with James Moore, although this drawing, published as an engraving in July 1798, was based on a sketch by W. S. Hasleden; a companion view of the abbey from the east was taken from a sketch by T. Espin.

The ruins of Thornton Abbey are approximately five miles from Barton in north Lincolnshire. This view shows the Gothic gateway, which was the principal surviving part of the abbey, originally founded for Augustinian canons in 1139 by William le Gros, Earl of Albemarle.

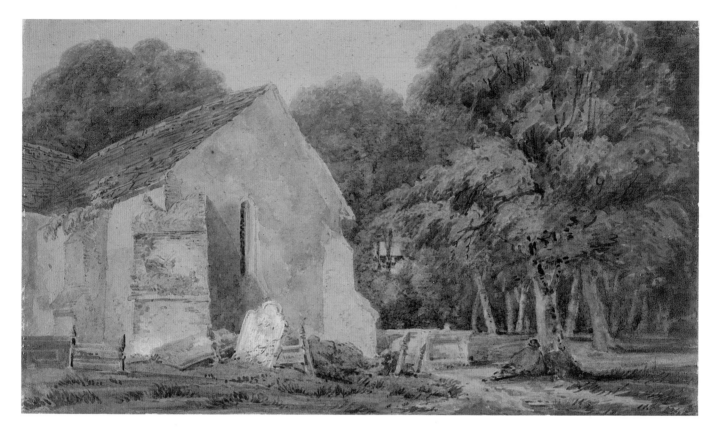

A country churchyard
Watercolour over graphite with white high-
lights on paper 233 × 409 mm
Given by Mrs E. Vulliamy, 1935
Girtin and Loshak 295 no.735

Painted *c*.1797 to 1798. Girtin is said to
have preferred a rough Dutch cartridge
with slight wire-marks, 'to be had only of a
stationer at Charing-Cross', which gave
texture to his flat colour washes and a
warmth to the overall tonality. In larger
drawings, lines of darker pigment would
sometimes occur where Girtin had un-
folded and stretched the foolscap sheet;
these were prized by collectors as a mark
of authenticity and genius. In this water-
colour, the dominant brown tonality is due
partly to fading, but also reflects Girtin's
use of a rough, warm-toned paper.

The 'reversing-out' of the tree trunks to
suggest recession, by lifting out the colour
in those in deepest shadow, is reminiscent
of a technique much favoured by Cozens
(see p.48), whose work Girtin would have
known well, and copied at Dr Monro's
'Academy' from the mid 1790s.

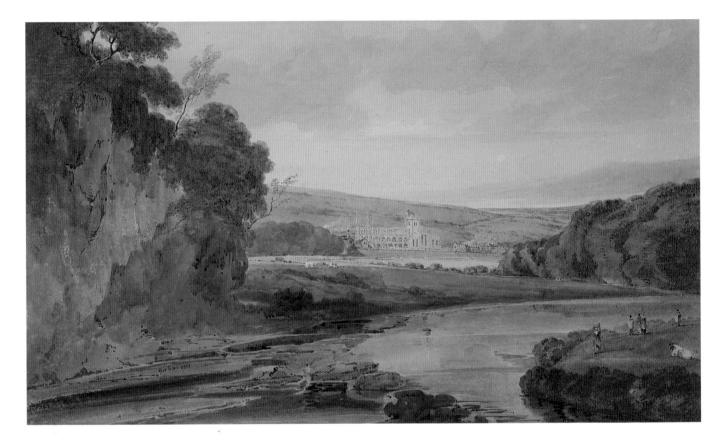

Jedburgh
Graphite and watercolour on paper, laid down
376 × 645 mm
Signed and dated in ink, lower left: *Girtin. 1801*
Bought, 1951 PD.5–1951
Girtin and Loshak 165 ii

This imposing watercolour appears to be the latest of several views which Girtin painted of the town of Jedburgh and its abbey. It is based on a sketch in graphite drawn during Girtin's tour of the Scottish Borders in 1796, and now in the Yale Center for British Art (Girtin and Loshak, 165 i).

The fading of blues and greys in the sky and the clouds is due to Girtin's use of the notoriously fugitive pigments indigo and lake. According to an account of 1823, 'His skies were rarely composed of many parts. The azure spaces were washed in with a mixture of indigo and lake, and the shadows of the clouds with light red and indigo, and an occasional addition of lake. The warm tone of the cartridge paper,

frequently served for the lights, without tinting, acquiring additional warmth by being opposed to the cool colour of the azure, and the shadow of the clouds' (*Somerset House Gazette*, 15 November 1823, p.83).

Despite this, the composition retains a magisterial breadth and assurance. The articulation of the rock face (massively, but not disturbingly out of scale with the rest of the landscape) exemplifies the 'broad sword-play of the pencil' for which he was much admired (Girtin and Loshak, p.95).

Lindisfarne Abbey
Watercolour over graphite on paper, laid down
410 × 287 mm
Given by the Friends of the Fitzwilliam Museum, 1932 no.1608
Girtin and Loshak 164

Probably painted in 1797, this watercolour is one of Girtin's most powerful and ambitious views of architectural ruins. The dramatic angle of vision suggests the influence of Piranesi, whose etchings for the *Antichità romane* were well known to British artists in the 1790s (see also p.63). Girtin's own watercolour copies of plates in the *Antichità*, dated 1798–9 by Girtin and Loshak, are in the British Museum and the Yale Center for British Art (Girtin and Loshak 302–305). The use of dots and loose scribbles in brown watercolour to describe the texture of the masonry is a technique adapted from Canaletto's calligraphic use of reed pen. Another view of the interior of the abbey is in the British Museum (Girtin and Loshak, 184).

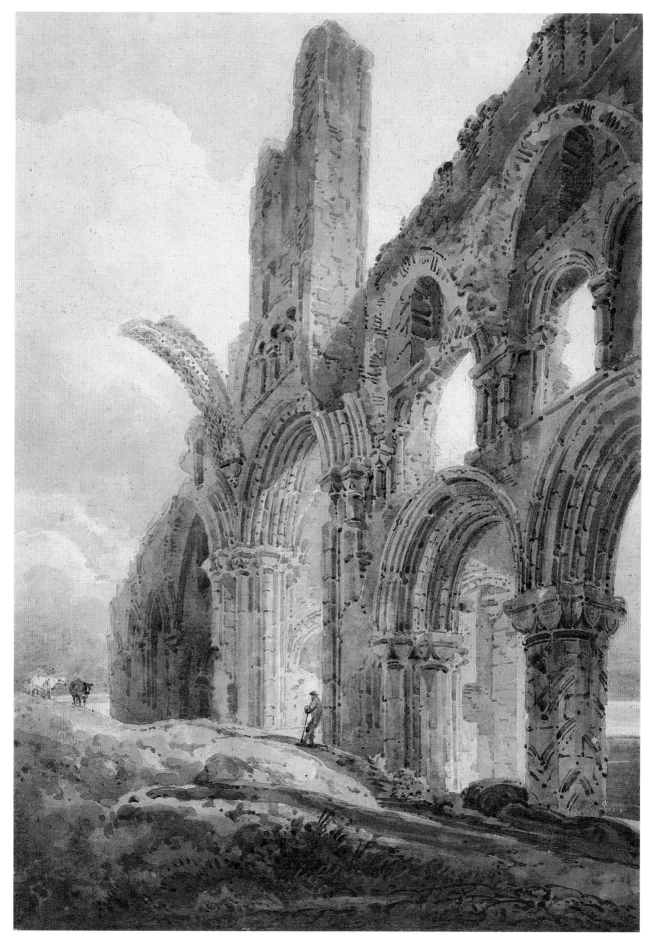

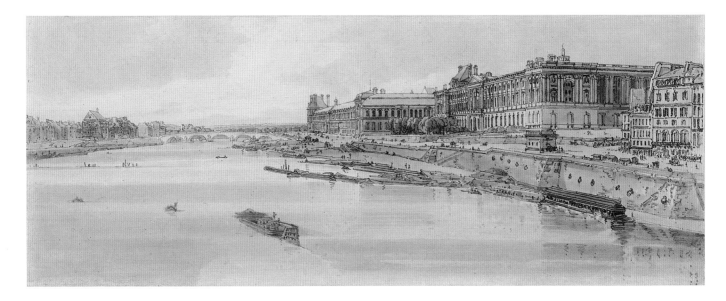

View of the Louvre and the Pont des Tuileries from the Pont Neuf
Soft-ground etching, graphite and watercolour on paper 165 × 438 mm
Bought, 1983 PD.5–1983

Girtin travelled to Paris in November 1801, perhaps with the aim of finding an exhibition venue for his recently completed panorama of London, called the Eido-metropolis. During his six-month stay, he made a number of drawings of the city and its environs, and his first prints, a series of twenty soft-ground etchings for *A Selection of Twenty of the Most Picturesque Views in Paris and its Environs*, were published posthumously in 1802. This view comes from one of two sets which were probably hand coloured by Girtin himself as a guide to the aquatint engravers. The pale colour washes, and careful adherence to the etched outline links it to the so-called 'Bedford Set', said to have been given to the Duke of Bedford by Girtin's patron, the 5th Earl of Essex, to whom the publication is dedicated.

The *Twenty Views of Paris* were exhibited posthumously at the Spring Gardens in 1803 at the same time as his panoramic Eidometropolis of London (since lost). Their influence on the next generation of watercolour painters was profound, and inspired ideas for similar sets by Richard Parkes Bonington (1802–28), Thomas Shotter Boys (1803–74) and Cotman (who owned a set; see Allthorpe-Guyton 1982, p.28, n.3). See also Cox's watercolour of *The opening of the new London Bridge by William IV* (p.107).

J. M. W. Turner 1775–1851

Christ Church, Oxford
Watercolour on paper 395 × 320 mm
Signed and dated in ink, lower right: *Turner 1794*
Given by Mrs E. S. Dewick, 1918 no.917
Cormack 4; Wilton 72

This is one of a number of large-scale finished drawings of Oxford which Turner produced between 1794 and 1795, as a result of sketching tours to the area in 1792 and 1793. His consummate ability, at the age of nineteen, to render the detail and stonework of the thirteenth-century Norman tower and spire can be attributed in large part to his training with the architectural draughtsman Thomas Malton (1748–1804), although the picturesque treatment of the subject and delicate, feathery handling also show the influence of Thomas Hearne, whose drawings Turner was copying at Dr Monro's evening 'Academy' around this time. The gowned academic is an early example of Turner's idiosyncratic – and often quietly witty – use of staffage figures.

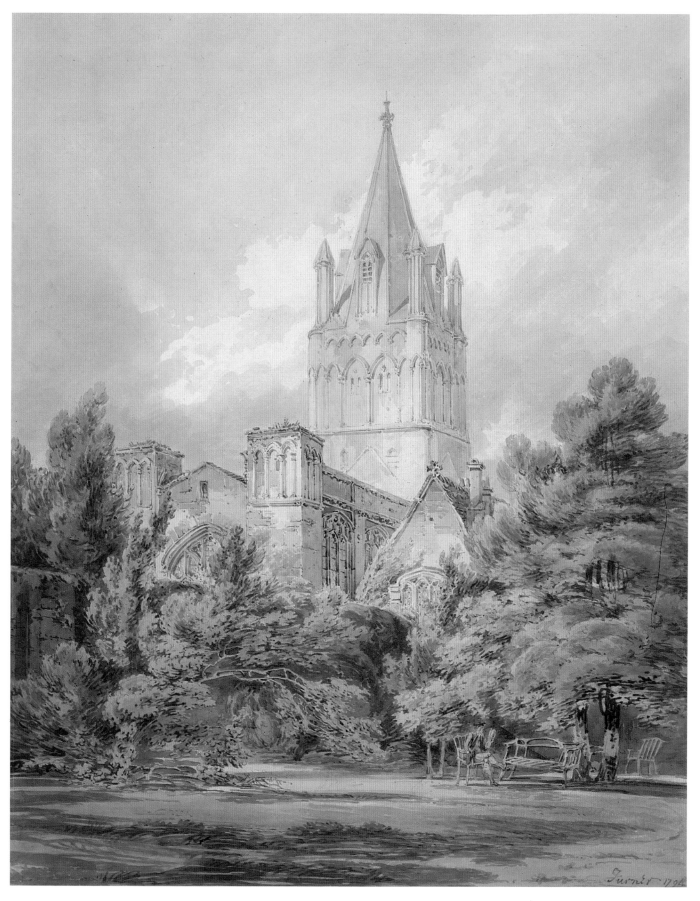

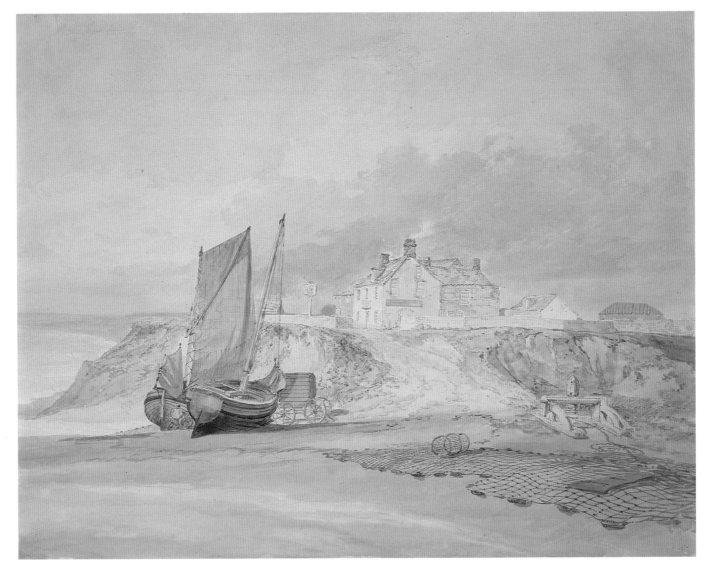

View on the Sussex coast
Watercolour on paper
Watermark: J WHATMAN / 1794
395 × 505 mm
Given by the Friends of the Fitzwilliam
Museum, 1913 no.751
Cormack 6; Wilton 148

Turner probably visited Brighton in 1796.
Although the precise location of this
drawing remains uncertain, the general
topography is that of the Sussex coast.
On the basis of the painted ship on the
signboard of the inn, Eric Shanes has
recently suggested that it might represent
the Ship Inn – now the Old Ship Inn –
which still stands, in modernized form, on
the sea front at Brighton (1986, p.39). In
support of his hypothesis, he has also
drawn attention to a number of other
topographical and local details, such as the
curved form of the coastline (characteristic
of the stretch between Brighton and

Worthing), the bathing machine, and the
presence of fishing vessels known as 'hog
boats', which were designed especially to
fish in the shallow waters off the town.

The luminous palette of sandy-beige
colours, and highly refined control of
wash, show a subtle handling of tone
which some scholars have attributed to the
influence of Michael Angelo Rooker
(1746–1801).

Ullswater, Patterdale Old Hall (opposite
above)
Watercolour over traces of graphite on paper
258 × 371 mm
Inscribed, verso, in brown ink: *Patterdale
Grange (?) of Patterdale Palace*
Given by the Friends of the Fitzwilliam
Museum, 1926 no.1171
Cormack 8, Wilton 228

This drawing was identified by A. J. Fin-
berg as a sheet from the 'Tweed and Lakes'

sketchbook, used by Turner on a tour of
the Lake District in 1797. As Cormack has
observed, the simplicity of design and
broad washes of colour show a breadth of
vision more often associated with his
friend and rival Thomas Girtin (see
Jedburgh, p.60).

At the time of Turner's visit, the Old
Hall at Patterdale belonged to the
Mounsey family, known as the 'Kings of
Patterdale' since they had defeated
marauding Scots at Stybarrow Crag. By
1830, when John Ruskin visited the Lake
District, it was the property of William
Marshall MP; it is now an hotel.

Fortified pass, Val d'Aosta (opposite below)
Black chalk, watercolour and bodycolour on
grey prepared paper, with scratching out
319 × 474 mm
Given by the Friends of the Fitzwilliam
Museum, 1931 no.1585
Cormack 10; Wilton 360

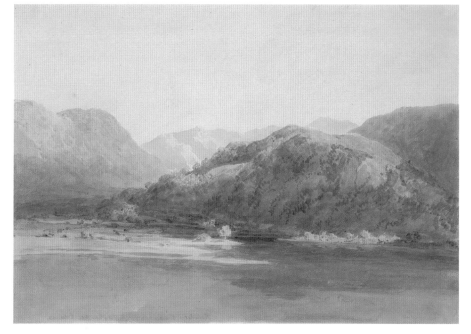

In July 1802, Turner took advantage of the brief lull in hostilities between France and Britain to make a trip to Switzerland, travelling through France and the Savoy. The size and technique of this drawing, and the use of grey prepared paper as a support identify it as from the *St Gothard and Mont Blanc* sketchbook (T.B. LXXV), which Turner used in Switzerland in 1802. As Andrew Wilton has established, it was used as the basis of a more finished watercolour made for Walter Fawkes *c*.1804–10 (Wilton 369), which in turn was worked up by Turner into a finished watercolour, *The Battle of Fort Rock, Val d'Aosta, Piedmont, 1796*, exhibited at the Royal Academy in 1815, with a quotation from Turner's poem, 'Fallacies of Hope' (Wilton 399). By using a dark, bodycolour ground Turner was obliged to introduce highlights by scraping into the paper, in this case possibly using his thumbnail, which he kept especially long and sharpened for the purpose. The relatively restricted palette in these early Swiss drawings may reflect his attempt to convey the grandeur and sublimity of the rock masses, but it may also have been influenced by his experimentation with a toned background in his oil paintings (see Wilton, 1976, p.23).

This drawing originally belonged to John Ruskin, who considered it 'a quite stupendous piece of drawing power' (*Works*, XIII, 422). It passed from him to his protégé Arthur Severn (1843–1931), from whose sale in 1931 it was acquired for the Friends of the Fitzwilliam.

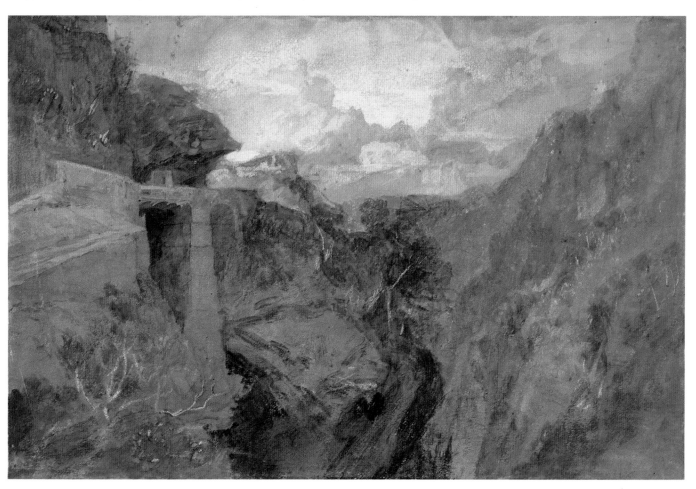

Gateway to the Close, Salisbury
Watercolour on paper 456 × 315 mm
Signed in ink, lower right: *JMW Turner RA*;
inscribed in graphite on verso (Turner's hand?):
S' R Hoare Bart / Salisbury [?] & Hampton

Bequeathed by P.-C. Manuk and Miss G. M.
Coles through the National Art Collections
Fund, 1948 PD.38–1948
Cormack 11, Wilton 208

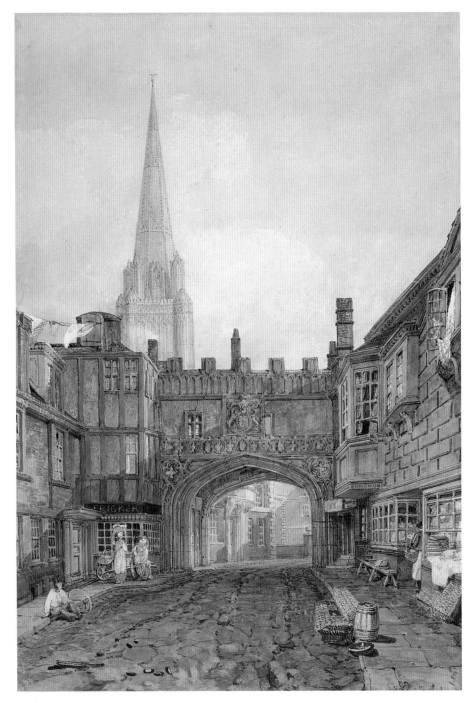

Between *c.*1796 and 1805, Turner worked on a project to execute a series of drawings of Salisbury for the banker and collector Sir Richard Colt Hoare (1758–1838) of Stourhead. Two sets of drawings were produced: the so-called 'Cathedral' set, comprising eight large drawings, to which the present sheet belongs; and nine smaller format drawings, once bound in a single volume, known as the 'City' set. He made at least two watercolours of the Close, one of which was exhibited at the Royal Academy in 1796. As Cormack has pointed out, however, both the style of this water-colour, and the signature, which must post-date his election as a Royal Academician, are consistent with Turner's work of around 1802.

Colt Hoare owned an important collection of watercolours by contemporary British artists including John Robert Cozens and 'Warwick' Smith, as well as a group of Italian views by Carlo Labruzzi (1765–1818) and thirteen large-scale gouache landscapes by the Swiss painter, Louis Ducros (1748–1810). Ducros's gouache drawings were highly prized by English Grand Tourists in Italy, and considered by Colt Hoare to have been central to 'the advancement from *drawing* to *painting* in watercolours' (quoted Stainton, 1985, p.28). Turner's grasp of the sublime in the Salisbury watercolours may well owe something to Ducros, although his powerful use of light and shade in this series also suggest the influence of Piranesi. Transcending this complex set of in-fluences, however, is Turner's distinctive artistic personality, evident in the lively sense of colour, and gently humorous attention to details such as the patriotic fluttering of red, white and blue laundry on the rooftops.

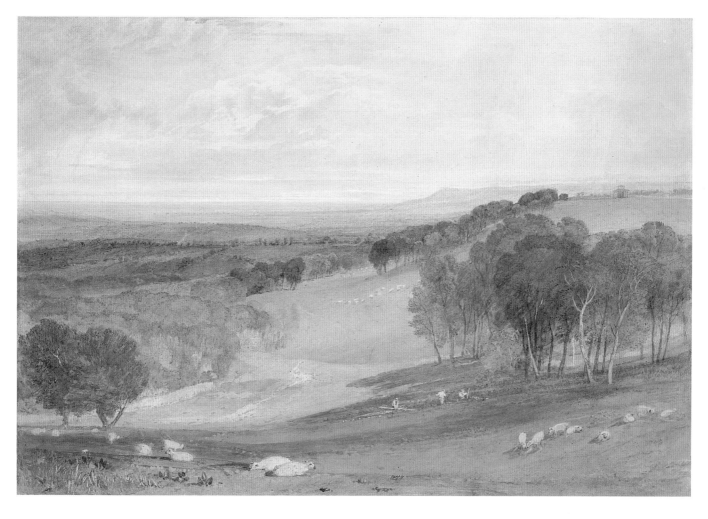

The Vale of Pevensey, from Rosehill Park
Watercolour over traces of graphite with
scraping out on paper 391 × 568 mm
Bought, 1979 PD.19–1979
Wilton 432; Shanes, 1981, no.2, p.18

In 1810 Turner met the eccentric MP for
Sussex ('Honest' or 'Mad') Jack Fuller, who
commissioned him to execute a series of
watercolours of the landscape and impor-
tant houses and castles in the area around
his own residence at Rosehill (now known
as Brightling Park). Wilton lists sixteen
watercolours in connection with this

commission, four of which – including this
view from the rear of Rosehill House
towards Beachy Head – were aquatinted in
colours by Joseph Sadler between 1816 and
1818, and circulated privately to members
of Fuller's circle.

This is among the most serene and
harmonious of the Sussex landscapes. A
perfectly controlled recession leads the eye
from the human activity and exquisitely
scratched-out detail in the foreground
shadow, through subtly winding paths and
intersecting clumps of trees to a shimmer-

ing horizon of almost imperceptibly
stippled brushstrokes. Close inspection of
the last row of trees in the middle distance
shows that Turner removed a tree, presu-
mably in order to provide a visual and
psychological gateway to the tremulous
infinity beyond.

Fuller was a passionate creator of follies,
and erected a number around his estate
and in other parts of Sussex. The rotunda
on top of the hill on the right was designed
by Sir Robert Smirke, architect of the
British Museum.

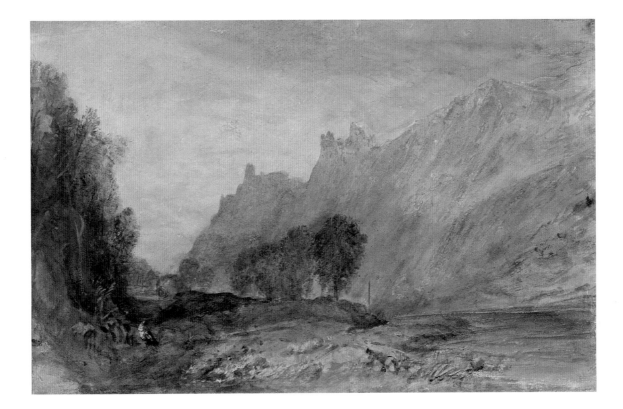

Brüderburgen on the Rhine
Watercolour on paper prepared with a grey
wash 212 × 327 mm
Bequeathed by the Hon. Mrs Dighton Pollock,
1929 no.1520
Cormack 15; Wilton 651

This is one of a group of fifty-one draw-
ings produced as a result of a twelve-day
walking tour up the Rhine in August 1817,
and sold to Walter Fawkes of Farnley
Hall. The drawings appear to have been
made in one or two roll sketchbooks which
Turner took with him on his journey. On
these he indicated the main compositional
lines and architectural features in fluid
watercolour washes; with one or two
exceptions – including the present draw-
ing, which Wilton considers to be un-
finished – these were later elaborated in
bodycolour on grey prepared paper, using
scratching, rubbing and blotting to enliven
the picture surface. The 'Brothers' castles
represented in silhouette on the east bank
of the Rhine are the ruins of the Sterren-
berg and Liebenstein castles, above
Bornhofen. As David Blayney Brown has
recently suggested, Turner's tour of the
Rhine may have been inspired by Byron's
vivid description of the river in his poem
Childe Harold's Pilgrimage (1992, no.88).

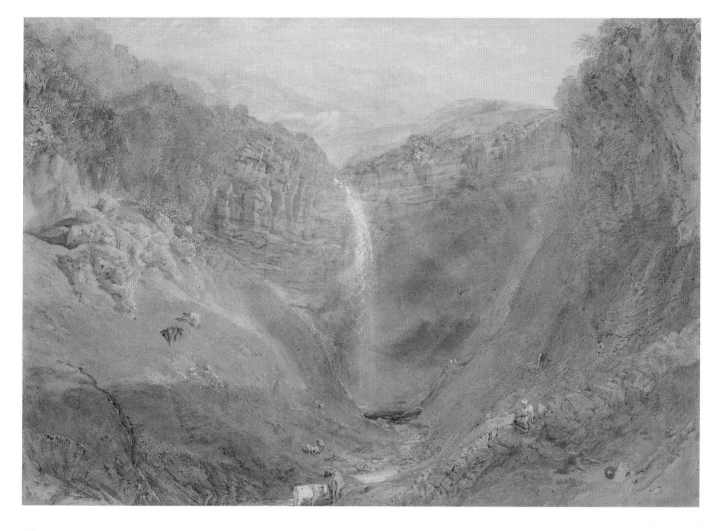

Hardraw Fall
Watercolour on paper, with scratching out
Watermark: J WHATMAN 292 × 415 mm
Bequeathed by J. E. Bullard, 1961 PD.227–1961
Cormack 17; Wilton 574

This is one of twenty views in watercolour which were engraved to illustrate the Revd Dr T. D. Whitaker's *History of Richmond-shire*, published between 1819 and 1823; another watercolour for this publication, depicting Mossdale Fall, was given to the Museum by John Ruskin in 1861 (Cormack 16).

The original commission, which Turner secured in May 1816, was for at least 120 watercolours depicting the scenery of the entire county of Yorkshire, for which, according to Farington, he was to be paid 3000 guineas. This grandiose scheme was subsequently abandoned on grounds of cost, and some of the drawings of other parts of Yorkshire were used for another series, *Picturesque Views in England and Wales*, begun in 1827. As John Gage has pointed out, this is the first series of designs for which Turner consistently executed 'colour beginnings' in preparation for the completed watercolours (1987, p.83).

Hardraw (or Hardrow) Force falls for about ninety-six feet into the River Ure in a tall, narrow limestone valley approximately one mile north of the town of Hawes, Wensleydale.

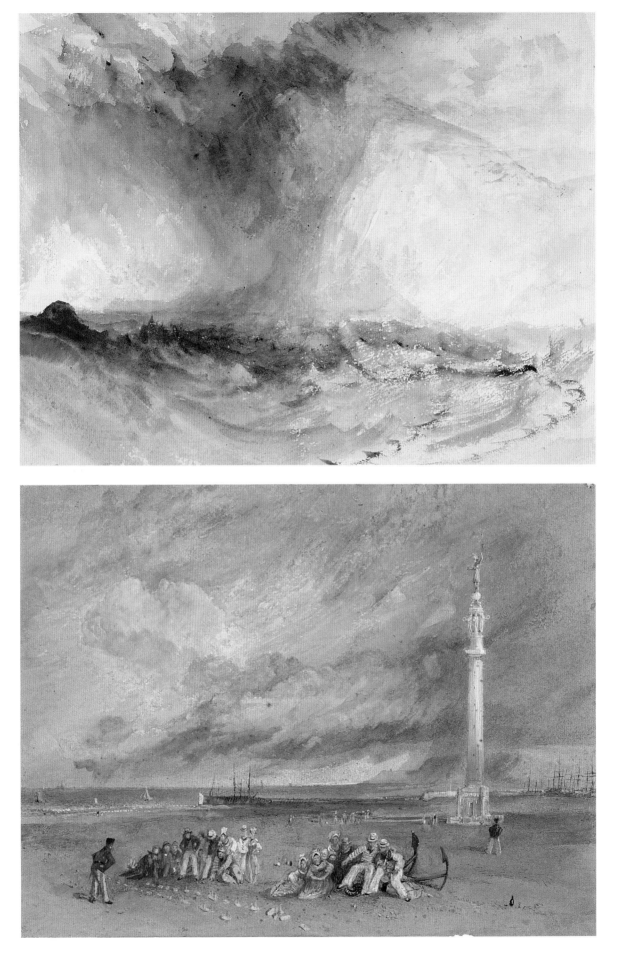

Shakespeare Cliff, Dover (p.70 above)
Watercolour on paper 181 × 245 mm
Given by T. W. Bacon, 1950 PD.114–1950
Cormack 21; Wilton 764

Between *c.*1820 and 1825, Turner made a number of drawings as designs for engravings as *The Ports of England*, mezzotinted by Thomas Lupton (1791–1873), and published under his name between 1826 and 1828. This drawing, dated by Wilton to around 1825, may be connected with the scheme. Turner's design for the wrapper for *Ports of England* was given to the Museum by John Ruskin in 1861 (Cormack 20).

Yarmouth Sands (p.70 below)
Watercolour and bodycolour on blue paper
185 × 245 mm
Inscribed in graphite, verso: *NELSON'S COL
[…] Yar …*
Given by John Ruskin, 1861 no.576
Cormack 22; Wilton 904

This is one of a group of twenty-five watercolours given to the Museum in 1861 by John Ruskin, which were intended, in his own words, to 'illustrate Turner's modes of work at various periods of his life'. According to Wilton, this is one of a group of eleven designs and associated drawings, which appear to have been conceived as a series of *Picturesque Views on the East Coast of England*, perhaps intended as a sequel to the *Picturesque Views on the Southern Coast of England* published between 1814 and 1826. All but one of the drawings are executed on blue paper, a fact which has led Wilton to associate the group with Turner's drawings of Petworth and the Rivers of Europe, executed between 1825 and 1834.

Ruskin described this as a 'Drawing of the middle time in bodycolour. Highest possible quality' (*Works*, XIII, 558).

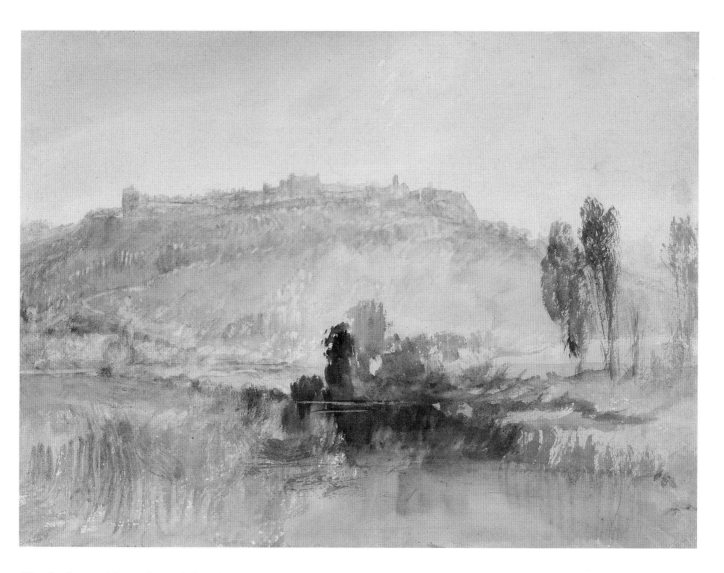

River landscape with a castle on a hill
Watercolour over traces of graphite on paper
167 × 228 mm
Given by T. W. Bacon, 1950 PD.112–1950
Cormack 24; Wilton 421

Both the date and the location of this watercolour are uncertain. Although Cormack has suggested that it may be linked stylistically with a group of views of English rivers executed in the 1820s, Wilton prefers an earlier date of around 1811, and suggests a connection with a series of drawings made on tours to the West Country in 1811 and 1813. The suggestion that the distant castle and town represent Stirling has received some support.

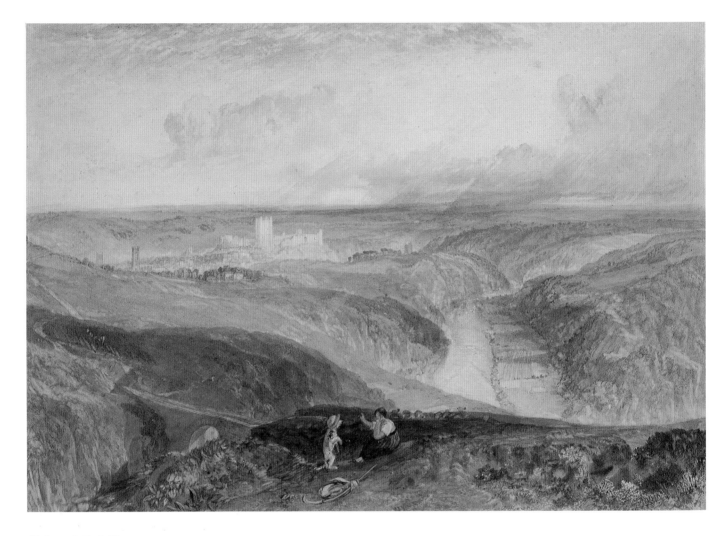

Richmond, Yorkshire
Watercolour and scratching out on paper
280 × 400 mm
Given by John Ruskin, 1861 no.572
Cormack 25; Wilton 808; Shanes, 1979, 23

This watercolour belongs to a series made for subsequent line-engraving in Charles Heath's *Picturesque Views of England and Wales* published in twenty-four parts between 1827 and 1838, usually in groups of four, issued three times each year. The view, taken from Swaledale above Whitcliffe looking southeast, is based on a drawing made during a walking tour of the North Riding of Yorkshire in about 1816. Some time between 1825 and 1828, the initial sketch in graphite was elaborated into this magnificent watercolour, which stands as a remarkable testimony to Turner's conceptual powers and technical mastery. The ease with which the broad panorama is grasped belies a rigorous pictorial organization through passages of light and shadow, and a great variety of handling, from the 'lifting out' of the leaves in the foreground to the delicately stippled brushstroke in the distant horizon. The figure of the girl and dog – probably based on first-hand observation – reappear, less comically posed, in another view of Richmond Town and Castle for this series, now in the British Museum (Wilton 791).

The watercolour was engraved – like all of the series on less durable and hence more expensive copper plate – by James Tibbitts Willmore (1800–63) in 1828, and exhibited, along with thirty-four other drawings for the series, at the Egyptian Hall in Piccadilly in 1829. It is an interesting indication of the expense and production of the project that, while Turner is said to have received 30 guineas for each watercolour, the engravers, on average, were paid £100 per plate. Heath's investment did not pay off. Only one volume of sixty plates was completed, and of the remaining sixty only thirty-six were published sporadically. After failing to negotiate a private sale for the plates and print stock, they were put up for auction in 1839, but bought in by Turner before bidding could begin, in order to keep them out of the 'clutches' of irresponsible print publishers.

For a full account of Turner's work on the project see Shanes, 1979.

Orléans, Twilight (right)
Watercolour and bodycolour with pen, red and
grey ink on blue paper 140 × 195 mm
Given by John Ruskin, 1861 no.579
Cormack 26; Wilton 997

This view of the market place at Orléans
was drawn, but not selected for engraving
in *Turner's Annual Tour*, published by
Charles Heath in 1833 as *Wanderings by the
Loire*. This was the first instalment of an
ambitious publishing project to illustrate
the river scenery of Europe with engrav-
ings after Turner's watercolours. Although
Turner made a number of tours to the
Continent in connection with the scheme,
only two further *Annuals*, featuring the
scenery of the River Seine, were published
in 1834 and 1835.

As Wilton has pointed out, Turner's
drawings for the *Rivers of Europe* mark a
turning point in his use of colour. In place
of a white paper ground and transparent
washes of colour (however highly worked
and scraped), Turner began from the mid
to late 1820s to use bodycolour pigments on
a blue paper ground, which allowed him to
alter his colour register, and to explore a
more brilliant range of colouristic effects.

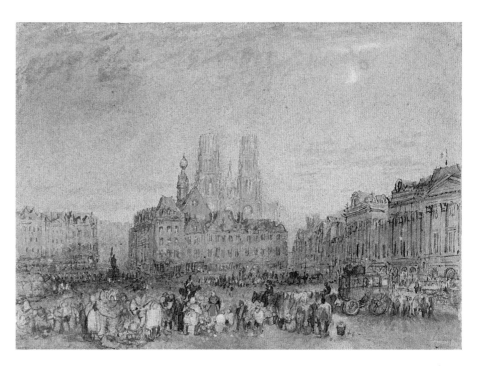

Nantes [?] (left)
Watercolour, pen, black and red-brown ink
with white highlights on paper 142 × 193 mm
Given by John Ruskin, 1861 no.580
Cormack 27; Wilton 996

Given to the Museum as a drawing of
Amboise, Cormack re-identified the town
as Nantes, however the proximity of the
shipping to the massive fortified walls has
thrown doubt over his suggestion. Turner
visited the Loire Valley in 1826 on one of
his first tours in connection with Charles
Heath's projected publication, *The Rivers of
Europe*.

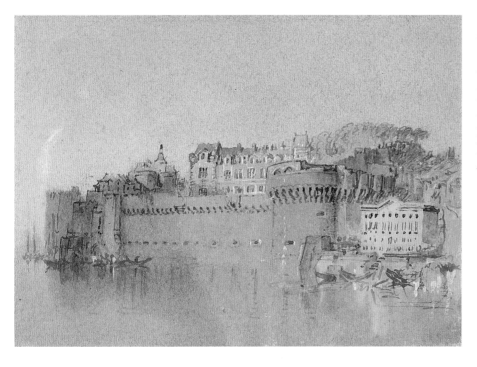

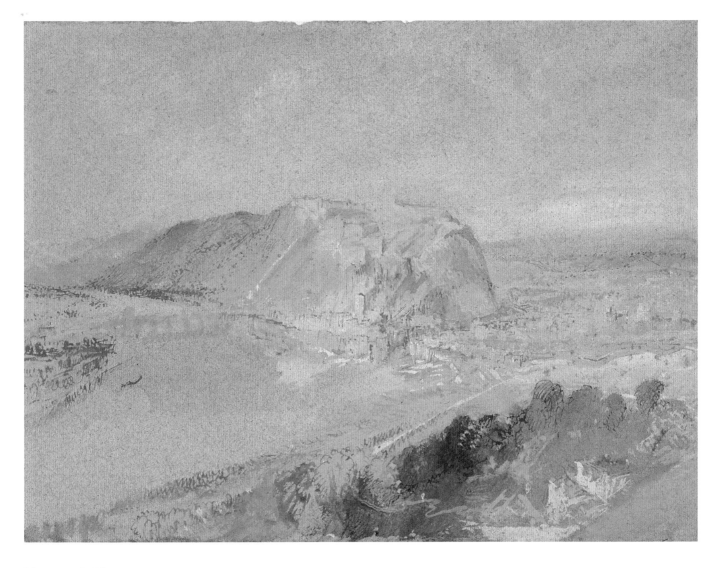

Namur on the Meuse
Watercolour and bodycolour, with pen, red and grey ink on blue paper 140 × 190 mm
Given by John Ruskin no.577
Cormack 28; Wilton 1025

Painted between 1827 and 1834.

Turner toured Holland, the Meuse and Moselle between August and November 1825, and visited the Meuse again in 1834. From sketches made on the spot, he made a number of black and white drawings, some of which, such as this, and the view of Huy (p.75), were worked up into finished watercolours. These were presumably drawn with the intention of producing a series of views of Belgian rivers for engraving in connection with Charles Heath's project to publish views of the *Rivers of Europe*, although in the event no further publications appeared after the views of the Seine and the Loire (see p.73).

Turner appears to have continued to work on this project from 1825 to 1834. Similarities in media and technique between drawings made in association with the *Rivers* project make it difficult to date individual views with precision.

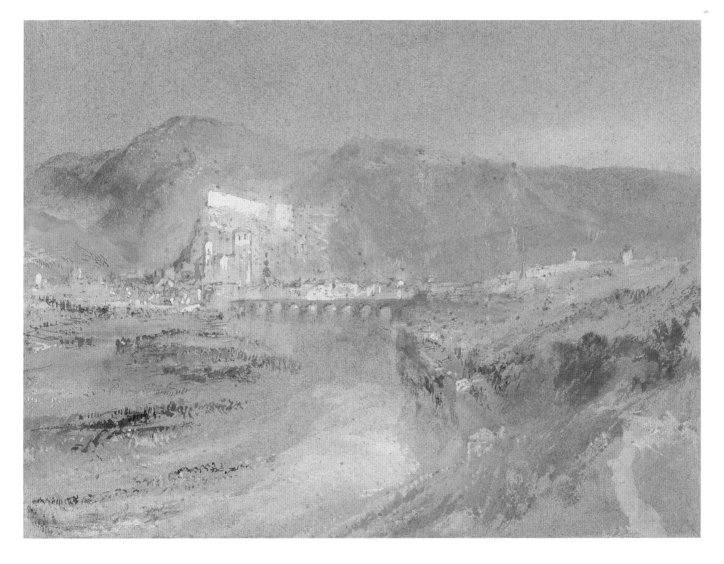

Huy on the Meuse
Watercolour and bodycolour with white
highlights and touches of red ink on blue paper
140 × 194 mm
Given by John Ruskin, 1861 no.578
Cormack 29; Wilton 1024

Drawn in connection with the *Rivers of
Europe*, and described by Ruskin as 'Nearly
first-rate' (*Works*, XIII, 558).

Ashestiel

Graphite and watercolour on paper, laid down
287 × 223 mm
Inscribed in brown ink upper centre:
MARMION / vol; and, lower centre: *Ashistiel*
[*sic*]
Given by John Ruskin, 1861 no.573
Cormack 30; Wilton 1083

Like *St Cloud*, this is one of a group of
designs commissioned in 1831 for the *Prose*
and *Poetical Works* of Sir Walter Scott, and
engraved between 1834 and 1836. After
their financially disastrous collaboration on
The Provincial Antiquities of Scotland
during the first half of the 1820s, Scott was
at first reluctant to employ Turner on the
project, but later relented, no doubt due to
his publisher's confidence that Turner's
fame would secure a far larger subscription
(see p.16).

The main illustration depicts Ashestiel,
Scott's summer residence between 1804
and 1811, where he composed *Marmion*;
the two figures just visible at the end of the
steeply ascending path are supposed to
represent the author and his friend Mar-
riott walking across the moors, discussing
poetry. As Jan Piggott has pointed out,
Turner solves the problem of representing
both location and narrative by adding
marginalia scenes representing, on the left,
Constance de Beverley, about to be en-
tombed alive, and on the right, Lord
Marmion dying on Flodden Field – a
solution abandoned in the engraved design
(1993, p.55).

St Cloud

Watercolour on paper 90 × 145 mm
Given by John Ruskin, 1861 no.574
Cormack 31; Wilton 1109

Turner was in Paris during September
1832 in order to gather information for
Walter Scott's *Life of Napoleon*. His trip
was funded by the Edinburgh publisher
Robert Cadell, who had originally in-
tended to begin his twenty-four volume
edition of Scott's *Prose Works* with *Napo-
leon*, but deferred its publication due to
Turner's late delivery of the commissioned
drawings (see Finley, 1973 p.392). The
engraving after this drawing, by William
Miller (1796–1882), appears as the frontis-
piece to volume 12. Preliminary drawings
for this project are in the *Paris and Environs*
sketchbook (T.B. CCLIV), which also con-
tains a number of sketches of St Cloud; the
latter were reproduced in *Turner's Annual*
Tour (Wanderings by the Seine), published
by Charles Heath in 1835.

The park at St Cloud was a popular
resort for Parisians in the nineteenth
century, particularly during the annual fair
in September, when crowds gathered
around the Lantern of Diogenes (an
obelisk erected by Napoleon), and all the
fountains were set playing: 'Then is the
time to see the metropolitans in their glory.
In our epoch, when every day is a fair on
every street, these periodical assemblages
preserve little of the character which for-
merly distinguished them. Pleasure is the
grand pursuit, not business' (Leitch Richie,
Wanderings by the Seine, 1835, p.154).

It is tempting to imagine that the small
figure on the left, dressed in black and
with bowed head, is intended to represent
Napoleon.

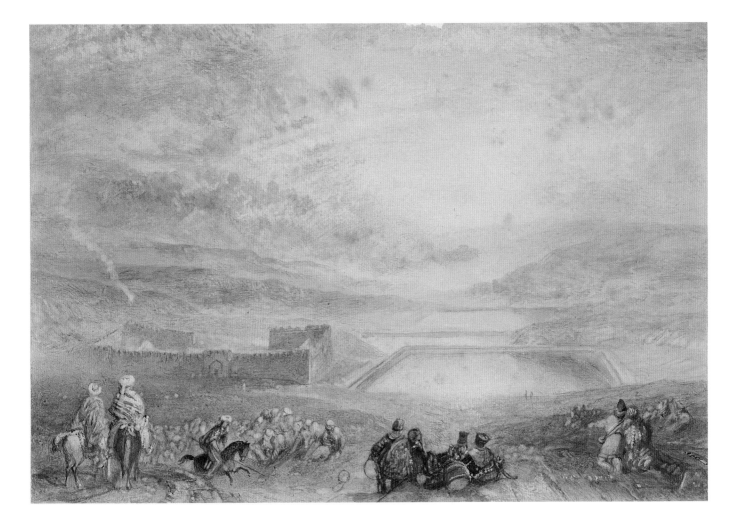

The Pools of Solomon
Watercolour with touches of gum arabic on
paper 142 × 206 mm
Given by John Ruskin, 1861 no.575
Cormack 33; Wilton 1244

Turner was one of a number of artists
employed between 1833 and 1836 by
Edward Finden and his publisher John
Murray to provide illustrations for *The
Biblical Keepsake* or *Landscape Illustrations
of the Most Remarkable Places mentioned in
the Holy Scriptures*, more commonly
known as *Finden's Bible*. As he had never
visited the Holy Land, he based his water-
colours for the publication on sketches
made by artists or architects who had
travelled there, such as Sir Charles Barry.

Ruskin appears to have given this
drawing to the painter J. F. Lewis in 1858,
who, for reasons which are unclear, re-
turned it to him shortly afterwards. That
Ruskin admired the composition is clear
from his recommendation of the engraving
after it by J. Stephenson to students of
drawing, for its outstanding qualities (to
use his shorthand) *c*, *l*, *p* and *q*, that is,
'Clouds, including mist and aeriel effects',
'effects of light'; 'power of general arrange-
ment and effect' and 'quiet water' (*Works*,
xv, pp.76–7).

The 'Yellow Castle', Beilstein on the Moselle
Watercolour on paper 160 × 235 mm
Given by the Friends of the Fitzwilliam
Museum, 1933 no.1725
Cormack 34; Wilton 1336

The date of this watercolour is uncertain.
Cormack has related it stylistically to a
number of freely-painted sketches along
the Moselle, executed around 1834,
although Wilton considers it to have been
painted over a decade later, around the
same time as *Heidelberg* (p.90).

Turner is known to have worked
rapidly, and on several sheets of paper at a
time. In the initial stages, these were
soaked and stretched on boards, after
which colour was applied on the wet paper
to block in the main forms of the composi-
tion. The way the colours have been
floated on to the surface of this drawing
recalls an account of the 'papers tinted with
pink, blue and yellow' which Turner hung
on a cord to dry in his bedroom at Farnley
Hall, some time between *c.*1818 and 1825
(Shanes, 1979, p.21), and neatly highlights
the problems of dating the more loosely-
painted of Turner's watercolours.

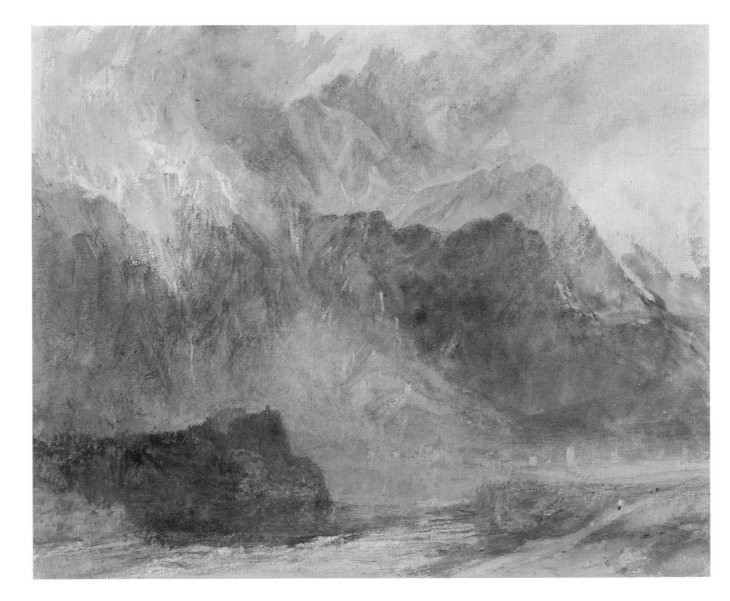

A scene in the Val d'Aosta
Watercolour and bodycolour on paper, with scratching out 237 × 298 mm
Given by the Friends of the Fitzwilliam Museum, 1932 no.1612
Cormack 35; Wilton 1430

One of the most brilliant watercolours to be produced as a result of Turner's visit to Switzerland in 1836 (see p.81) with his friend and patron H. A. J. Munro of Novar. Although the freedom of handling has been considered by some scholars to suggest a later date, Turner does not appear to have returned to the Val d'Aosta during his visits to Switzerland in the 1840s, and the rich colouring is more consistent with those produced as a result of his earlier tour.

Shanes has drawn attention to the full range of technical means by which Turner has evoked the 'dynamic unity of earth, space and the elements', and interpreted the miniscule figures on the right as a reflection of the artist's growing pessimism in the 1830s and 1840s, demonstrating the insignificance of humanity in the face of Nature (1986, pp.14, 62).

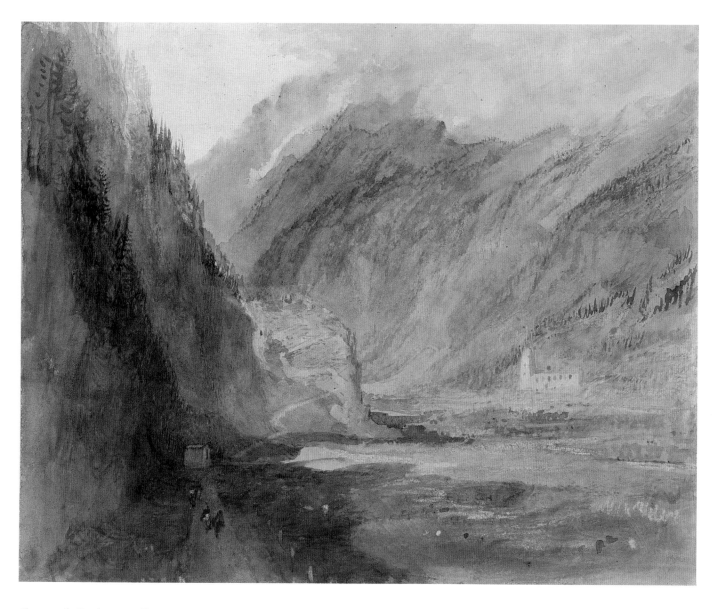

Couvent du Bonhomme, Chamonix
Watercolour on paper 242 × 302 mm
Given by T. W. Bacon, 1950 PD.111−1950
Cormack 37; Wilton 1449

In 1836 Turner accompanied his friend and patron H. A. J. Munro of Novar on a tour of Geneva, Bonneville, Chamonix and the Val d'Aosta. The dating of many of the Swiss views made following this tour is often problematic, due to the difficulties in establishing precise locations, and to stylistic similarities with later groups made after tours to Switzerland in 1841 and 1844. Although Cormack has argued that the fine pen-work has more in common with watercolours executed after the 1841 tour, there are perhaps stronger grounds for associating it with the richer colouring of a group to which Wilton assigns a notional date of 1836.

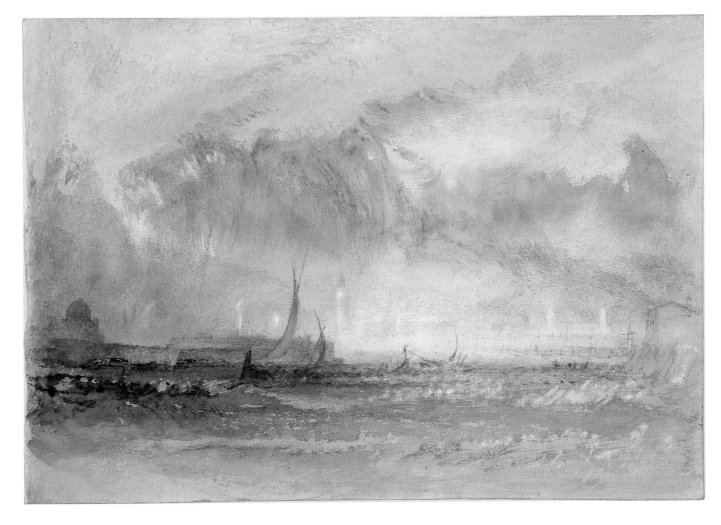

Venice, storm at sunset
Watercolour and bodycolour with touches of
pen and faint red ink and scratching out on
paper Watermark: J. WHATMAN 1834
222 × 320 mm
Inscribed, verso with eight lines of illegible
writing, probably in verse
Given by John Ruskin, 1861 no.590
Cormack 38; Wilton 1353; Stainton 86

Turner visited Venice on at least three
occasions, in 1819, 1833 and 1840, although
the possibility that he returned on one or
more occasions between 1835 and 1839 has
not been excluded by recent scholars
(Stainton, p.21). Both this, and the follow-

ing watercolour were painted on, or
shortly after, his final visit, and were
grouped as a pair by Ruskin when pre-
sented to the Museum in 1861. While there
is no evidence to suggest that Turner had
intended them to be complementary, both
stylistically and emotionally they represent
two extremes in his response to the city.

Ruskin, with good reason, considered
this watercolour 'superb' (*Works*, XIII, 557).
The turbulent movements of sky and
water are brilliantly conveyed by an
energetic directional brushwork, and by
the scratching out – almost grazing – of
highlights on the paper surface; beyond,

the distinctive silhouette of La Serenissima
takes on a spectral, visionary quality, and
holds the ensuing drama in check.

No finished watercolours were made on
these later visits, and the majority of his
drawings and watercolour sketches are
now in the Turner Bequest. Of the
twenty-four sheets extracted from the
artist's collection and dispersed among
various private collectors (probably
through his dealer Thomas Griffiths) six
were owned by Ruskin; a further nine
were bequeathed by Henry Vaughan to the
National Gallery of Scotland and the
National Gallery of Ireland in 1900.

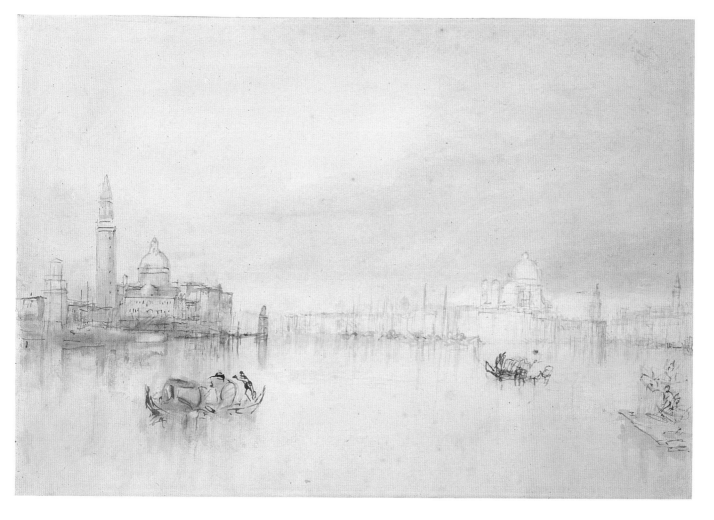

Venice, calm at sunrise
Watercolour, pen and red ink on paper
222 × 325 mm
Given by John Ruskin, 1861 no.591
Cormack 39; Wilton 1361; Stainton 68

During his two weeks' stay in Venice between August and September 1840, Turner made 180 summary studies of the city in 'roll' sketchbooks, often returning to views and subjects he had drawn on earlier visits. A view of San Giorgio in morning light was one of only four watercolours to be executed during his first, brief visit to the city in 1819 (Stainton 2), and the distinctive profile of its campanile, Palladian church and convent (easily visible from his hotel) recur in a number of the watercolours painted around 1840. William Callow, who dined with Turner at the Hotel Europa, later recorded in his *Autobiography* Turner's industriousness during this last trip: 'One evening whilst I was enjoying a cigar in a gondola I saw in another one Turner sketching San Giorgio, brilliantly lit up by the setting sun. I felt quite ashamed of myself for idling away the time whilst he was hard at work so late' (quoted Stainton, p.22).

The poor state of preservation of Turner's late oil paintings of Venice has meant that his vision of the city has been best preserved in the (notionally frailer) medium of watercolour. So personal has his style become at this stage in his career, that in this beautifully limpid watercolour he completely reverses the eighteenth-century concept of a 'tinted' drawing, by defining form in pen and red ink only after the initial thin colour washes had been floated over the paper. Like *Venice, storm at sunset*, the method of description and palette are entirely non-naturalistic, yet wonderfully 'true' as a representation of place; as Lindsay Stainton has pointed out, Turner's aim was to 'create a new reality from observed fact' (p.27), to evolve a visual language which operated in the same emotional key.

83

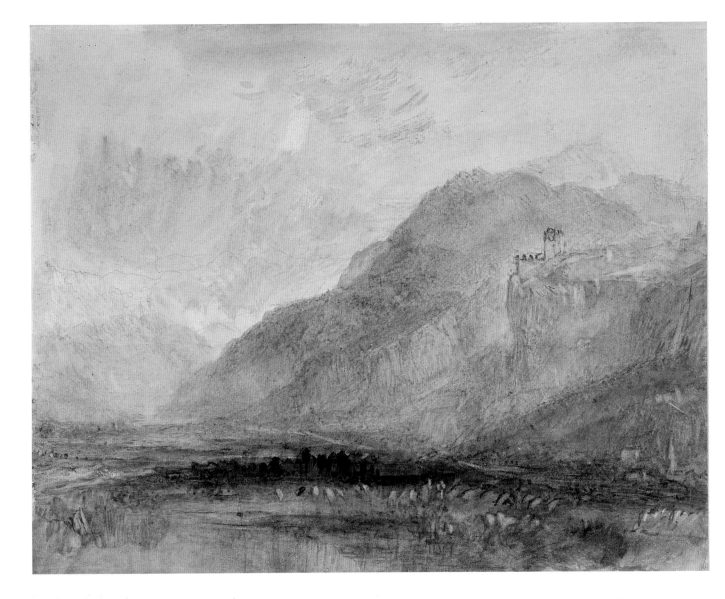

Alpine landscape
Watercolour over graphite with some pen work
in red on paper 228 × 291 mm
Given by John Ruskin, 1861 no.582
Cormack 42; Wilton 1511

The location of this view has yet to be
conclusively identified; Wilton suggests
that it may depict a road in the Grisons.
Stylistically it may be associated with a
group made after Turner's visits to
Switzerland in 1841 and 1842.

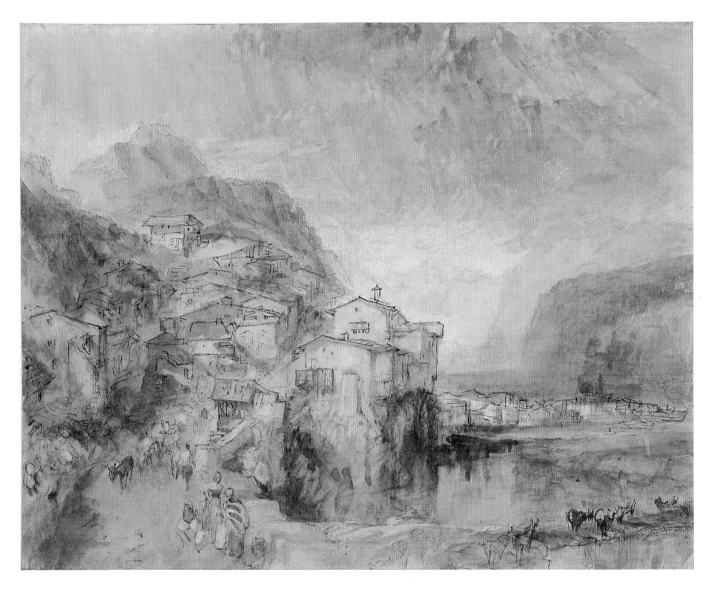

Brunnen, Lake Lucerne in the distance
Watercolour and pen with grey brown ink over
graphite on paper Watermark: J. WHATMAN /
TURKEY MILL / 1841 225 × 290 mm
Inscribed by Turner in graphite, verso: *Brennern /
Lake of Lucern*; numbered twice: *15*; *18*, and *X 8*
Given by John Ruskin, 1861 no.584
Cormack 43; Wilton 1486

In 1842 Turner presented his dealer
Thomas Griffiths with a group of fifteen
'sample' watercolours from which he
proposed to work up ten large finished
watercolours on the receipt of commission
for specific views. In the event, Griffiths
succeeded in finding only three purchasers
– Munro of Novar, Elhanan Bicknell and
John Ruskin – who between them agreed
to buy all but one of the finished group
which Ruskin romantically, if not entirely
accurately, called 'the ten drawings which
Turner did for love' (*Works*, XII, 475).
Undaunted by the limited clientele willing
to subscribe to this last group, Turner
made similar arrangements with Griffiths
for a series of watercolours painted in 1843
(and sold only five, to Munro and to
Ruskin), and again in 1845, when B. G.
Windus, who initially disliked the change
in style in the Swiss watercolours, joined
his select group of supporters.

As Gage has shown, Turner extended
his knowledge of the central Alps and the
north shore of Lake Geneva during his
visits to Switzerland in 1841 and 1842, con-
centrating particularly on Lakes Zug and
Lucerne and their mountains (1987, p.62).

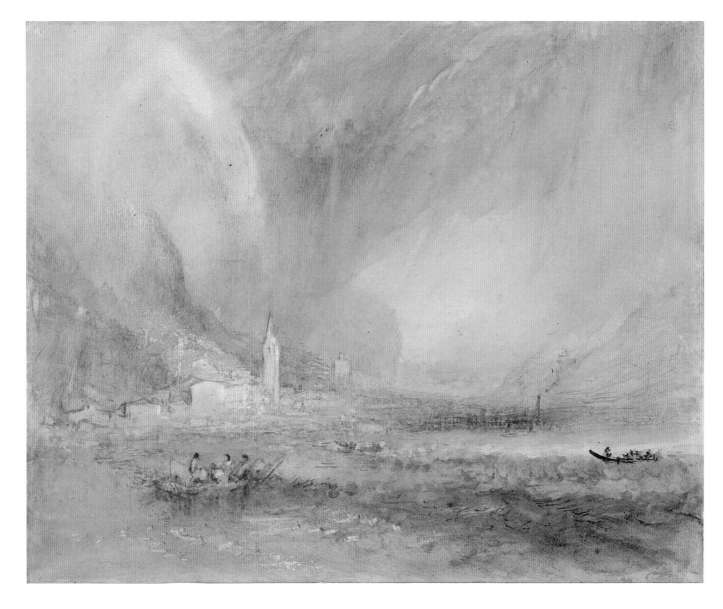

Fluelen from the lake
Watercolour with red and black ink and
scraping out on paper Watermark: J. WHAT-
MAN TURKEY MILL 1840 232 × 290 mm
Given by John Ruskin, 1861 no.585
Cormack 44; Wilton 1483

In all but the stormy conditions, this
watercolour is close to the 'sample' view of
Fluelen (CCCLXIV – 38) which was worked
up into a finished watercolour for H. A. J.
Munro of Novar in 1845 (Wilton 1549).

Broad similarities with *Venice, storm at
sunset* (p.82) in the rendering of the vortex
of the storm and churned up surface of the
lake support Wilton's date of *c*.1841 for this
watercolour.

The Devil's Bridge, St Gothard

Watercolour, pen and grey, red and brown ink over traces of graphite on paper Watermark: traces of a coat of arms 238 × 305 mm
Inscribed in graphite, verso: *Devil's bridge No.8; 04 X ; 20*
Given by John Ruskin, 1861 no.586
Cormack 45; Wilton 1499

In 1841 Turner crossed the St Gothard pass, from Lucerne and Altdorf to Bellinzona, for the first time in nearly forty years. Since 1802 the flimsy bridge which had been built to replace one destroyed by the French in 1799, had itself been replaced by another more stable structure during the 1830s (see Hill, 1992, pp.136–43). A view of the pass taken from one of the paths near the level of the bridge, also painted in the early 1840s, depicts a broad, if indistinct view over the valley below (Wilton 1497), however in this watercolour Turner returns to the dizzying verticality of his earlier compositions. A direct confrontation with the sheer rock face and apparently bottomless chasm is encouraged by eliminating an 'introductory' foreground and excluding all but a fragment of the sky. Whereas the rugged technique and monochromatic palette in the 1802 watercolours retained a notional element of naturalistic description, the vigorous downward hatching of the pen and sweeps of the brush here conspire solely to enhance the overall effect of sublimity.

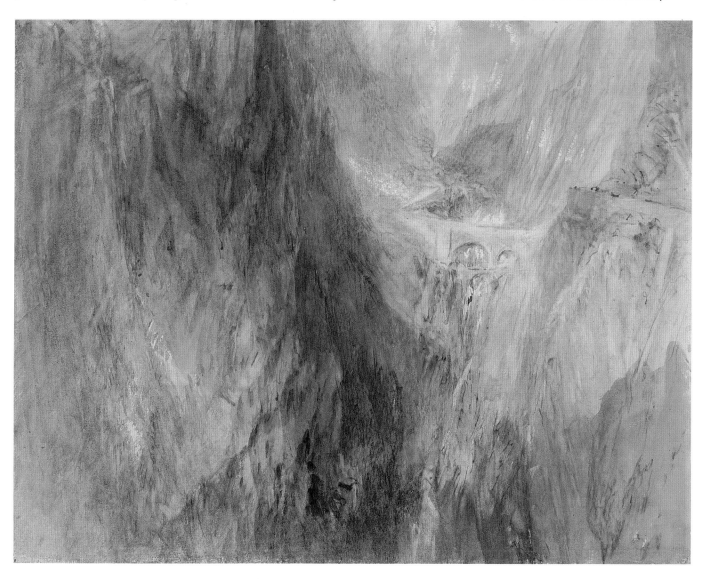

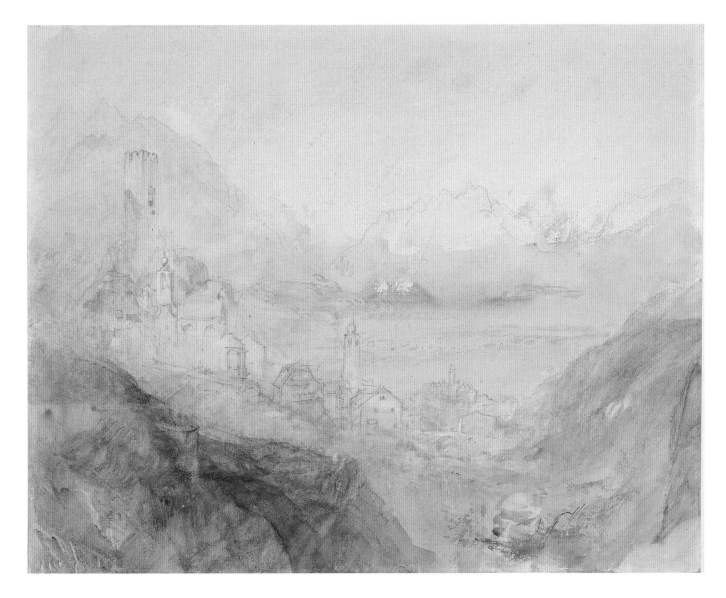

Hospenthal, Fall of St Gothard, morning
Watercolour with white highlights, pen and
blue-black ink over graphite on paper
226 × 285 mm
Given by John Ruskin, 1861 no.588
Cormack: 47; Wilton 1500

In his gift to the Museum, Ruskin grouped
this and the following watercolour as a
pair, but there is nothing to suggest that
Turner intended them as complementary,
and they may even have been executed on
different visits.

As Cormack noted, the inscription by
Turner of a number, the name of the
ultimate purchaser, and another number
preceded by an 'X' on the back of this, and
other Swiss views (see pp.85–7, 89), seems to
be confined to those produced as 'samples'
for his dealer, Thomas Griffiths in 1843.

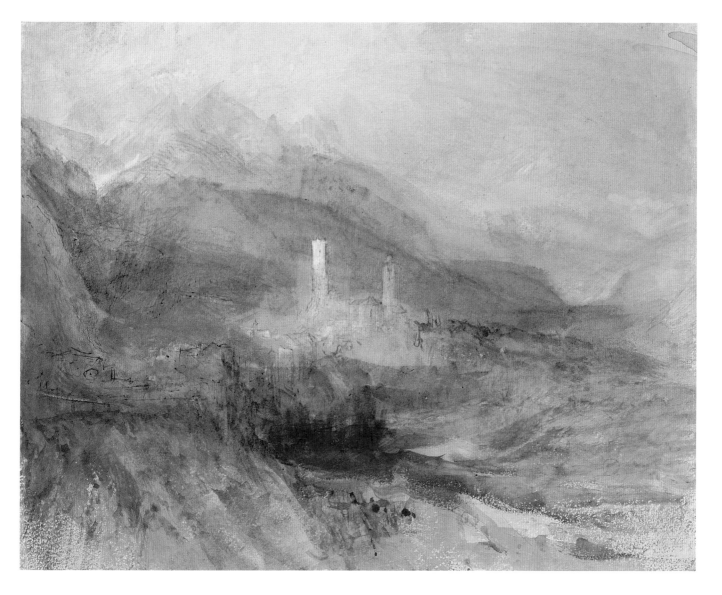

Hospenthal, Fall of St Gothard, sunset
Watercolour, pen and grey ink over graphite on
paper 227 × 286 mm
Inscribed, verso, in graphite: *Hospital N,. St.
Gothard / No. 5. X 014*
Given by John Ruskin, 1861 no.587
Cormack 46; Wilton 1501

Turner frequently exhibited paintings of
paired subjects viewed under different
atmospheric conditions or times of the day.
Presumably on this general basis, Ruskin
linked this and the preceding watercolour
as morning and crespular views of the
same place, however, as Cormack has
pointed out, Hospenthal (often called
'Hospital' by Turner) occurs in a number
of other views, and there is nothing to
suggest that Turner himself intended them
as a pair. Wilton has assigned both a date
of *c*.1843.

From his earliest watercolours of the
1790s, Turner was conscious of the value of
having a clearly-defined patch of light as a
focus in a composition; and, as Gage has
shown, his experience of engraving helped
him to extract the maximum expressive
potential from his other media (1987, p.78).
One of his favourite engravers, John Pye
(1782–1874) recalled Turner's belief that
'the art of translation of landscape,
whether in colour or black and white …
was to enable the spectator to see through
the picture into space' (quoted Gage, 1987,
p.77). In this remarkable watercolour, the
white of the tower – exaggerated in height
for effect – assumes a positive colouristic
quality, anchoring the composition, and
drawing the eye through the fluidly-
washed mists of colour.

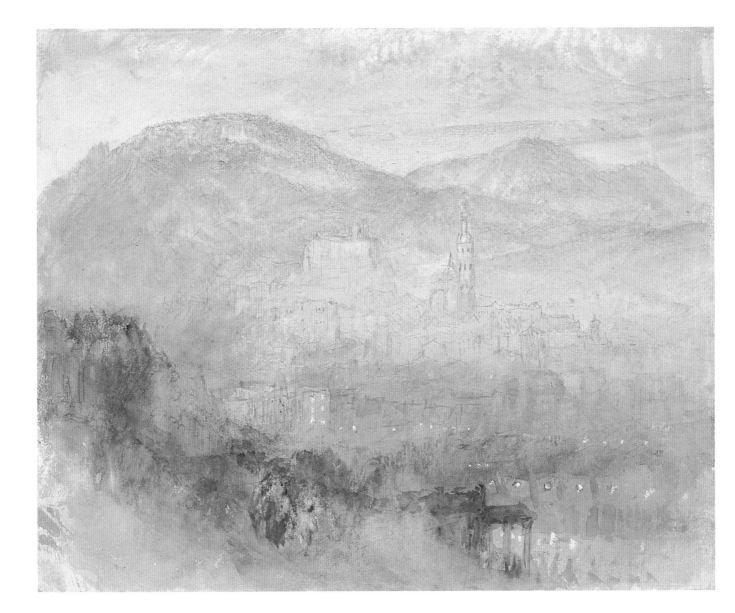

Heidelberg
Watercolour on paper 236 × 298 mm
Given by the Friends of the Fitzwilliam
Museum, 1937 no.2284
Cormack 51; Wilton 1326

The topography of this view has been much discussed, but most scholars now accept that it represents Heidelberg, with the castle and tower of the Jesuit church at the centre of the composition. The date of execution is more problematic. Turner visited Heidelberg on a number of occasions between *c*.1835 and 1844, and although Wilton has suggested it was painted around 1844, Cormack has argued that stylistic similarities with Turner's Swiss watercolours favour a date somewhat earlier in the 1840s.

A number of sketches of Heidelberg are in the 'Spires and Heidelberg' sketchbook and the 'Heidelberg up to Salzburg' sketchbook of 1840 in the Tate Gallery (CCXCVII and CCXCVIII).

The Whaler
Watercolour and graphite on paper
227 × 325 mm
Inscribed in graphite, lower right: *He breaks away*
Given by T. W. Bacon, 1950 PD.116–1950
Cormack 52; Wilton 1411

Turner is known to have made drawings of whales, all probably for book illustrations, from the late 1830s (see Wilton 1307–1310, and Shanes, 1986, pp.62–4), but his interest peaked in 1845 and 1846, when he exhibited four paintings depicting whaling scenes at the Royal Academy. Three of these were accompanied in the Royal Academy exhibition by quotations from Thomas Beale's *The Natural History of the Sperm Whale*, first published in 1835, which may also have been the inspiration for this watercolour. Butlin and Joll have tentatively suggested that this watercolour is a preliminary idea for the series of paintings, relating to a passage in Beale which describes the harpooning of a whale off Japan in June 1832 (1984, 1, pp.262–3). It could also be that Turner was drawn to the subject through his association with

his patron Elhanan Bicknell, a whaling entrepreneur, or by seeing the 14½ foot whale which was found off Deptford in October 1842 (see Butlin and Joll, 1984 1, p.262).

A number of sketches of whales appear in the 'Whalers' sketchbook which Turner used between 1844 and 1845 (CCCLIII–6–14), and in the *Ambleteuse and Wimereux* sketchbook (T.B. CCCLVII – 6), from which this sheet may have originally come.

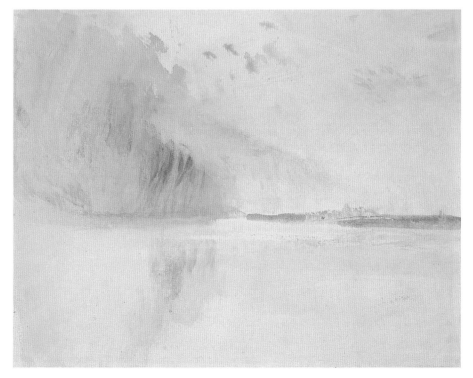

Storm cloud over a river
Watercolour on paper 233 × 286 mm
Inscribed in graphite, verso: *Sept. 12 / 45*
Given by T. W. Bacon, 1950 PD.115–1950
Cormack 53; Wilton 1427

The date, as Wilton points out, may well read 1846. It is one of many so-called 'colour beginnings', which Turner executed throughout his career (see p.69), particularly in the last two decades of his career.

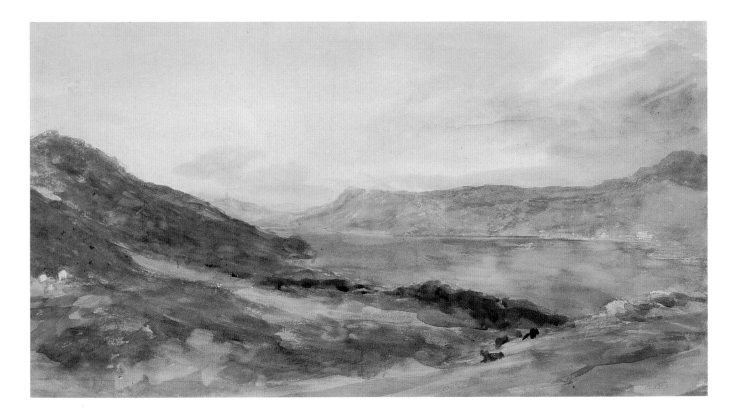

John Constable 1776–1837

Windermere
Graphite and watercolour on paper
Watermark: 1804 202 × 378 mm
Given by T. W. Bacon, 1950 PD.77–1950

Constable spent about two months in the Lake District in the autumn of 1806, on a trip financed by his uncle, David Pike Watts. He stayed with Mr Worgan, his uncle's almoner in a cottage in the grounds of Storrs Hall and with a Mrs Harden, who described him as, 'a genteel, handsome youth', and, 'the keenest at the employment I ever saw' (Cormack, 1986, p.50). Over seventy watercolours survive from this visit; according to his biographer C. R. Leslie, these were for the most part 'of a large size on tinted paper, sometimes in black and white, but more often coloured' (quoted Cormack, 1986, p.50). The importance of Constable's Lake District tour has traditionally been played down by his biographers, on the basis of Leslie's having heard him say that the solitude of mountains oppressed his spirits. However, as Cormack has pointed out, the quantity and originality of work which he produced there, and the fact that he exhibited Lake District subjects at the Royal Academy over the following three years would seem to indicate some considerable enthusiasm on his part.

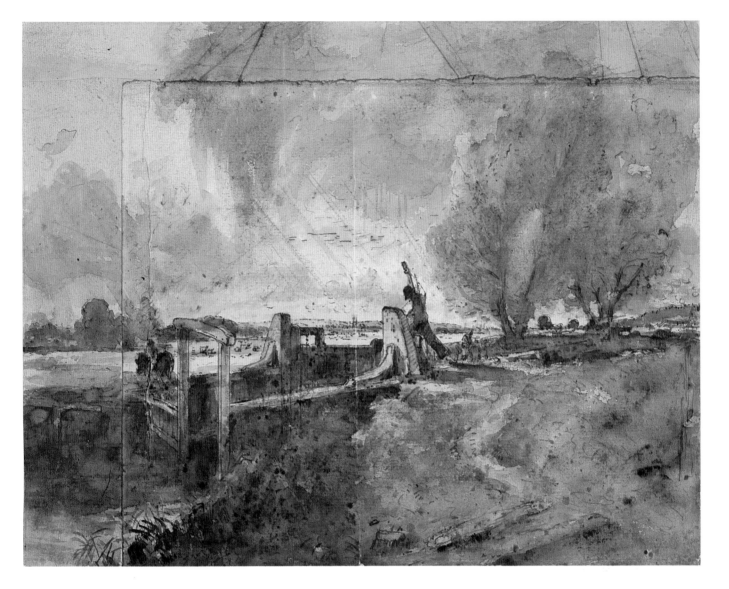

The Lock

Reed pen, brown wash, graphite and traces of
white highlights on paper, creased in the centre,
and with two additional strips 287 × 364 mm
Bequeathed by Percy Moore Turner, 1951
PD.11–1951

Constable's first painting on this theme –
A Boat Passing a Lock (Sudeley Castle, the
Walter Morrison Picture Settlement) – was
exhibited at the Royal Academy in 1824.
Unusually, it found an immediate buyer,
and it was no doubt this extraordinary
success, together with the fact that Con-
stable thought the subject 'an admirable
instance of the picturesque' (Cormack,
1986, p.156), which encouraged him to
produce a second version in 1826. This
drawing is a study for the later version,
which Constable sold to the bookseller
James Carpenter, but bought back, with no
little acrimony, in order to present as his
Diploma Painting to the Royal Academy.
The most striking difference between the
two compositions is the shift from a
vertical to a horizontal format, a transfor-
mation effected in this preliminary study
by the addition of strips of paper at the top
and on the left.

While working on the painting in 1826,
Constable expressed the wish that the end
result would be 'as good as Claude Lorrain'.
As Cormack has pointed out, the feathery
handling of the trees shows the morphology
of his 'Claudian' style of drawing, which
became noticeable after a visit to Sir George
Beaumont's collection at Coleorton in 1823.

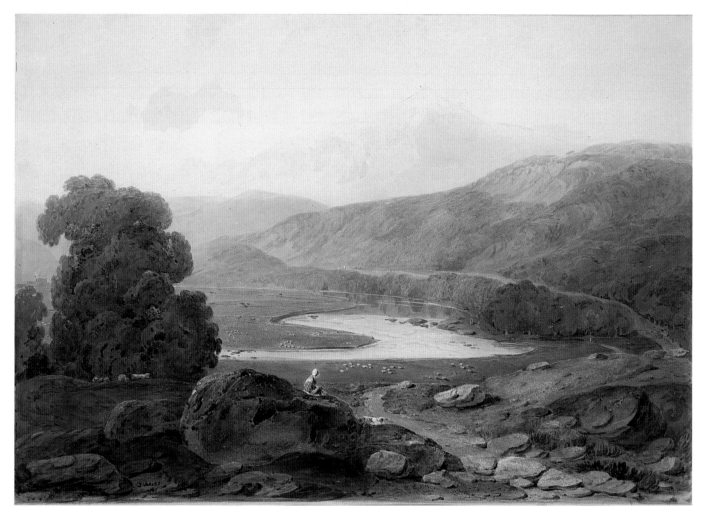

John Varley 1778–1842

Valley of the Mawddach

Black chalk and watercolour with scratching
out on paper 441 × 626 mm
Signed and dated in ink, lower left: *J. Varley,
1805* [and again, blocked out]
Given by the Friends of the Fitzwilliam
Museum, 1931 no.1607

Varley made his first trip to Wales in 1798
to 1799 with the landscape painter George
Arnald (1763–1841), and by 1802 he was
coming to the attention of the London
cognoscenti as 'an ingenious young man
who had been making drawings in Wales'
(Farington, 2 November 1802). From then
until his death in 1842, he exhibited views
of Wales in oils and watercolours almost
annually at the Royal Academy, British
Institution and Old Water-Colour Society.
As C. M. Kauffmann has pointed out
(1984, pp.25–6), many of his early draw-
ings are influenced by the picturesque
views published in antiquarian and travel
books such as Thomas Pennant's *Journey to
Snowdon* (1781) and William Gilpin's

Observations on the River Wye (1782).
However, unlike these picturesque travel-
lers, Varley had first-hand knowledge of
the wild countryside, having climbed
Cader Idris during his journey of 1800 or
1802 (see Bicknell, 1982, p.23), an experi-
ence which no doubt contributes to the air
of naturalism and breadth of vision with
which this view is painted. Typically, a
figure has been added to the foreground in
order to lead the eye to the distant view –
what Varley called the 'look there' of a
picture.

*View from the doorway at Warkworth Castle,
looking down the river Coquet towards the
Hermitage*

Watercolour over traces of black chalk on paper
354 × 288 mm
Signed and dated in ink, lower left: *J. VARLEY
180?5*
Bequeathed by Arthur W. Young, 1936 no.1791

There can be few more brilliant, or more
literal, interpretations of the Gilpinesque
picturesque than this view, through an
internal picture 'frame', of the beautiful
valley of the Coquet in Northumberland.
Like Gilpin, Varley believed that nature
required 'cooking', and although many of
his later watercolours are stiff and formu-
laic in their pursuit of effect, his finest
works successfully balance a rigorous
pictorial composition with a powerful
originality of vision.

Varley had important patrons in
Northumberland, and in 1808 made a tour
of the county, visiting the seats of William
Ord of Whitfield, the Countess of Tanker-
ville and Sir John Swinburne of Cap-

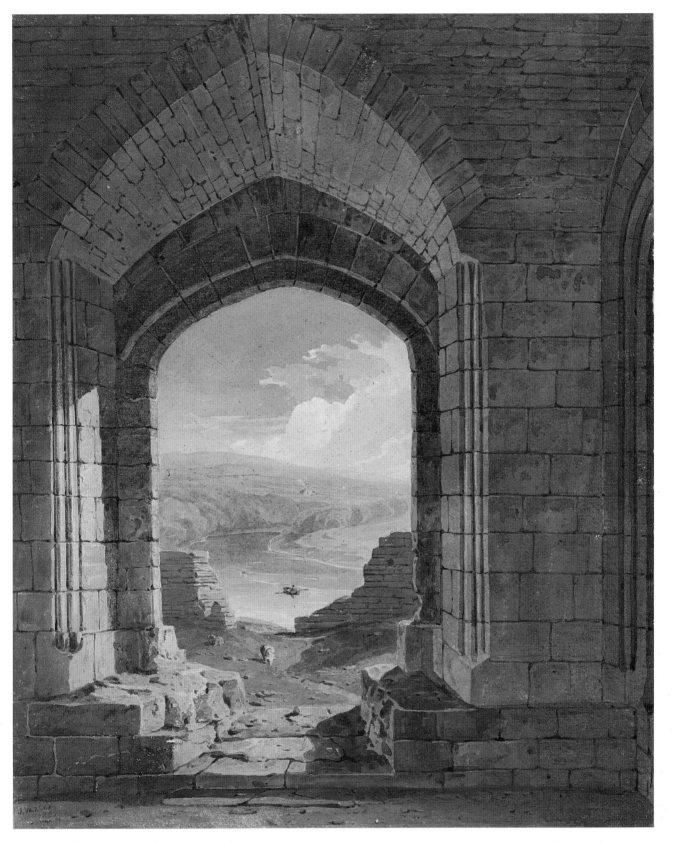

heaton, and exhibited two views of Warkworth at the Society of Painters in Water-Colours (later the Old Water-Colour Society) the following year. Although this is thought to have been his first tour of Northumberland, the most likely reading of the date inscribed on this watercolour would seem to corroborate Cornelius Varley's statement that he also visited the area in 1805, while on a trip to Yorkshire (see Kauffmann, 1984, p.17). A sketchbook of views of Northumberland made during his 1808 visit, including four views of Warkworth Castle, is in the Victoria and Albert Museum (ibid., pp.118–22).

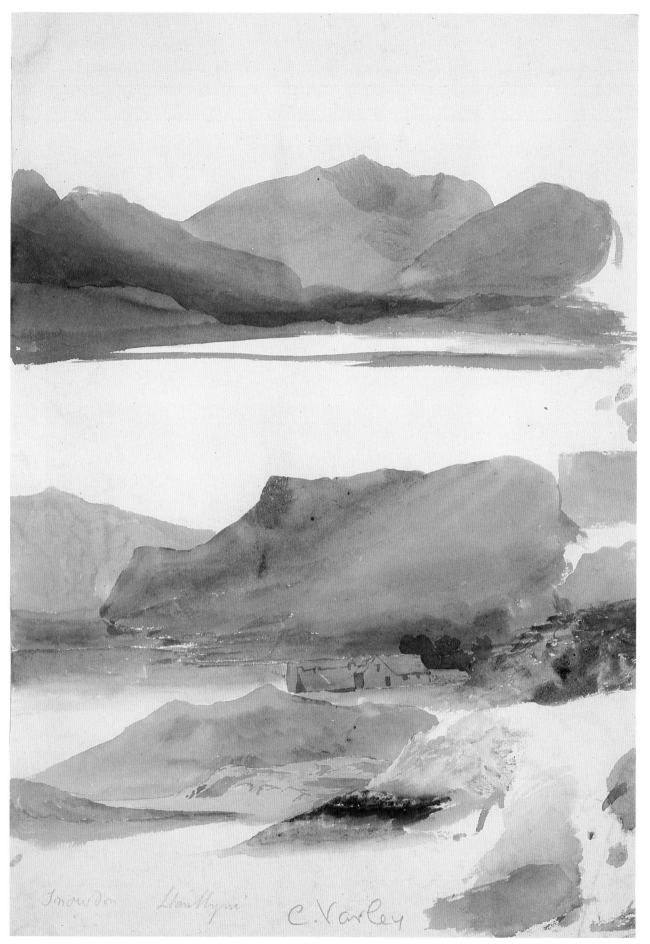

Snowdon Llanllyni C. Varley

Cornelius Varley 1781–1873

Studies of Mount Snowdon

Watercolour on paper 375 × 263 mm
Signed in graphite, lower centre: *C. Varley*;
inscribed in graphite, lower left: *Snowdon /
Llanllym*
Verso: grey wash mountain landscape, inscribed
below: *Snowdon*
Given by Sir Frank Brangwyn, 1943 no.3287

Varley made several sketching tours to
Wales. In 1802 he and his brother John met
up with the painters Thomas Webster
(1772–1844), Joshua Cristall (1768–1847)
and William Havell (1782–1857), and they
returned the following year, again in the
company of Havell and Cristall.

On both trips, Varley executed numer-
ous drawings in graphite, sometimes over
two pages of a sketchbook, in order to
encompass the grandeur of the mountain
scenery. Many of these are inscribed with
colour notes, but he also made a number of
sketches in pure watercolour – often
several to a sheet – in which he sought to
establish the general forms and composi-
tion of the landscape. Michael Pidgley has
argued that the freedom of handling in
Varley's early watercolours, executed
between *c.*1802 and 1805, had a considera-
ble influence on artists such as Constable
and John Linnell (1982, p.782; see *Winder-
mere* p.92 and *Sunset* p.123).

The Fitzwilliam Museum owns a
sketchbook used by Varley on his 1802
tour, which included views in graphite and
watercolour of Dolbadern, Barmouth,
Llanberis, Harlech and Snowdon, as well
as recipes for curing poisonous animal bites
and cancer of the lips (PD.78–1972). A
sketchbook of Varley's better-documented
visit of 1803 is in the Pierpont Morgan
Library, New York.

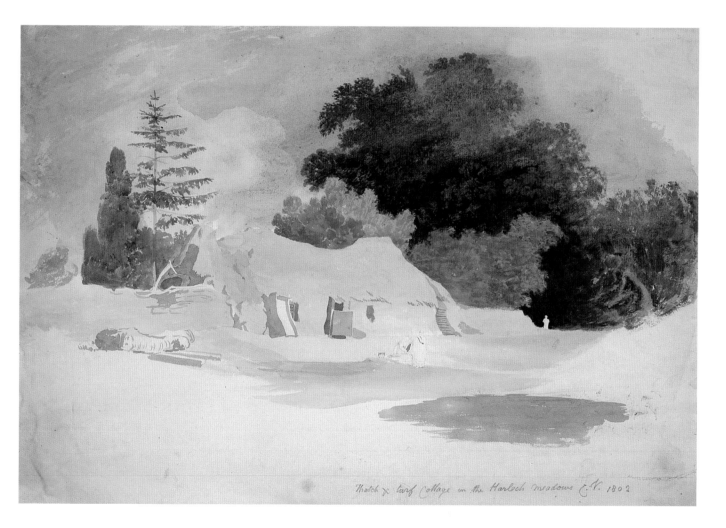

Thatch and turf cottage on Harlech meadow

Graphite and watercolour on paper
316 × 460 mm
Signed, dated and inscribed in graphite, lower
right: *Thatch & turf Cottage on the Harlech
Meadows C.V. 1802*
Verso: sketches in graphite of perspectival lines
and a circle
Bequeathed by Dr R. E. D. Harvey-Samuel,
1992 PD.123–1992

Drawn during Varley's tour to Wales in
1802.

Comparison with the works of his more
prolific elder brother suggests an approach
to nature which was at once more spon-
taneous and naturalistic. According to
John Linnell's biographer A. T. Storey, the
two men differed as much in temperament
and stature as they did in artistic accomp-
lishment, the devout and intellectual
Cornelius representing, 'a striking contrast
to his broad, bluff King Hal of a brother,
being small, dapper and sharp as a needle'
(1892, p.28).

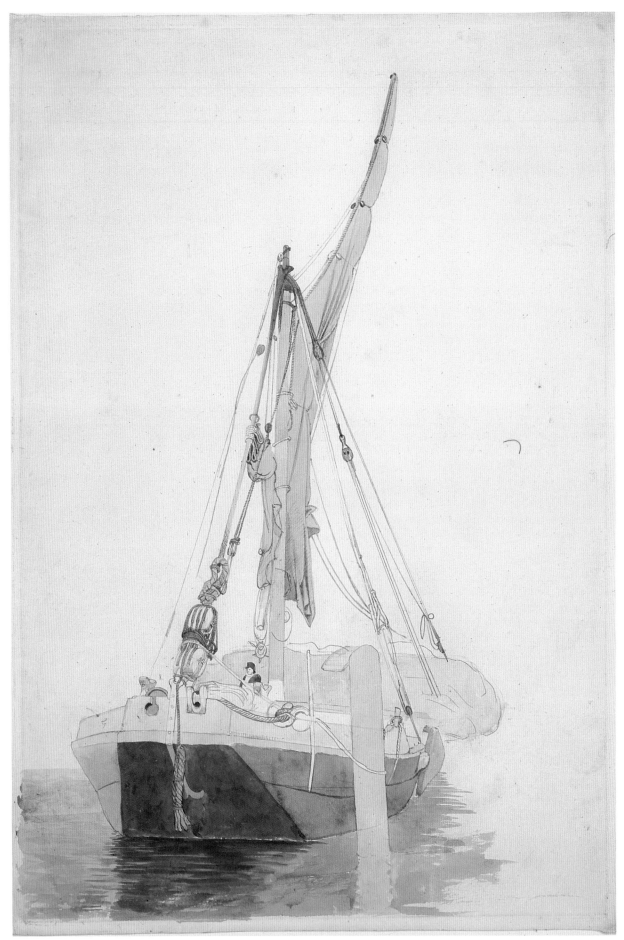

Study of a masted boat
Graphite and watercolour on paper
475 × 325 mm
Bought, 1993 PD.42–1993

Throughout his career, Varley made numerous studies of Thames craft and shipping on the coasts of England and Wales. In 1809 he published with his brother John, *Scenery on the Thames*, a series of seven etchings and lithographs of shipping, fishing boats, barges and vessels, some of which were later copied by Cotman (see Pidgley, 1982, p.782). This was followed in 1828 to 1829 by the publication of *Shipping and Craft*, and in 1847 by another collaborative venture, *Varley's Drawing Book of Boats*, a set of lithographs by W. Boosey after original drawings by Varley. According to the title of the *Drawing Book*, the original drawings for the publication were made with the aid of a 'Patent Graphic Telescope', a form of *camera lucida* invented by Varley in 1811 by means of which an object, physiognomy or landscape was inverted by reflection onto a flat surface, and subsequently traced onto paper. The unhesitant accuracy with which he has drawn the outline of the boat in this watercolour is characteristic of the effect it produced, and suggests that it postdates 1811.

Varley devoted much of his life to scientific pursuits. As well as the 'Pt Gc Tpo' (as it is inscribed on many of the drawings for which it was used) he also invented air pumps, optical instruments and a variety of different kinds of microscopes, some of which were awarded medals by the Society of Arts, and at the Great Exhibition of 1851.

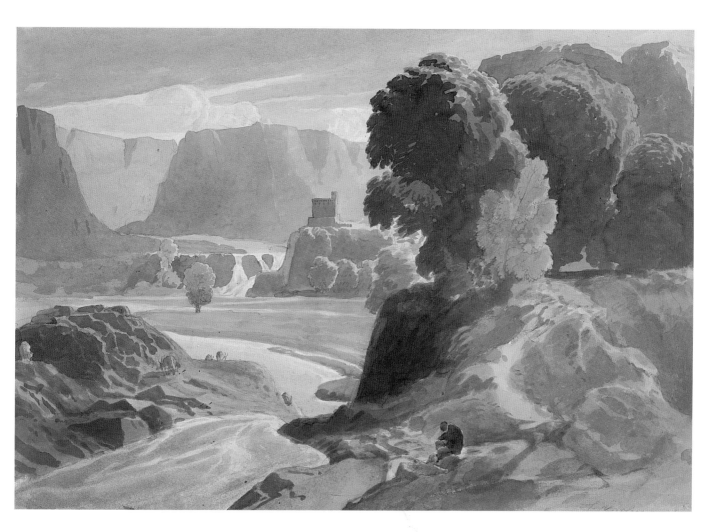

Mountainous landscape with a castle
Watercolour over graphite on paper
321 × 467 mm
Signed in graphite, lower right: *C. Varley* (signature cut at lower edge)
Bought, 1967 PD.4–1967

Probably a view in Wales. The loosely applied washes of colour and staffage figures in the foreground recall the work of Joshua Cristall, with whom Varley worked in Wales in 1802 and 1803. Both men were among the original members of the Society of Painters in Water-Colours, and from 1808 they also attended meetings of the Society for the Study of Epic and Pastoral Design.

According to an old inscription, this drawing was formerly in the collection of the painter James Ward (1769–1859), who attended meetings of the Sketching Society from c.1800 to 1806, and whose early views of Wales, painted around 1802 have distinct stylistic affinities with both Girtin and Varley (see Munro, 1992, no.47).

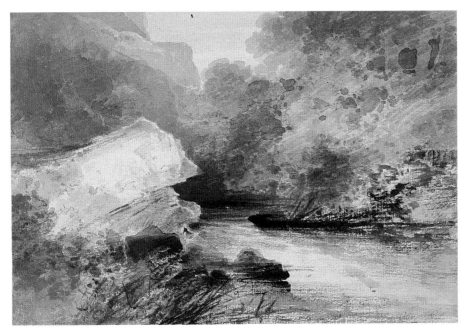

John Sell Cotman 1782–1842

The 'Crystal Pool' (above)
Grey and black wash over graphite on paper
222 × 321 mm
Signed in brown ink, lower right: *Cotman f.*
Inscribed in brown ink on verso of the card on
which this drawing was formerly laid: *Subject. /
Where the rill by slow degrees / Swells into a
chrystal pool; / Shelving Rocks & Shaggy Trees /
Shoot to keep the water cool – / Cunningham
Poems / J.S. Cotman. Presd (?) T.R. Underwood.
P.S. Munn W. Alexander J. Varley – Visitor W
Munn May 5: t 1802*
Bought, 1980 PD.39–1980

This wash drawing was painted in May
1802 during a meeting of the Sketching
Society, originally founded in 1799 by a
small group of artists whose aim was to
establish a school of historical landscape
painting in Britain. 'The Brothers' met
weekly at one of the members' homes
from six or seven to ten o'clock, when
simple sustenance with ale and porter was
provided. The host of the evening acted
as President, nominated the subject to
be represented (usually a 'poetick' pas-
sage derived from a literary quotation)

and kept the drawings made by the other
members. As Rajnai has pointed out,
Cotman preserved a sizeable collection
of drawings by fellow members of the
Society, twenty-seven of which were sold
as one lot in the posthumous sale of his
drawings at Norwich in 1862 (1982, p.60).

To judge from the inscription on the
verso of the card on which this drawing
was formerly mounted, the subject –
apparently drawn from Allan Cunning-
ham's *Poems* – was selected by Cotman
himself, as President of the evening's
seance. Two other drawings made at the
same session survive: one, by William
Alexander (1767–1816) was acquired with
this drawing in 1980; another, attributed to
Paul Sandby Munn (1773–1845), is in the
Oppé collection.

Classical colonnade in a wooded landscape
(below left)
Graphite, grey wash and black ink on paper
268 × 362 mm
Given by A. E. Anderson, 1931 no.1539

Cotman's association with the Sketching
Society is documented from 1802 to 1804,
but he may well have continued to attend
meetings until 1806. Both the subject
matter and use of monochrome in this
drawing are reminiscent of those executed
at the Society's meetings, although the
broader application of wash more closely
resembles a series of drawings on classical
themes made around 1806 (see Rajnai,
1982, nos 50–52).

An overshot mill (opposite)
Graphite and watercolour with scraping out on
paper 486 × 380 mm
Bought, 1953 PD.29–1953

Cotman came to London in the autumn of
1798, and was initially employed to colour
aquatints for the German print publisher
Rudolph Ackermann. According to
Hardie, his early hardships (and possibly
also his later triumphs with the opposite
sex) became the model for Jane Porter's
novel *Thaddeus of Warsaw* (1809), in which
the young Count Thaddeus, having flown
a battle-torn Poland, attempts to make his
way in London by selling wash landscapes
of German towns to a grudging and
avaricious print-seller (1967, II, p.75).

In 1799, however, Cotman joined the
circle of artists at Dr Monro's informal

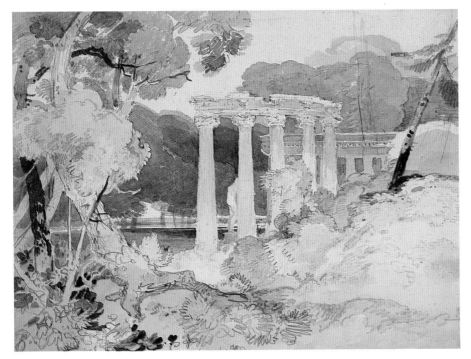

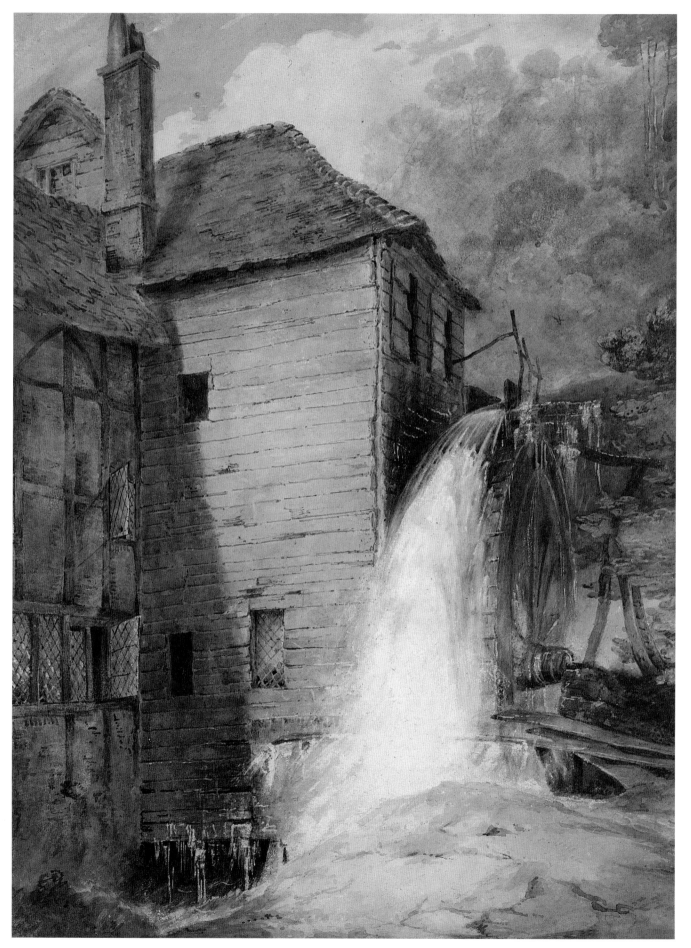

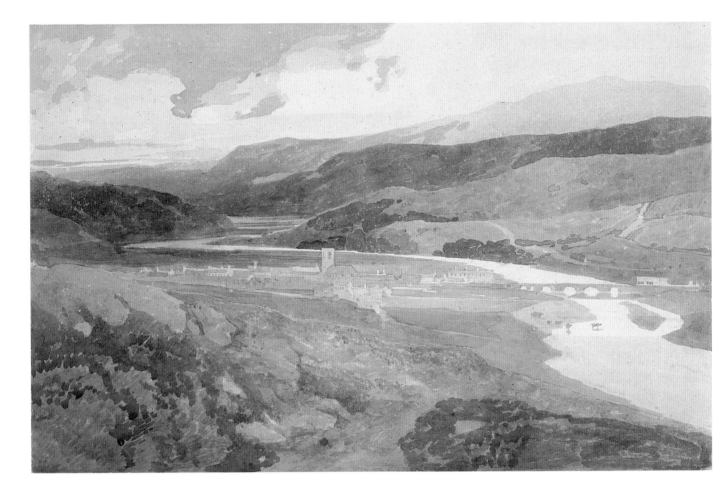

'Academy' at Adelphi Terrace, where he would have come into regular contact with Turner and Girtin. The following year, he exhibited for the first time at the Royal Academy, and was awarded 'the greater Silver Palette' by the Society for the encouragement of Arts, Manufactures and Commerce for a drawing of a water-mill, perhaps the watercolour formerly in the collection of Dr Harvey Samuel. The present watercolour was probably painted around 1802–3, and shows the influence of Girtin in its dramatic vertical perspective and use of scribbles in graphite and brown ink to articulate the texture of wood and thatch.

Dolgelly, North Wales
Watercolour over graphite on paper
285 × 450 mm
Bequeathed by Sydney D. Kitson, 1937
no.2303

Situated at the foot of Cader Idris, Dolgelly (or Dolgellau) was in the eighteenth century an important centre of the flannel trade and a favourite stop for travellers and artists on their tour of Wales. Thomas Pennant, one of the first of a generation of tourists to visit the town, noted that its name derived from the fact that it was located in 'a dale abundant in hazels' (1781, p.106), and by the end of the century it was being recommended to painters for its 'bold and terrific' surrounding countryside, 'which boasts of every species of scenery necessary to mark the sublimest subjects in

nature' (*The Itinerant*, 1799). According to Kitson, this commanding panorama over the River Wynion and the estuary of the Mawddach was painted in the winter of 1804–5 from a sketch made at the end of July 1802, during Cotman's second tour of Wales with the painter Paul Sandby Munn. More recently, however, Adèle Holcomb has suggested that it was based on a study by his Norfolk compatriot John Crome (1768–1821), and that Cotman executed it in order to impress his patrons, the Dawson Turners, by his innovative style and 'synthetic breadth of space' (1978, p.12). Whatever the origins of the composition, this watercolour is one of the earliest and most impressive manifestations of Cotman's highly original artistic personality.

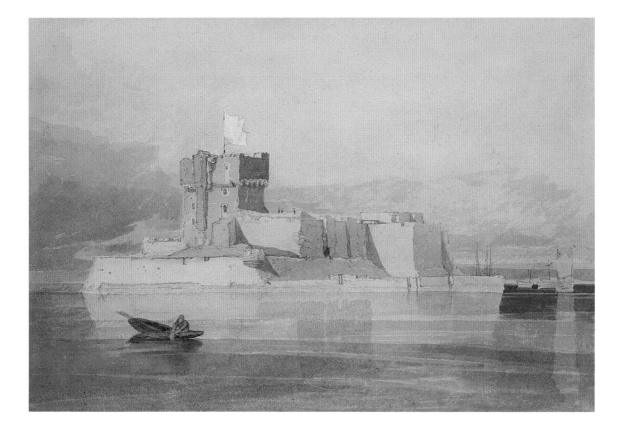

Fort Saint Marcouf, Near Quinéville,
Rade de la Hougue
Watercolour over graphite on paper
230 × 340 mm
Given by the Friends of the Fitzwilliam
Museum, 1927 no.1477

Cotman made three trips to Normandy in
the summers of 1817, 1818, and 1820. On
each of the trips he followed a punishing
work schedule, travelling for ten hours and
more in a diligence, becoming 'unhinged'
by excessive heat, and enduring anti-
English sentiment in Rouen (Rajnai, 1975,
p.3). Despite this, the tours were extremely
productive, and he returned with ninety-
seven drawings which were issued as
etchings in two lavish volumes with
letterpress in Cotman and Turner's *Archi-*
tectural Antiquities of Normandy, 1822; a
further twenty etchings after his drawings
were published in Dawson Turner's *Tour*
in Normandy, 1820.

This watercolour is based on a sketch
which he made towards the end of his
third tour in 1820. Cotman's diary shows
that he was sketching in the vicinity of
Quinéville on 11 September 1820, and in a
letter to his wife of 17 September he also
records that 'the bay of La Hogue [*sic*] is
also in my portfolio' (Isherwood Kay,
Walpole Society, 1926–7, p.121). The limpid
atmosphere and pronounced sense of
structure created by the reflections on the
water evoke a luminous stillness character-
istic of Cotman's finest work.

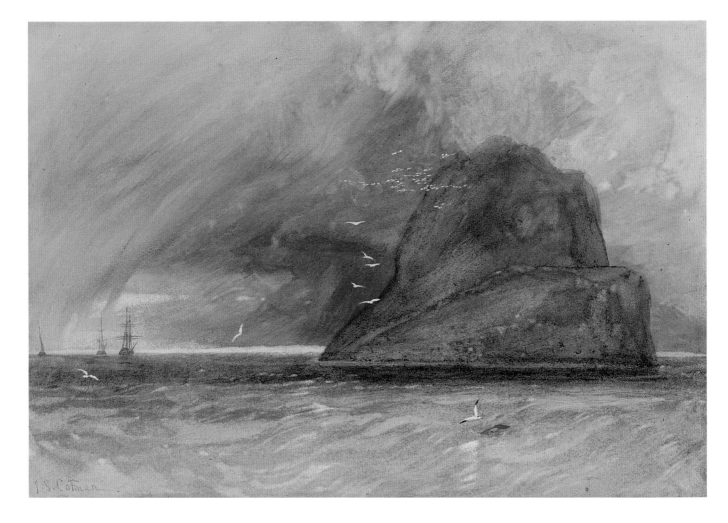

The Bass Rock
Watercolour and scraping out on paper
218 × 322 mm
Signed in watercolour, lower left: *J.S. Cotman*
Bequeathed by J. A. Fuller Maitland, 1936
no.1783

Probably painted between 1833 and 1835.
A drawing of the same subject in graphite
heightened with yellow chalk on toned
paper, dated 1833, is also in the Museum's
collection (no.3274).

Cotman is not known to have visited
Scotland, and it could be that he was
inspired by the rich tonal effects of William Miller's engraving after Turner's
drawing of the same subject, published in
Walter Scott's *The Provincial Antiquities of
Scotland*, 1826.

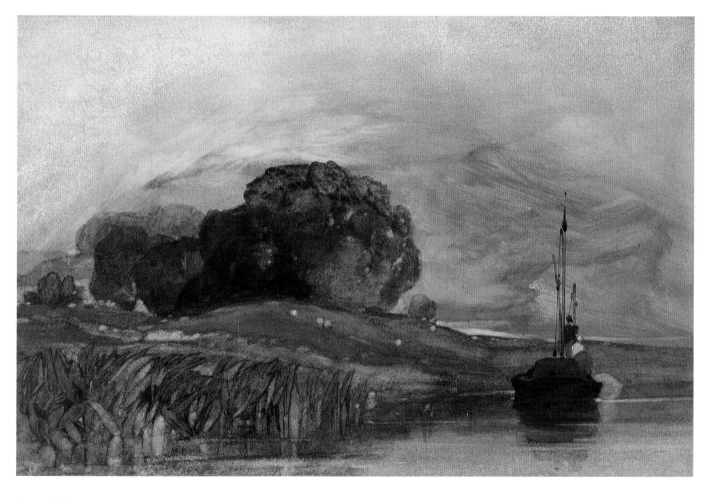

Postwick Grove

Watercolour on paper 178 × 272 mm
Given by T. W. Bacon, 1950 PD.80–1950

Critics and biographers have judged
Cotman's later watercolours harshly.
Although a large number of these are
executed in what one reviewer of 1825
described as 'an intemperance of bright
colours' (Hardie, 1967, II, p.89), others –
such as the present example, painted
c.1835–40 – show that he preserved a
remarkable fluency of handling even when
working in the more opaque medium
which he favoured in the last decade or so
of his life. In the mid 1830s Cotman began
to experiment by adding to his water-
colours a thickening agent (possibly de-
rived from flour paste or size) which gave
them a richness of finish comparable to oil
paint. In order to create highlights, he
dampened the paper and removed areas of
colour where they were required, using a
sponge (as he appears to have done in areas
of the sky) and a barely-dry brush, blotting
paper, or bread for smaller areas, such as
the reeds in the foreground. The result was
a softening of effect and blurring of form
which suspend topographical accuracy for
evocation of mood.

Postwick Grove, on a bend of the River
Wensum, near Norwich, was one of
Cotman's favourite sketching grounds.

Schaffhausen
Watercolour over graphite on paper
497 × 342 mm
Bequeathed by Joseph Prior, 1919 no.944

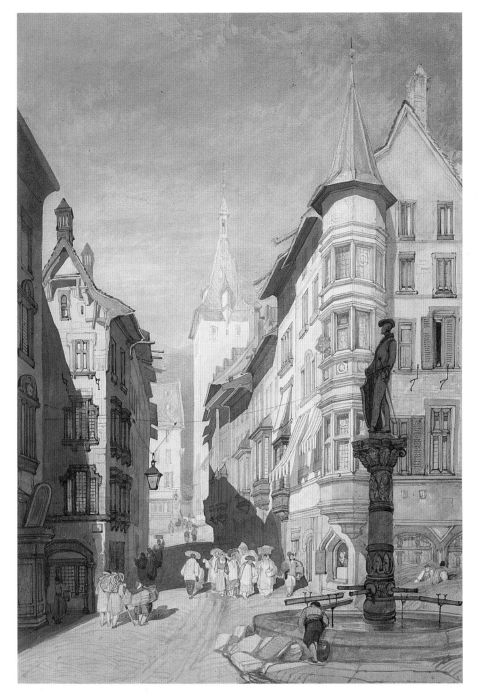

In March 1834, when he took up his post as drawing master at King's College in London, Cotman wrote to his patron Dawson Turner to inform him that he had abandoned his plan to produce an annual, these being now '*passé* and unfashionable', in favour of 'something more artist-like' (8 March 1834, Kitson, 1937 p.75). His proposal – unfortunately never realized – was to publish a selection of ten or twelve drawings after views of the Continent by W. H. Harriot (*fl.*1811–37), a pupil and follower of Samuel Prout (1783–1852), which he considered '*very fine* … [and] … ought not to be lost to the world'.

Some fifteen years earlier, Cotman had planned 'a *Splendid Book*' of his views of Normandy, although this project likewise came to nothing, partly due to his involvement in the production of the *Architectural Antiquities of Normandy*, but also because he was pre-empted by a number of French and English publications on the region (see Allthorpe-Guyton, 1982, pp.28–9). Given the contemporary popularity of publications such as the *Landscape Annual* and *Heath's Picturesque Annual*, the timing of his new suggestion was opportune; quite why it failed is uncertain – ill health may have been partly to blame, but perhaps, like other artists, he felt that the market had been cornered by Turner and Prout (see Uwins, 1858, 1, p.387).

Cotman's bright palette and use of opaque colours was much criticized in the 1820s and 1830s. However, as he lamented to Dawson Turner in 1834, these seemed pallid beside the vibrantly coloured views of Spain which John Frederick Lewis exhibited that year at the Old Water-Colour Society (see p.132): 'words cannot convey to you their splendour, *My poor Red Blues* and Yellows, for which I have been so much abused and broken hearted about, are faded fades, to what I saw there. Yes and aye, *Faded Jades* & trash' (Kitson, op. cit., p.306).

Another view of Schaffhausen, horizontal in format, is in Norwich Castle Museum (207.235.951).

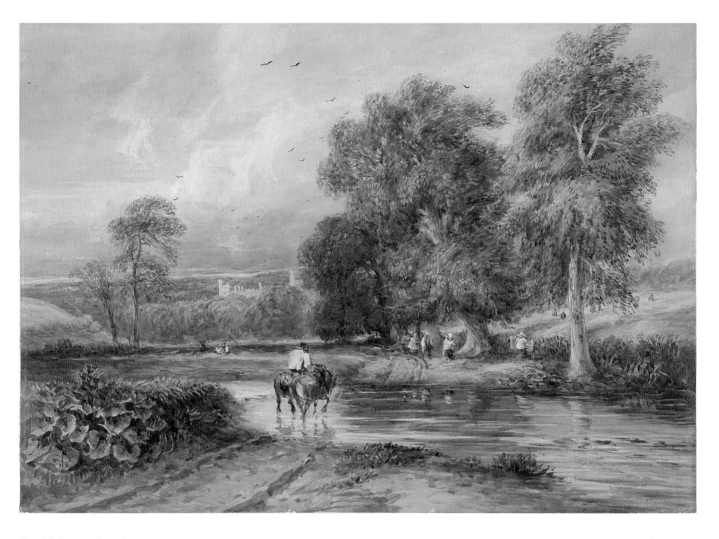

David Cox 1783–1859

Returning from the hayfield, with a distant view of Haddon Hall
Watercolour on paper 352 × 555 mm
Inscribed in graphite, verso: *Returning from the Hayfield*
Bequeathed by Arthur Young, 1936 no.1789

Cox first visited Haddon Hall in August 1831, and returned on several occasions over the next two decades. The Hall had belonged to the Manners' family since the sixteenth century, but was abandoned as a family residence in favour of Belvoir Castle after the death of the Duke of Rutland in 1711. During the first part of the nineteenth century it was much visited by artists and writers, and inspired a plethora of romantic evocations of its medieval past in prose and verse.

Cox despised 'portraits of places' (Hall, 1881, p.160). Accordingly, most of his views of Haddon are of its late medieval interiors and terraces, or broad landscapes in which the architecture plays a relatively minor role in the composition. In this watercolour, Cox has devoted his fullest attention to the expression of atmosphere. By using a series of flecked, curled brushstrokes (what he called 'repetition of touches') and details such as the wind-buffeted birds in the sky, he vividly conveys the naturalistic effects of wind and rain for which he was most renowned. As a reviewer of the retrospective exhibition of his work held in London shortly before his death observed, Cox 'spares neither man nor animals, clouds or trees; his masculine and relentless pencil rends the

clouds to pieces ... and living things, whether man or beast, are as mercilessly dealt with as the brook forced over its banks, or the rushes by its sides when torn up by their roots, and blown away to wither on dry land' (Solly, 1873, p.336).

Few of Cox's views of Haddon are painted on this scale. Some years earlier, he had complained of the difficulty of selling his large-scale works, noting that he was forced to sell them for barely half their real value: 'I could not live at the price asked, and shall make but few large drawings, on account of the few purchasers. I intend to make small drawings, and perhaps one large each year' (Hall, op. cit., p.33).

For a detailed account of Cox's association with Haddon, see Lockett, 1983–4, pp.28–33.

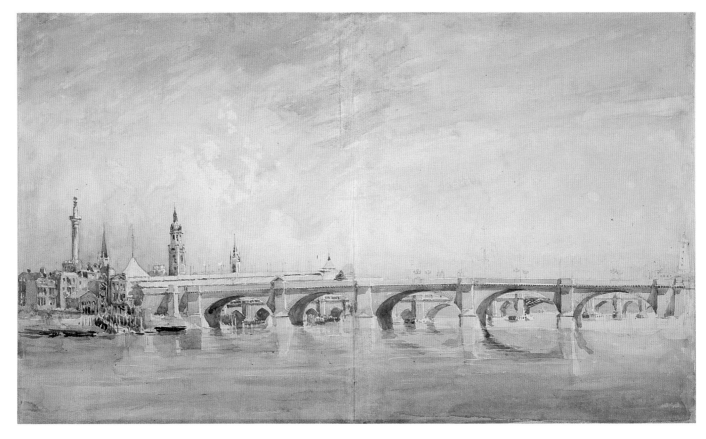

The opening of the new London Bridge by William IV
Graphite and watercolour on two sheets of paper, joined together 319 × 541 mm
Bequeathed by J. R. Holliday, 1927 no.1285

Cox lived in London from 1804 to 1814, and again from 1827 to 1841. While contemporaries such as Varley and Linnell were attracted to the leafy countryside around Hampstead Heath and Kensington, Cox preferred the riverfronts and areas close to the Thames, principally around Westminster, Greenwich and Blackfriars.

This sweeping riverscape was painted to commemorate the opening of the new London Bridge on 1 August 1831. Designed by John Rennie, the bridge had taken seven years to build, and its opening was an occasion of great pageantry, with a procession of barges bearing King William and Queen Adelaide from Somerset House to the City end of the bridge, a scene Cox is said to have witnessed from a coal wharf near St Saviour's Church, Bankside (Solly, 1873, p.67). Although in this initial watercolour sketch signs of festivity are confined to the marquees and banners erected at the

north end of the bridge, it could be that Cox planned to use it as the basis for a more elaborate (and peopled) watercolour along the lines of his *George IV embarking for Scotland at Greenwich, 1822*, which enjoyed remarkable success when exhibited at the Old Water-Colour Society in 1823.

Compositionally, the view owes much to Canaletto, whose works had a marked influence on British landscape painters at the end of the eighteenth century, however a more direct inspiration may have been Thomas Girtin's series of panoramic soft-ground etchings of Paris (see p.62).

Other studies in graphite and watercolour are in the Yale Center for British Art, New Haven.

On the road to Tremadoc, North Wales
(opposite above)
Graphite and watercolour on paper
267 × 361 mm
Inscribed in graphite, lower left: *On the road to Tremadoc*
Verso: sketch in graphite of a ruined building in a landscape
Given by Augustus Walker, 1909 no.3323

Presumably painted during one of Cox's later sketching expeditions to Wales. Tremadoc was built on land recovered from the Glaslyn estuary in Caernarvonshire by William Alexander Madocks in 1792. The first embankment was swept away by the sea and rebuilt from the money raised by an appeal, generously supported by, among others, the poet Shelley, who lived at nearby Tan-yr-allt from 1812 to 1813.

Betws-y-Coed (opposite below)
Watercolour over black chalk on paper
217 × 295 mm
Signed in watercolour, lower left of centre:
David Cox
Bequeathed by J. R. Holliday, 1927 no.1273

'Dear old Bettws' was one of Cox's favourite sketching haunts. He first visited the picturesque town on the banks of the River Llugwy in Caernarvonshire in 1844 with the painter Harry John Johnson (1826–84), and spent a few weeks there almost every year until his health and eyesight began to deteriorate in 1856. On most of his visits he stayed at the Royal Oak Inn (a pen and ink

sketch of which is also in the Museum's collection; no.1328), where he was joined by an ever-increasing group of admirers and followers. In his biography of Cox, Solly describes something of the genteel, convivial atmosphere which prevailed in this most sedate of artists' colonies: 'His habits at Bettwys were exceedingly simple and primitive. In the evening he sat in the parlour of the Royal Oak inn, which in those days was an artist's club *pur et simple*. Here he took his cigar (he smoked no pipe) and his pint of ale, with one or two cronies by his side, willing to listen, and willing to teach. There was no racket, no shouting, no fastness or slang; it was an intelligent, rational, pleasant evening's amusement, and I have heard French, German, Hungarian, English and Welsh flowing on like a polyglot stream at the same time in that dingy parlour' (1873, p.172).

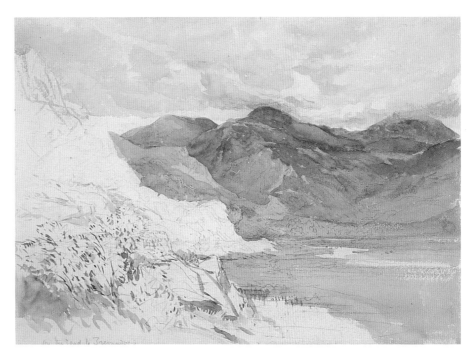

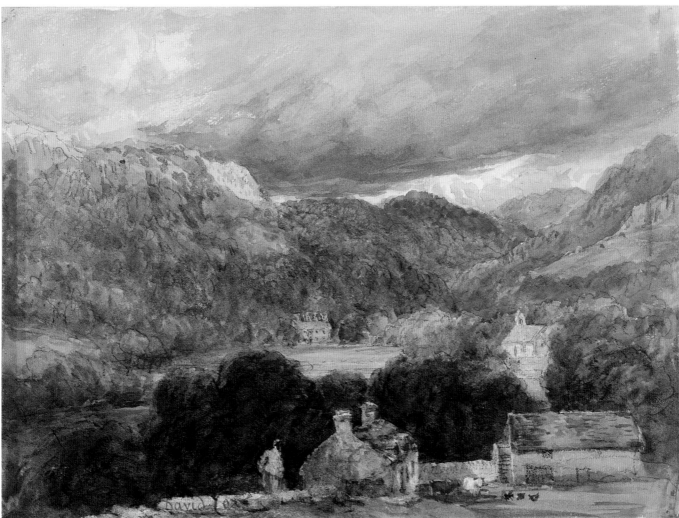

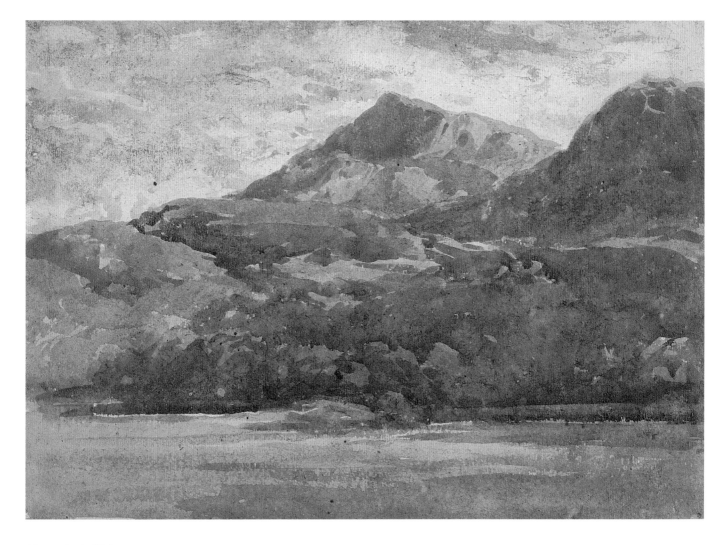

Mountains in Wales
Graphite and watercolour on paper, laid down
311 × 453 mm
Given by Augustus Walker, 1909 no.695

Cox made a clear distinction between his
'sketches' and his finished exhibition
watercolours, which he referred to as
'drawings'. Like Turner, he is known to
have worked simultaneously on as many as
four watercolours, on which he laid large,
flat washes of colour with a large swan's
quill brush (see Solly, 1873 p.174).

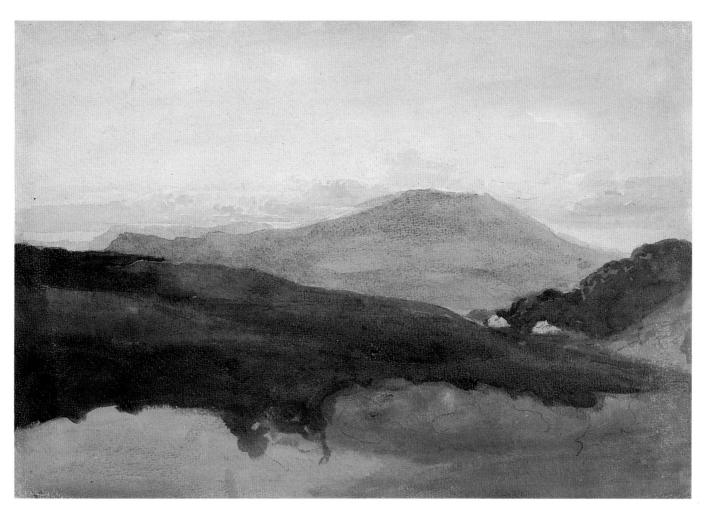

Mountain scene
Watercolour on rough 'Scotch' paper
263 × 368 mm
Given by T. W. Bacon, 1950 PD.87–1950

Despite the growing range of papers which was being manufactured from the beginning of the nineteenth century by firms such as James Whatman and Winsor and Newton, some landscape painters continued to seek out special papers whose colour, texture and sizing were particularly suited to their style (see p.17). Foremost among these was Cox, who favoured a, 'rough Scotch wrapping paper … very unabsorbent of colour … made from old linen cloth, well-bleached', which he discovered in 1836, and frequently used in both his sketches and finished drawings. This freely-washed mountain landscape exploits to the full the irregularities and (*pace* the description of the original paper) the absorbency of the sheet to add texture and luminosity to the scene.

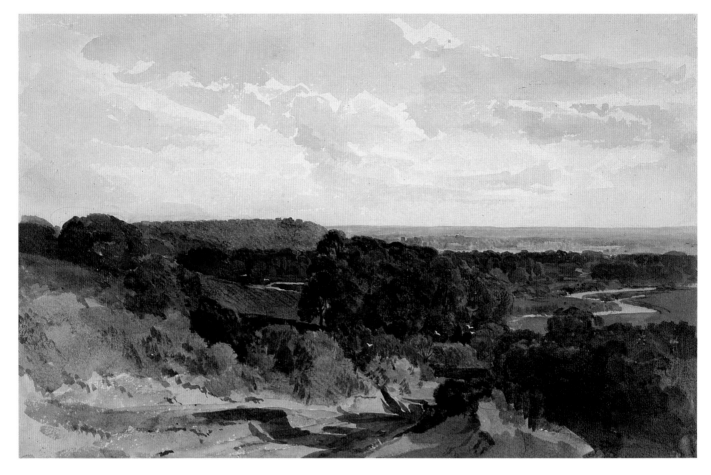

Peter DeWint 1784–1849

Cliveden-on-Thames
Watercolour with gum arabic over traces of
graphite with highlights scratched in on paper
298 × 467 mm
Given by T. W. Bacon, 1950 PD.120–1950

DeWint enjoyed favourable critical acclaim
for much of his career. His watercolours
were frequently praised for their 'sim-
plicity of effect', 'lack of affectation', and
(sometimes implicitly) for their quintessen-
tial Englishness. As the poet John Clare
remarked, DeWint was, 'the only artist
that produces real english scenery in which
british landscapes are seen and felt upon
paper with all their poetry and exillerating
expense of beauty about them'.

DeWint painted two versions of this
subject in oils, one of which was exhibited
at the Royal Academy in 1813. Another
loosely-painted oil sketch, no longer
described as Cliveden, is in the Victoria
and Albert Museum (261–1872).

Caerphilly Castle (right)
Watercolour over traces of graphite on paper
264 × 469 mm
Inscribed in graphite, verso: *Caerphilly Castle –
Sunset*
Given by T. W. Bacon, 1950 PD.118–1950

DeWint's first trip to Wales in 1829 was
undertaken with some reluctance. As his
wife Harriet recalled in her *Memoirs*, the
surfeit of bad drawings of the country
which he had seen in the early part of his
career convinced him that 'he should not
like the scenery and consequently [he] did
not go there until 1829 or 1830, but, seeing
the country himself, he declared it was the
land for a painter. Sublime and the beauti-
ful were blended and so diversified, that
every step afforded a subject for a picture'
(quoted Hammond Smith, 1982, p.123).

The old Welsh name for the castle was
'The Blue Castle'.

Harvesters resting
Watercolour with gum arabic over graphite on
paper 324 × 340 mm
Bequeathed by J. R. Holliday, 1927, received
1931 no.1583

Harvest scenes were among the most
popular of DeWint's subjects. That their
appeal was moral as well as purely aes-
thetic is evident from numerous critics and
reviews in the 1820s and 1830s, including
the watercolourist William Henry Pyne,
who observed of his *Cornfield*, exhibited in
1824: 'The hay-field is cheerful and gay.
The cornfield is rich and begets reflection.
It is the consummation of the farmer's
hopes and toils, and excites the whole
people to acknowledge the goodness of a
bountiful creator!' (*Somerset House Gazette*,
11, 12 June 1824, p.143).

 A full-size study for the left-hand
section of the painting is in the collection of
Sir Ian Forbes Leith of Fyvie, Bt.

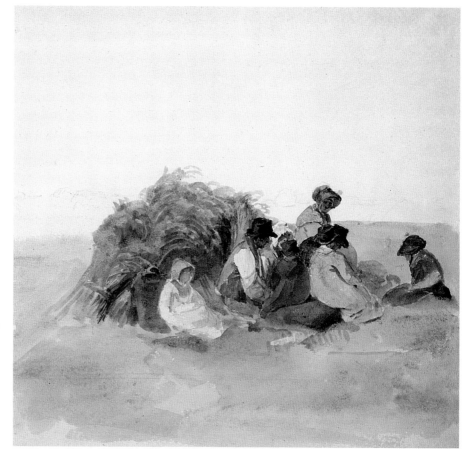

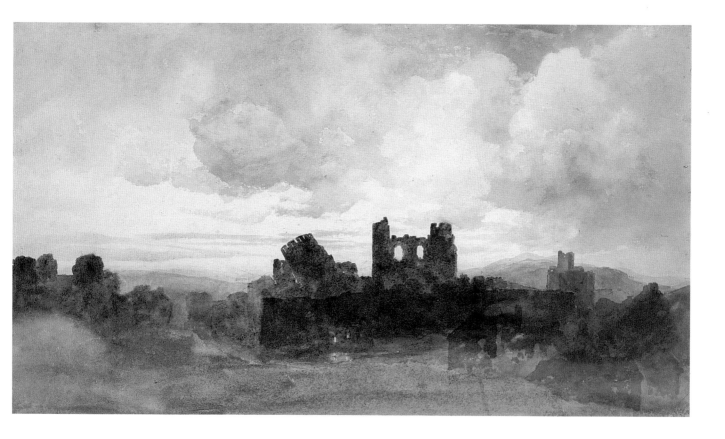

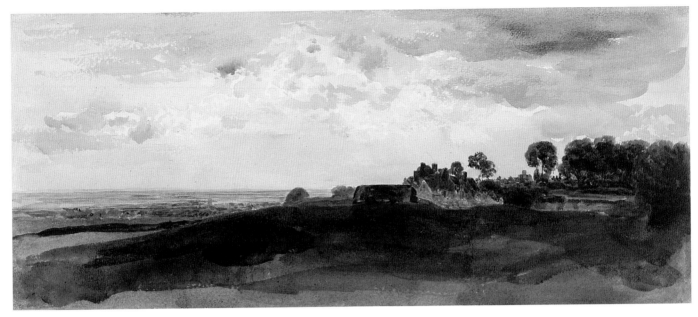

In the Lincolnshire fens
Watercolour over traces of graphite on paper
221 × 525 mm
Given by T. W. Bacon, 1950 PD.125–1950

In 1814 DeWint bought Hilton House, in
his wife's native town of Lincoln, and from
then until 1835 he spent most of his late
summers and autumns there, finally selling
the property in 1846.

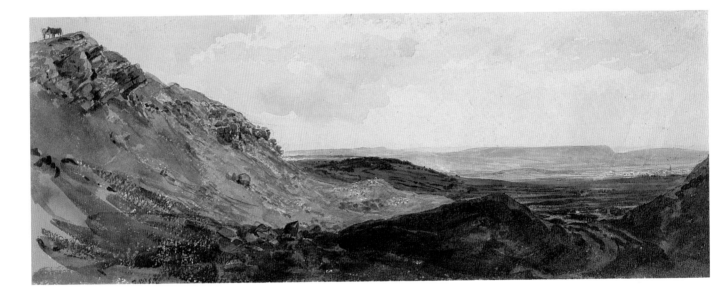

Middleham in Wensleydale (?)
Watercolour with gum arabic over black chalk
on paper 175 × 456 mm
Given by T. W. Bacon, 1950 PD.128–1950

DeWint was a master of the saturated
brush. According to his follower James
Orrock (1829–1913): 'He flooded the paper
and drove the running colour in masses
deep into it; the lay in was therefore rich
and full in the extreme, and looked like
mosaics (Hammond Smith, 1982, p.49).

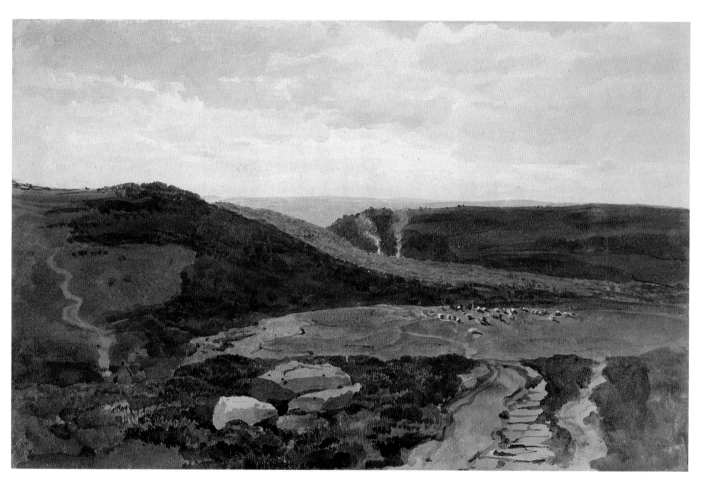

Yorkshire Fells
Watercolour with gum arabic over traces of
graphite on paper 363 × 565 mm
Given by T. W. Bacon, 1950 PD.130–1950

Perhaps no other watercolour by DeWint
speaks so eloquently of his debt to Thomas
Girtin. As a visitor to Dr Monro's
'Academy' from *c*.1806, DeWint would
have known and copied Girtin's work, and
it might plausibly be suggested that he
could have seen there, or in the collection
of his patron Lord Lonsdale at Lowther

Castle, some of the group of large water-
colours of Yorkshire which Girtin painted
in 1801 (see, for example, Girtin and
Loshak 453). The slowly ascending column
of smoke linking earth and sky is a
strikingly Girtinesque feature, used to
great effect in his view *On the Wharfe, near
Farnley* (Girtin and Loshak 443). The rich
palette of russets and maroons is character-
istic of DeWint's preference for warm,
autumnal hues.

Study of trees at Lowther
Watercolour with gum arabic over traces of
graphite on paper 461 × 297 mm
Inscribed in graphite, verso: *Lowther / 14626 /
221 / Mr Bradshaw?*
Given by T. W. Bacon, 1950 PD.136–1950

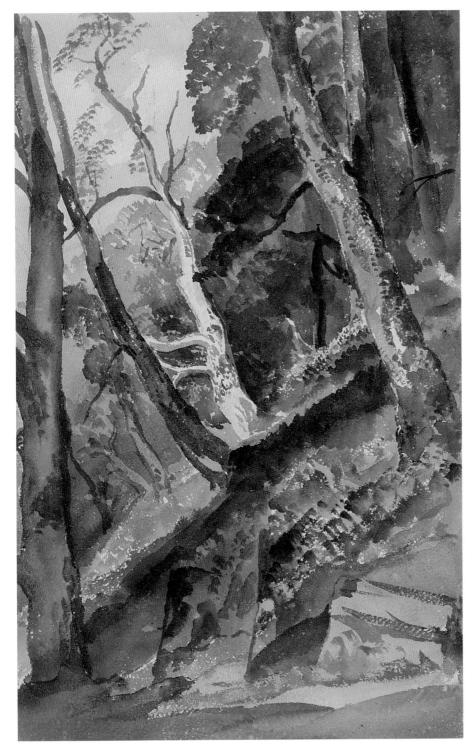

This is one of DeWint's most arresting watercolours. While the remarkable assurance with which he has applied loaded brushes of colour to paper has been likened to oriental painting, the natural-istic palette and direct confrontation with an isolated element of the natural world are leading characteristics of British Romanticism.

DeWint visited Lowther Castle on several occasions, and exhibited water-colour views of the estate in 1839. Al-though a date of *c*.1839 has recently been suggested for this watercolour (Brown, 1991, p.38), DeWint also painted a number of boldly-executed tree studies at Oakley Park in the 1840s, and on the whole it seems wiser to assume that this study was painted during the last decade of his life.

The Constable's Tower, Dover Castle
(opposite above)
Watercolour over traces of black chalk paper
Watermark: CRESWICK 295 × 459 mm
Inscribed in graphite, verso: *Dover Castle / 29th
August 1845*
Given by the Friends of the Fitzwilliam
Museum, 1924 no.1127

The Constable's Tower was one of the subsidiary defences of the Norman castle.

This watercolour was painted on buff-coloured 'Creswick' paper, one of a range of rougher papers being produced in the nineteenth century especially for landscape painters. Its coarsely-grained surface texture allowed the paint to be dragged over the surface of the paper, leaving the 'pits' untouched by the brush to glimmer as highlights through the fluid washes of colour.

The Westgate, Canterbury (opposite below)
Watercolour with gum arabic on paper
151 × 264 mm
Given by T. W. Bacon, 1950 PD.119–1950

DeWint exhibited a watercolour of Canterbury in 1846, and his wife's account book records the sale of a drawing of Canterbury – presumably that exhibited – in the same year.

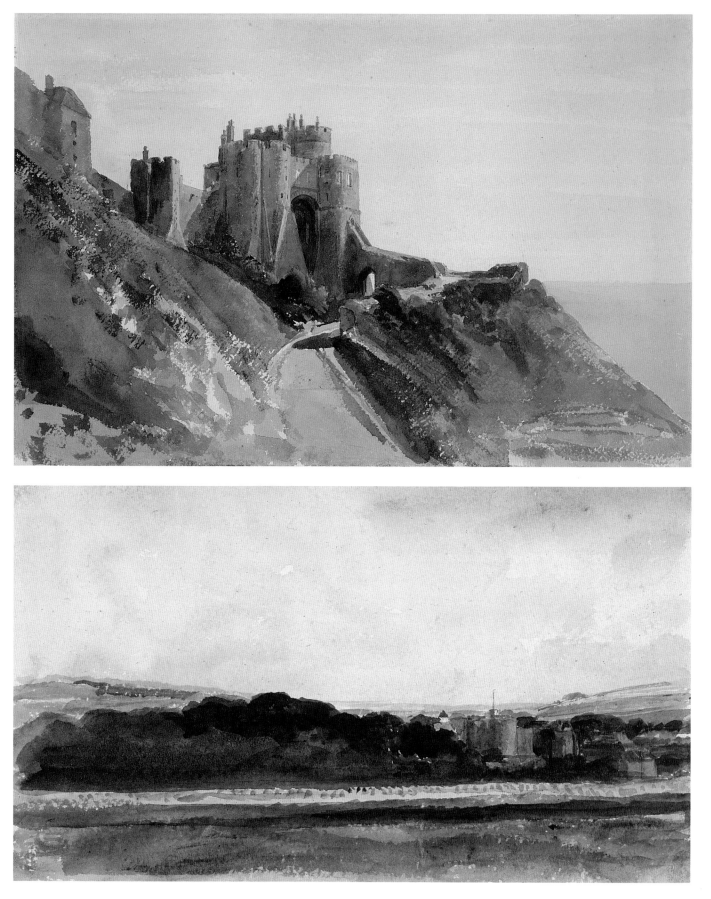

On the Dart
Watercolour with gum arabic over traces of
graphite on paper 332 × 507 mm
Inscribed in graphite, verso: *Holme Chase on the
river Dart, Devonshire / 9th Sept. 1848*; and
numbered: *3*
Given by T. W. Bacon, 1950 PD121–1950

Painted during DeWint's last sketching
trip in the autumn of 1848, when he stayed
with Mr Champernowne in Dartington
House. This is a study for the watercolour
of the same title, which was exhibited at
the Old Water-Colour Society in 1849 (see
p.119). Other, slighter, preliminary studies
are in the Usher Art Gallery, Lincolnshire
(UG.866) and the Fitzwilliam Museum
(PD.3–1977).

Holne Chase, as it is now known, is said
to derive its name from the abundance of
holly (from 'holm' in old West Country
dialect, hence the 'm' in DeWint's inscrip-
tion) which grows in this part of Devon.

On the Dart
Watercolour heightened with bodycolour and
gum on paper 558 × 930 mm (irregular)
Bought, 1977 PD.5–1977

This watercolour is generally considered to
be DeWint's last major work. It was
exhibited to popular acclaim at the Old
Water-Colour Society in 1849, where it
was bought for fifty guineas by John
Vokins, one of the few dealers to enjoy a
successful, if short-lived, business relation-
ship with the artist.

Although, by the 1830s, admiration for
DeWint was such that, every 'scrap' from
his hand was highly prized, comparison
between this watercolour, and the smaller,
related study for the subject (see p.118)
shows that DeWint, in common with his
contemporaries, maintained important
distinctions in style and handling between
spontaneous sketches and finished 'ex-
hibition' watercolours. In this version,
originally laid down on canvas board,

topographical detail and perspective are
defined with far greater precision: the
bends of the river, foreground and distant
hills are more clearly articulated, greater
expression is given to the sky, and the
composition has been extended to include
the distinctive arches of Holne bridge in
the mid-distance. An angler and a group of
cows animate the river banks, and in-
troduce a note of tranquillity and reflection
to the scene.

William Mulready 1786–1863

Mounces Knowe, Northumberland
Graphite and black chalk with white chalk
highlights on buff paper 272 × 368 mm
Signed, dated and inscribed, lower right:
Mounces Knowe / Sept 8/9 1814 WM
Bought, 1988 PD.19–1988

Irish-born, Mulready came to London as a
child, and at the age of fourteen gained
entry to the Royal Academy schools,
thanks to the support of the sculptor
Thomas Banks (1735–1805). Not long

afterwards he studied landscape painting
with John Varley, whose sister he married
in 1803. Mulready's fame rests with the
highly-finished rural and domestic genre
scenes which he began to execute around
1809, but, as this drawing shows, he
maintained an active interest in sketching
from nature.

Mounces Knowe was the temporary
residence during the shooting season of Sir
John Swinburne, one of Mulready's main
patrons, near his country seat at Capheaton
in Northumberland. Mulready's earliest

recorded work at Capheaton is dated 1814,
and in his diary for 13 October 1815,
Joseph Farington noted: 'Calcott called.
He has been at Sir John Swinburne's in
Northumberland 8 to 10 weeks, and
during 6 weeks of the time Mulready was
there and was a great favourite of the
family' (1981, VIII, p.40). Two other
drawings of Mounces Knowe in black and
white chalks, both showing a different
bridge over the stream, perhaps further up
the valley, are in the Victoria and Albert
Museum (nos 6089 and 6090).

William Henry Hunt 1790–1864

Study of fruit – melon, black grapes, plums and redcurrants
Watercolour on prepared ground on card
264 × 362 mm
Signed with the brush in brown ink, lower left of centre: *W HUNT*
Bequeathed by Arthur Young, 1936 no.1795

Hunt was apprenticed to John Varley, who famously advised him and his fellow students to 'go to Nature for everything'. Between 1805 and 1809 he made regular sketching trips along the Thames with John Linnell, and was a favourite of Dr Monro, frequently visiting his country home at Bushey in Hertfordshire. His early watercolours are in the transparent watercolour style of his master, but from his election to the Old Water-Colour Society in 1826, he turned to painting rustic genre subjects and still lifes in bodycolour.

Painted around 1840, this watercolour demonstrates the extraordinarily painstaking technique which earned Hunt his contemporary renown. Although the overall effect is harmonious, the handling of paint is by no means uniform: while the rugged skin of the melon is described in comparatively broad touches of transparent pigment, a more minute dappling with a dry brush is laid over white prepared ground in order to render the bloom on the grapes and plum. Although Ruskin admired Hunt's craftsman-like approach towards his *métier*, he occasionally joined the artist's critics in finding his attention to detail too obsessive; as a reviewer for *Frazer's Magazine* observed, 'Mr Hunt … would just as soon drown his aunt Sarah in a butt of Meux's XXX, as displace a brick from a house, or a feather from a dead goose that was sitting for its portrait before him' (June 1830, p.533).

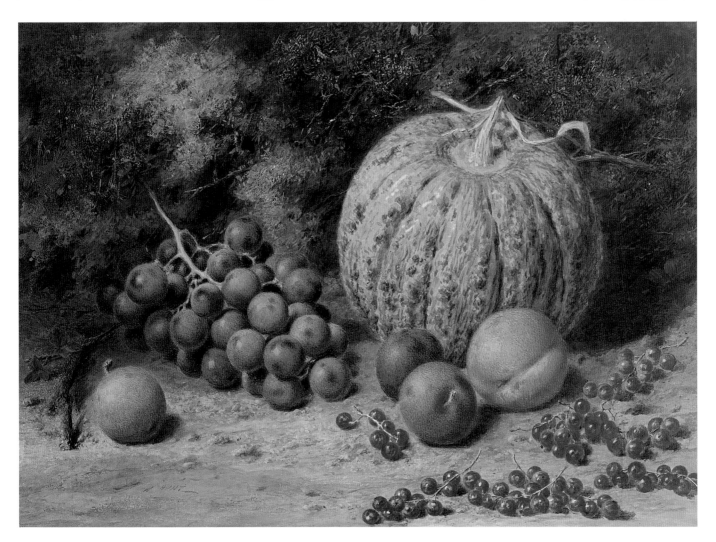

John Linnell 1792–1882

Study of trees
Graphite and watercolour, with white high-
lights on buff paper 439×287mm
Bought, 1957 PD.4–1957

Between 1817 and 1820, Linnell made
several visits to the estate of Tythorp, near
Thame in Oxfordshire. Notionally em-
ployed to paint the portraits of Philip
Thomas Wykeham and his family, and to
clean and repair Wykeham's collection of
paintings, he also found time to make a
series of drawings of the trees and land-
scape on the estate.

The study of the character of trees was
an important and recurrent concern of
British artists as diverse as Alexander
Cozens, J. D. Harding and John Ruskin.
Linnell had already made a number of
studies in Windsor Forest in 1815; like the
present drawing, these were executed for
the most part on toned paper, and with a
spareness of design which finds its visual
and spiritual counterpart in the studies of
German Romantic painters such as Caspar
David Friedrich (1774–1840) and Auguste
Heinrich (1794–1822).

Sunset (opposite above)
Watercolour and graphite on paper
107×146mm
Signed and dated in ink, lower right of centre:
J Linnell 1812, verso: sketch in graphite for the
same subject, inscribed: *fine pearly grey / boys
playing at cricket in the foreground / distant view
of Highgate Hill / clearer purple*
Bequeathed by J. E. Bullard, 1961 PD.226–1961

As a student of John Varley, Linnell could
not but have been aware of the power of
'effect' in landscape painting. From 1805 to
1809, he was encouraged to paint out of

doors with his fellow students William Mulready and William Henry Hunt, a practice he appears to have continued throughout much of the early part of his career. On the whole, these studies are no more than sketchy notations in water-colour, drawn on the pages of a small notebook; however Linnell's keen powers of observation and resonant use of colour give them an emotional intensity out of all proportion with their scale and infor-mality. As Katherine Crouan has sug-gested, Linnell's pursuit of visual accuracy may have had moral overtones, directly arising from his 'Damascus-like' conver-sion to Baptism in 1811 (1982, p.VIII). Certainly it made him receptive to the 'deeper properties' of nature which his future son-in-law Samuel Palmer and his associates sought at Shoreham at the end of the following decade (see p.136).

Snowdon, North Wales
Watercolour over graphite, with white high-lights on grey paper 290 × 484 mm
Signed, dated and inscribed in brown ink, lower right: *J Linnell 1813 – N. Wales, Snowdon in Distance*
Accepted in lieu of capital taxes and allocated by the Minister of the Arts from the Estate of the late Sir Geoffrey Keynes, 1985 PD.193-1985

Linnell's visit to Wales with the engraver George Lewis (1782–1871) in 1813 was the first, and perhaps the most important of his sketching tours. His route had been well trodden by artists and Picturesque tourists for almost half a century, but, rather than being dulled by familiarity, Linnell appears to have been inspired to find a means of

representation which more truly conveyed the countryside's natural grandeur: 'The Varley school of Welsh landscape I found to be conventional … so thoroughly did some of the valleys near Snowdon carry me away from all former associations with modern art' (Crouan, 1982, p.13).

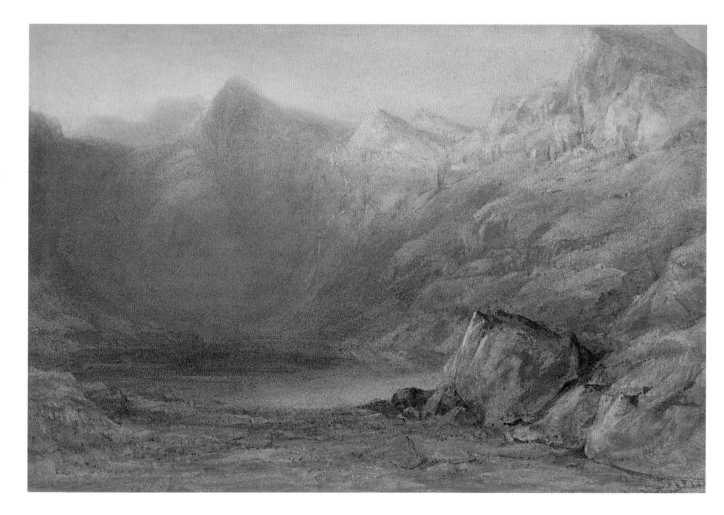

Samuel Jackson 1794–1869

Llyn Idwal, Snowdonia
Watercolour and bodycolour and scratching out
on paper 208 × 311 mm
Inscribed in graphite, verso: *586 / To be sent to /
No 5 Henry St. / D /Upper Lake Llanberis / North
Wales*
Bought, 1986 PD.37–1986

Jackson was among the most gifted pain-
ters working in Bristol at the beginning of
the nineteenth century. From 1826 he
worked principally as a drawing master,
but he also travelled widely throughout
Great Britain, to the West Indies (1829),

and later to Switzerland (1853 and 1858).
He exhibited his first Welsh views in 1829,
probably as a result of a tour of the country
the previous year, but his most important
journey to Wales was in the summer of
1833, on which he was accompanied by
William James Müller and John Skinner
Prout (1806–76).

This view of Llyn Idwal may have been
based on sketches made during this tour,
although, in all but the haunting exclusion
of figures or mountain goats, its composi-
tion closely resembles a similar view by
David Cox, engraved by W. Radclyffe in

Thomas Roscoe's *Wanderings through North
Wales*, 1836, pl.xxiii. Roscoe was particu-
larly struck by the 'bleak and stormy
character' of this remote area, which at the
time was little visited by tourists to Wales:
'Restless as the sea, and fiercely swept with
autumnal blasts, as I passed the lone and
savage spot, its aspect fell chill upon the
spirits, and I felt how truly this popular
feeling, which seldom errs, had given to
this gloomy region the marked appella-
tions of the "Cold Mountain Waste" and
the "Shepherd's Hill of Storms"' (op. cit.,
p.159).

James Duffield Harding 1797–1863

Bernkastel on the Moselle
Black chalk, watercolour and bodycolour on
buff paper 380 × 271 mm

Signed in black chalk with monogram, lower
right, and dated: *Aug^t 1837*; inscribed in black
chalk, lower right: *Berncastel on the Moselle*
Given by the Friends of the Fitzwilliam
Museum, 1912 no.743

Harding exhibited at the Royal Academy
from the age of fourteen, but his residing
fame is as a drawing master and skilled
lithographer. Between 1832 and 1852 he
published several drawing manuals, the
most important of which, *The Principles
and Practice of Art* and *Elementary Art*
appeared in 1845. His teaching was firmly
based on outline drawing in chalk or
graphite pencil and monochrome wash, as
he considered the technique of watercolour
too complex and unforgiving for the
beginner. In the third edition of *Elementary
Art*, deliberately extended to take account
of the growing popularity of chalk as a
medium, Harding recommended the use
of a coloured or tinted paper, particularly a
warm grey, 'to get over the difficulty of
obtaining local colour' without the use of
colour washes (1846, p.94).

Like his own teacher, Samuel Prout,
Harding made regular trips to the Con-
tinent, and contributed views of foreign
cities to a number of the popular landscape
annuals, and to lithographic publications of
his own. This drawing was made during
his second visit to the Rhine and the
Moselle in 1837.

Another view of Bernkastel, similar in
style to this drawing, but horizontal in
format, is in the Smith Art Gallery and
Museum, Stirling (7888). A highly-finished
watercolour of the town, viewed from the
banks of the Moselle, is in the Wallace
Collection, London (P.658).

James Holland 1799–1870

Spray of tulips, everlasting sweet pea, wild rose and hibiscus
Watercolour and bodycolour on pasteboard
304 × 222 mm

Signed and dated in ink, lower right: *J. Holland 1820*
Bequeathed by the Rt Hon. Henry Broughton, 2nd Lord Fairhaven; received 1973
PD.676–1973

Holland was born in Burslem, Staffordshire. Around 1811 he served a form of apprenticeship as a flower painter on pottery at James Davenport's Longport factory, and, after he came to London in 1819, he worked in potteries at Deptford and possibly also at Southwark. This highly finished watercolour was painted shortly after his arrival, at which time he was described in documents as an 'enamel painter'. Like many flower painters, Holland favoured the smooth surface of the pasteboard (often referred to as 'London' board) support, which allowed him to render with precision the individual characteristics of blooms and foliage.

Study of a hollyhock (opposite)
Graphite and watercolour with gum arabic on pasteboard 385 × 295 mm
Inscribed in graphite, verso: *J. Holland*, and with various, mostly illegible, notes relating to slight graphite sketches of flowers and leaves
Bequeathed by the Rt Hon. Henry Broughton, 2nd Lord Fairhaven; received 1973
PD.663–1973

Holland began to exhibit at the Royal Academy in 1824, and until 1833 flower pieces and nature studies dominated his submissions. After that date, however, he increasingly turned to landscape painting, sending views based on his continental travels to the Royal Academy and, from 1835, to the Old Water-Colour Society.

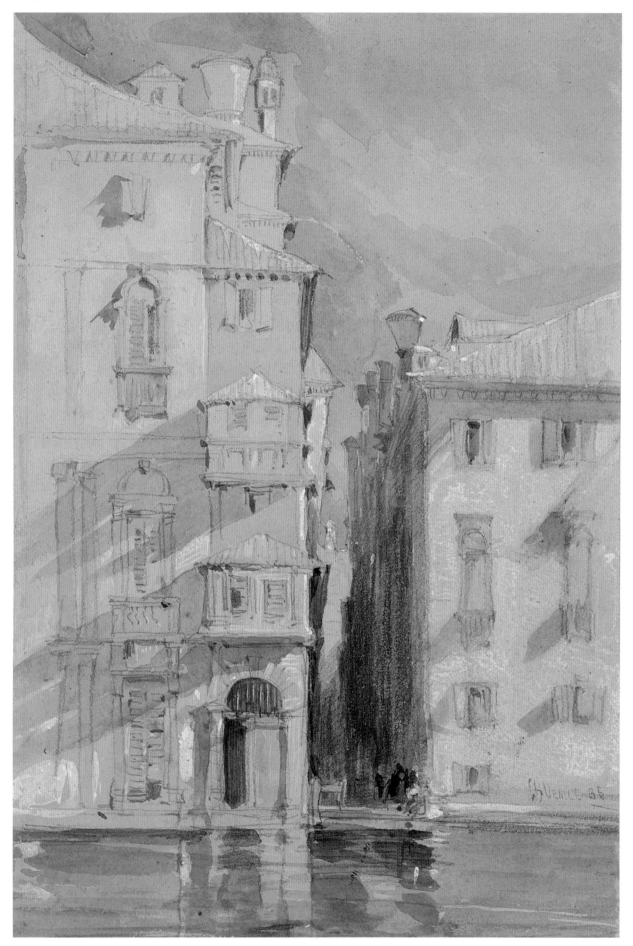

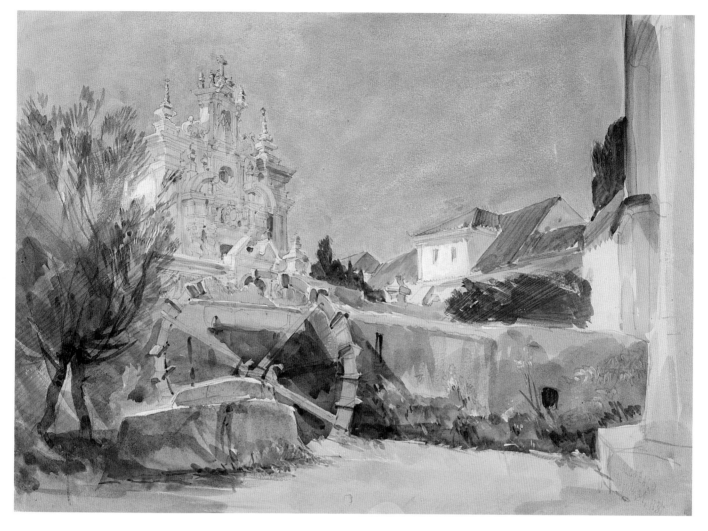

A side canal, Venice (opposite)
Graphite, watercolour and bodycolour on buff
paper 275 × 185 mm
Signed and dated in brown ink, lower right:
JH VENICE 35
Given by T. W. Bacon, 1950 PD.91–1950

Venice was 'rediscovered' by British
painters such as Richard Parkes Bonington
and Samuel Prout in the mid 1820s, and
from his first visit in 1835, Holland was
captivated by the city. He made at least
three further visits between 1845 and 1857,
and exhibited views in oil and water-
colours of its palaces and canals almost
annually until his death in 1870. After
about 1845, his work became increasingly
elaborate, and loses the fluency of handling
evident in his earlier watercolours.

This rapidly-executed sketch serves to
characterize Holland's particular vision of
the city; while Turner's Venice is subsumed
by atmospheric phenomena (see pp.82,83),
Holland probed the very fabric of the city,
drawing on its picturesque delapidation
and play of light on its crumbling façades.

The Cistercian Monastery, Alcobaça, Portugal
Graphite, watercolour and bodycolour on paper
253 × 360 mm
Signed, inscribed and dated in graphite, lower
right: *ALCOBAÇO / J.H. July 31, 1837*
Given by T. W. Bacon, 1950 PD.92–1950

Holland was sent to Portugal in 1837 by
Robert Jennings, the proprietor of the
Landscape Annual, in order to make a series
of watercolour views of the country and its
monuments, eighteen of which were
engraved for the 1839 edition entitled *The
Tourist in Portugal*, with text by W. H.
Harrison. The watercolours to result from
this trip – the majority of which are now in
the Victoria and Albert Museum – are
among the happiest and most assured of
his career.

The Cistercian Abbey of Alcobaça
(Mosteiro de Santa Maria) was founded by
Afonso Henriques after the capture of
Santarém, and built between 1148 and
1222. It was sacked by the French in 1800,
and secularized in 1834, before Holland's
visit. While still functioning as a religious

building, it was famous for having mass
celebrated night and day without intermis-
sion by nine hundred monks. William
Beckford, who stayed in the monastery
during a visit with the Prince Regent of
Portugal in 1835, considered the building
picturesque, but oppressive, and the
interior gloomy, austere and 'hideously
unharmonious' (*Recollections*, 1835, p.45).
That Holland travelled with Beckford as
his guide is evident from an inscription
referring to the latter's book on a drawing
of the monastery at Batalha (Thomas
Agnew and Sons, *English Watercolours and
Drawings*, exh. cat., 1978 no.212).

Perhaps surprisingly, given the historical
and architectural importance of the
monastery, Holland's watercolour was not
selected for reproduction in the *Annual* of
1839 – in fact the building is not even
mentioned in the text. However, as the
preface explained, the aim of the publica-
tion was to be informative, not definitive,
and to appeal principally to 'lovers of light
literature'.

Edward Duncan 1803–1882

On the shore, Portmadoc
Graphite and watercolour on paper, laid down
248 × 346 mm
Signed, dated and inscribed in graphite, lower
right: *on the shore / Portmadoc N. Wales / Oct
1865 / E Duncan*
Bequeathed by J. R. Holliday, 1927, received
1931 no.1558

Coastal scenes and marine subjects form
the mainstay of Duncan's work. Born in
London, he was apprenticed to the aqua-
tint engraver Robert Havell, and ran a
successful business as an engraver of
sporting and marine subjects until 1844.
Encouraged to take up watercolour by
Havell's brother William, he joined the
New Society of Painters in Water-Colours
in 1832, but switched allegiance to the
OWCS in 1848, and continued to exhibit
there annually until his death in 1882.
Little is known of his life, but from the
large number of informal artistic gather-
ings which he joined during the 1830s and
1850s – including the 'Graphic Society', the
'Chalcographic Society' and the 'Artists'

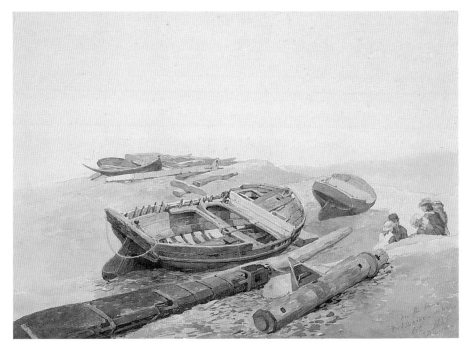

Society for General Study from the Life'
(from 1854 known as 'The Langham') – he
appears to have been a hugely gregarious,
and committed, individual.

The monogram with the initials 'E.D.'

indicate that this was one of the drawings
which was sold after his death at sales held
in 1883 and 1886. A view of *Port Madoc
Sands – Moonlight* was exhibited at the Old
Water-Colour Society in 1867 (143).

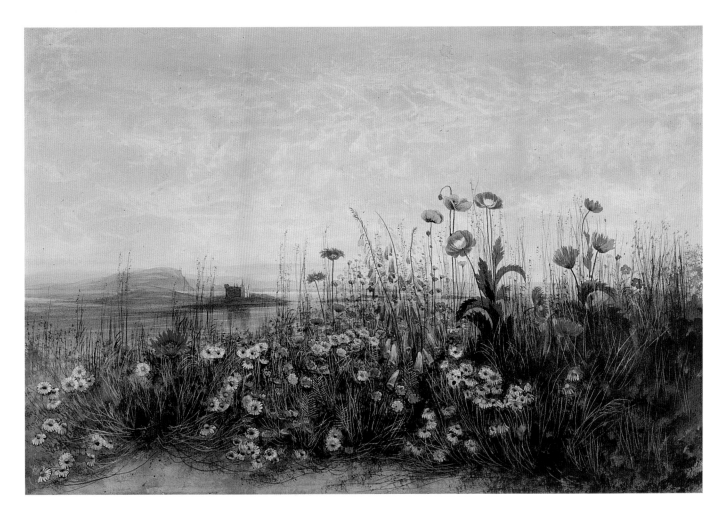

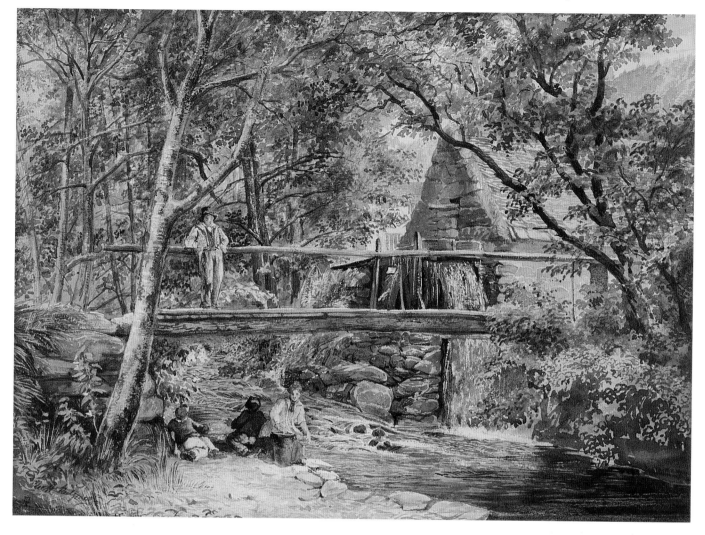

Andrew Nicholl 1804–1886

Summer wild flowers, Dunstaffnage Castle, Argyllshire (opposite below)
Watercolour with gum arabic, and scratching out on paper 355 × 526 mm
Inscribed in graphite, verso: *Summer Wild Flowers Dunstaffnage Castle Argyllshire*
Bequeathed by the Rt Hon. Henry Broughton, 2nd Lord Fairhaven, 1973 PD.835–1973

The son of a bootmaker, Nicholl was born in Belfast and worked initially in the letterpress department of the *Northern Whig*. In the 1830s he moved to London to continue his studies, and two years later returned to Dublin, from where he sent works to the Royal Hibernian Academy and the Royal Academy in London. Apart from a brief period as a drawing master in Ceylon in 1849, Nicholl divided the rest of his life between Dublin, Belfast and London. He was made a Royal Hibernian Academician in 1860.

Views of Ceylon and the Giant's Causeway dominate his exhibited work, but from about 1860 he also painted a number

of watercolours of banks of wild flowers with distant views over coastlines and ruins, of which this is a typical example.

The ruins of the thirteenth-century Dunstaffnage Castle lie to the northeast of Oban in Scotland.

Richard Redgrave 1804–1888

An overshot mill
Watercolour over graphite on paper, some scratching out 249 × 340 mm
Signed in brown ink, lower left: *Rich^d Redgrave*
Bought, 1989 PD.247–1989

Born in Pimlico, Redgrave had a long and distinguished career as a painter, design theorist, and art administrator.

Although art historians have until recently focussed almost exclusively on his paintings of impoverished, morally-compromised (and always pretty) working-class women – what one contemporary critic referred to as his 'love for lollipops with a vengeance' (*Frazer's Magazine*, June 1845, p.716) – Redgrave painted landscapes

throughout his career, and from the mid 1840s was particularly noted for his work in the genre. He made sketching tours to various parts of Great Britain, often in the company of his friends James Clarke Hook (1819–1907) and Charles West Cope (1811–90), whom he accompanied to the Tees and Greta in 1839. In the last decades of his life, as his administrative duties became increasingly onerous, he was limited to painting only during summer excursions to Abinger.

For Redgrave, the studies made on these trips were but the raw material of the landscape painter, to be made 'subordinate and subservient to those feelings and passions which stir the mind of the artist in connection with a particular effect in nature' (Casteras, 1988, p.71). 'A brook, well-shaded with boughs' was one of his favourite subjects; the date of this watercolour is uncertain, but it was probably painted after 1850, around which time Redgrave began to introduce figures to his delicately painted leafy recesses (ibid., p.75).

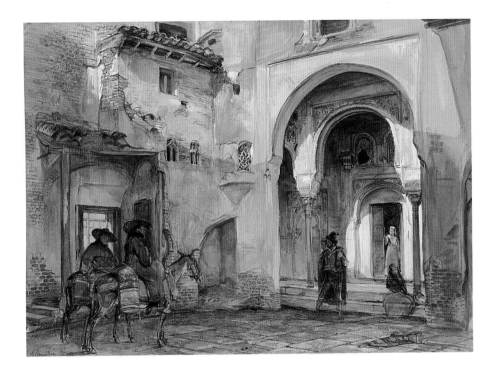

John Frederick Lewis 1805–1876

Courtyard of the Alhambra
Watercolour and bodycolour over traces of
black chalk with white highlights on paper, laid
down on card 259 × 358 mm
Inscribed and dated in watercolour, lower left:
Alhambra Oct 24 (?)
Bought, 1963 PD.4–1963

Lewis travelled in Spain from 1832 to 1834.
He visited the Alhambra twice, from
September to November 1832 and again in
1833, when he stayed with his patron
Richard Ford and his wife in the Casa
Sanchez, now known as the Torre de las
Damas in the Alhambra.

The sketches which he made on this
tour were later used as the basis for
finished watercolours, and for a volume of
twenty-five lithographs, *Lewis's Sketches
and Drawings of the Alhambra*, published in
1835 with a dedication to the Duke of
Wellington; a second volume of Spanish
subjects, *Lewis's Sketches of Spain and
Spanish Character*, appeared the following
year. This view was not published.

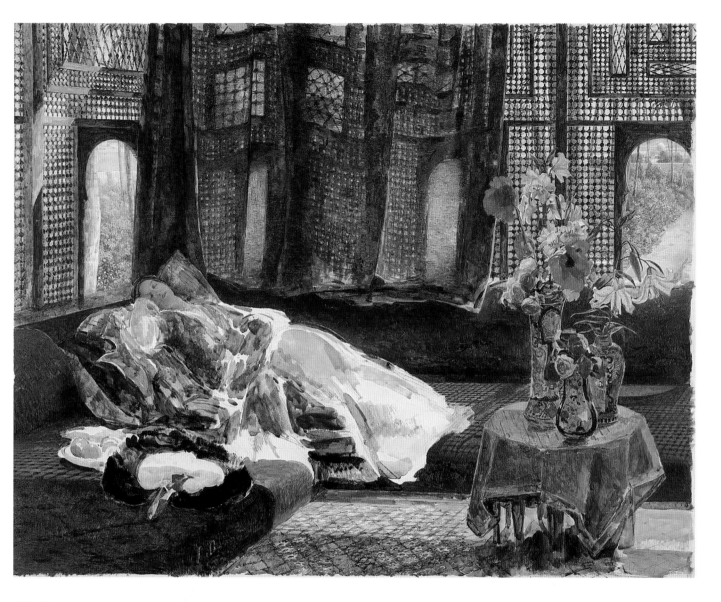

The Siesta
Watercolour and bodycolour with gum arabic
and white highlights, over traces of graphite on
paper. Squared up in graphite. 465 × 591 mm
(painted area)
Bequeathed by Charles Haslewood Shannon,
1937 no.2111

When William Thackeray visited Lewis in
Cairo in 1844, he found him living in a
grand Mamluk house, 'going about with a
great beard and a crooked sword, dressed
like an odious Turk' (1846, p.290). Having
travelled through Italy, Greece and the
Levant from 1837 to 1841, Lewis arrived in
Cairo, where he spent ten years living 'like
a languid Lotus-eater – a dreamy, hazy,

lazy, tobaccofied life' (ibid., p.290). On his
return to London, his highly-wrought
watercolours of Eastern life, were raptu-
rously received when exhibited at the Old
Water-Colour Society, not least by John
Ruskin, who ranked him as Carpaccio's
equal in exquisite rendition of detail, and,
'the painter of the greatest power, next to
Turner, in the English school' (*Works*,
xxxv, 403). This watercolour appears to be
a study for an oil painting of the same title
in the Tate Gallery, dated 1876. Lewis gave
up exhibiting watercolours on resigning
his Presidency of the OWCS in 1858,
having come to realize that he could earn
twice as much with no more effort as an oil

painter. While this has led some commen-
tators to suggest that this watercolour was
painted in the late 1850s, a gestation period
of nearly twenty years between study and
finished painting is unlikely, and it seems
more reasonable to assume that he con-
tinued to use the medium informally, for
preparatory work.

Lewis's model is something of an artistic
confection, combining eastern dress with a
European physiognomy. Like most nine-
teenth-century Orientalist painters, he was
attracted by the erotic and pictorial poten-
tial of the harem, but would have found
entry impossible.

Samuel Palmer 1805–1881

Dark trees by a pool (right)
Pen and sepia ink, sepia wash on card, laid
down 105×67 mm
Given by Mr and Mrs Paul Mellon in memory
of Martin Hardie, 1961; received 1962
PD.7–1962
Lister 71

Between 1826 and 1832, Palmer painted a
number of small-scale landscapes in brown
ink wash in which he explored the ro-
mantic depths of chiaroscuro. Lister dates
this drawing *c*.1827, and has suggested the
influence of Claude Lorrain's drawings,
although the miniaturist qualities of the
landscape also reflects Palmer's knowledge
of German landscape paintings and prints
of the sixteenth and seventeenth centuries.
It could be too, that he was seeking to
recapture something of the 'mystic and
dreamy glimmer' he so admired in Blake's

wood engravings for Thornton's *Virgil*
(Palmer, 1892, p.15).

Martin Hardie, in whose memory this
drawing was given, was one of the most
prominent figures in the revival of
Palmer's reputation in the first decades of
this century.

Sepham barn (below left)
Pen and brown ink and brown wash on paper
laid down on a wash mount Watermark: 1829
203×276 mm
Lent by Mr and Mrs G. A. Goyder
Lister 108

Between 1828 and 1829, Palmer made a
number of studies of farm buildings and
barns around Shoreham. This drawing
was once in the collection of John Linnell
(Palmer's future father-in-law), and may
have been executed in response to Linnell's
advice that, by making studies of the
Shoreham scenery, Palmer could 'get a
thousand a year directly'. That Palmer
considered this as tantamount to a betrayal
of his artistic integrity is evident from his
comments in a letter of 1828 to George
Richmond: 'By God's help I will not sell
away this gift of art for money; no, not for
fame neither, which is far better … Tho' I
am making studies for Mr Linnell, I will,
God help me, never be a naturalist by
profession' (Lister, *Letters*, I, p.36).

The identification of this building as
Sepham (pronounced 'Seppam') barn has
been doubted by Lister.

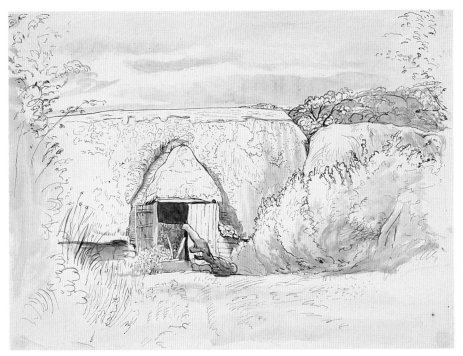

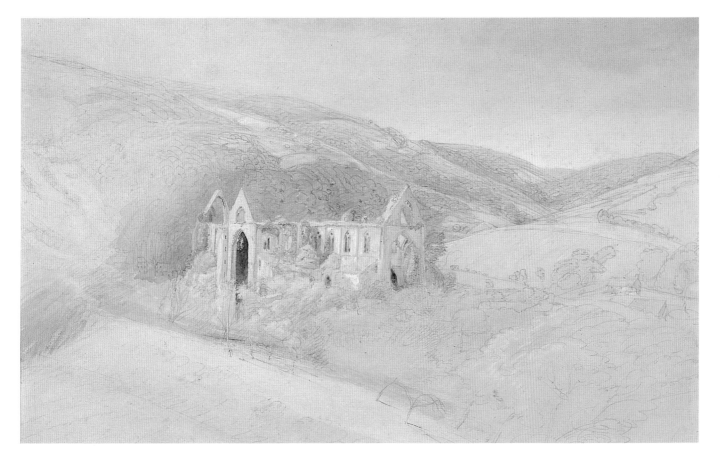

Tintern Abbey near the Chepstow Road,
looking towards Monmouth
Graphite and watercolour, heightened with
bodycolour on paper 297 × 458 mm
Lent by Mr and Mrs G. A. Goyder
Lister 235

Founded in 1131, the Cistercian abbey at
Tintern was famously described by Wil-
liam Gilpin in his *Observations on the River*
Wye (1781) as being in need of a 'judi-
ciously used' mallet to improve its unpic-
turesque regularity. For the best part of
half a century it was one of the picturesque
artist's favourite sketching-grounds, and,
although its charms had begun to pall with
many critics in the 1820s, Palmer appears
to have been quite overcome by the 'poetic
vapours' of the place, when he visited the
abbey during a tour to the West Country,
Monmouthshire and North Wales in 1835.
In a letter to George Richmond, from 'very
deep Twilight' at Tintern, he urged his
friend to visit this most Ossianic of loca-
tions, only a cheap coach ride away from
Bristol: 'such an Abbey! the lightest Gothic
– trellised with ivy and rising from a
wilderness of orchards – and set like a gem
amongst the folding of woody hills' (Lister,
Letters, 1, p.71).

Other views of Tintern Abbey nestling
in the surrounding hills are in the Victoria
and Albert Museum and Yale Center for
British Art (Lister 233, 234).

The Magic Apple Tree
Pen and Indian ink, watercolour, in places
mixed with a gum-like medium, on paper
349 × 273 mm
Given by A. E. Anderson, in memory of his
brother Frank, 1928 no.1490
Lister 127

The Magic Apple Tree is among the most
intense and visionary works of Palmer's
Shoreham period. Palmer had visited
Shoreham in Kent on several occasions in
the first half of the 1820s, mostly for
reasons of health, but settled there in 1826,
having bought a cottage from a modest
legacy left to him by his grandfather.
During the next six years he produced
some of the most remarkable and original
visions of the British landscape painted in
the nineteenth century.

As early as 1824, Palmer had detected a
marked lack of profundity in the work of
contemporary landscape painters. David
Cox and George Barret (1767/8–1842)
were, he wrote, 'sweet' and poetic in their
way, but, 'Nature has properties which lie
still deeper, and when they are brought out
in the picture, must be more elaborate and
full of matter even if only one object is
represented' (Palmer, 1892, p.15). Accord-
ingly, in his work of the 1820s and early
1830s, Palmer sought to give visual expres-
sion to this spiritual dimension by means of
a style rich in surface texture and allusion,
culminating in what Lister has described
as the 'hallucinatory brilliance' of this
watercolour (1987, p.38).

The source of the title remains obscure.
It differs markedly in tone from the more
prosaic descriptions of other works of this
period, and was in all probability added by
Palmer's son, from whose sale it was
acquired in 1928. The various pictorial
elements – piping shepherd (or shep-
herdess; the sex is difficult to determine),
flock of sheep and heavily-laden apple
bough – are recurrent motifs in Palmer's
watercolours, particularly between 1826
and 1832. However, the apparition of the
church steeple at the pivot of the tightly
enclosed composition invites an interpreta-
tion which is religious or mystical rather
than magical.

That this watercolour held some special
meaning for Palmer is implicit from the
fact that it was kept by the artist in his
'Curiosity Portfolio', the contents of which
were shown to only a select few who
visited Furze Hill, his neo-Gothic house in
Mead Vale, Redhill, whence he moved in
1862. A. H. Palmer suggested that, though
based on direct observation, the scene also
combines classical references to Ceres and
Pomona, with an evocation of the conclud-
ing verses of the sixty-fifth psalm: 'The
pastures are clothed with flocks; the valleys
also are covered with corn; they shout for
joy, they also sing.'

Lister has drawn attention to similarities
with the technique used by Blake in his
Songs of Innocence, a copy of which Palmer
had tried to acquire in 1827 (Lister, *Letters*,
1, pp.14–15).

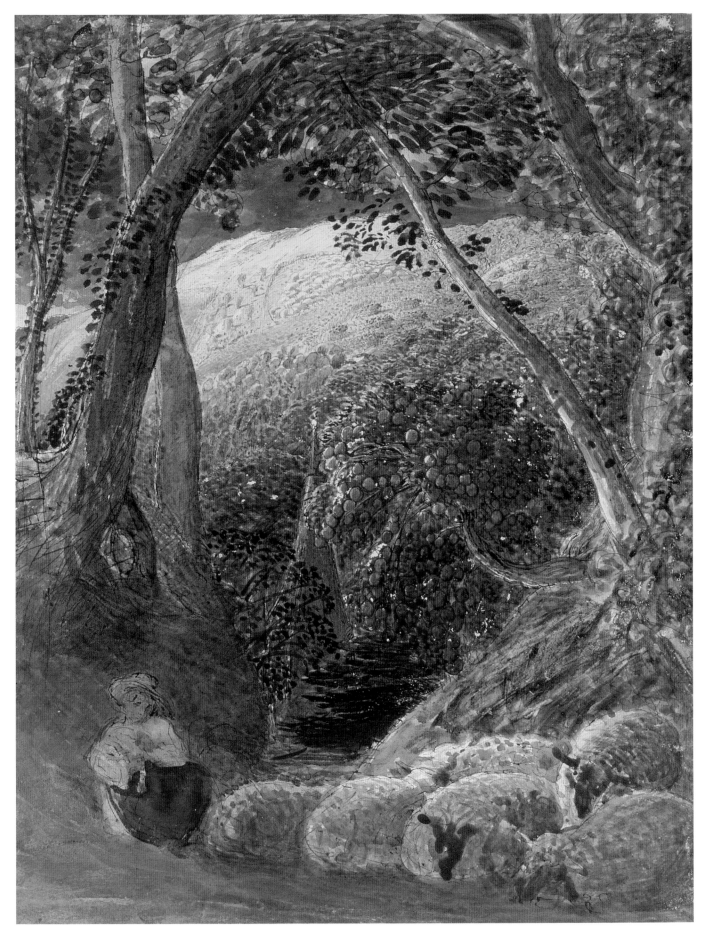

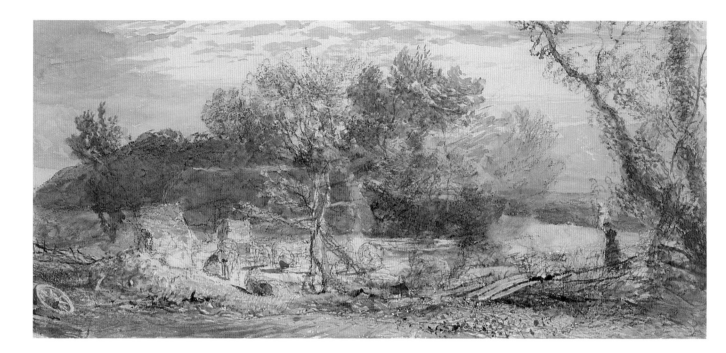

A farm in Kent
Brown and blue chalks, watercolour, body-
colour and gold paint on card 196 × 419 mm
Bought, 1971 PD.9–1971
Lister 359

Although Palmer's technique became less
dense in effect during the 1830s, it was no
less imaginative in its combination of
media. Writing to his pupil Louisa Twin-

ing in 1856, Palmer recommended a whole
range of pigments, supports and graphic
media – including tinted paper, crayons,
black and white chalk, sponge, water-
colour, HB pencil and a brush, 'sometimes
… wet, sometimes half-dry, sometimes in a
point, sometimes spread' – to be used by
the artist to achieve a variety of very

specific effects. Perhaps ironically, he was
also an advocate of simplicity: 'the right
process is always the most simple that can
be devised, *relatively to the end proposed*'
(Lister, *Letters*, II, p.520). The elongated
landscape composition is in the 'Little
Long' format which Palmer favoured
throughout much of his career.

The Sleeping Shepherd (opposite)
Watercolour and bodycolour with gum over
graphite on paper, laid down 247 × 178 mm
Signed, lower left, with the point of the brush:
S.PALMER
Bequeathed by Miss E. M. Wilson, 1980
PD.34–1980
Lister 539

Palmer seems to have treated this theme
first in a brown wash drawing of 1831–2

now in the Whitworth Art Gallery (Lister
142). Two or three years later he painted a
version of the subject in tempera with oil
glazes (Lister 179), in which the pose of the
shepherd (ultimately derived from an
antique marble in the British Museum) is
identical to the figure in this watercolour.
This version relates most closely to an
etching of 1857 (Lister E6), which,
although considerably smaller in format,

adopts the same vertical composition and
details such as the vine arbour, and distant
ploughman and oxen.

It may be, as Lister has suggested, that
Palmer was trying to recapture something
of the visionary intensity of his Shoreham
years; certainly the warm colouring and
dream-like haziness evoke a nostalgic
arcadian pastoral, remote in time and
place.

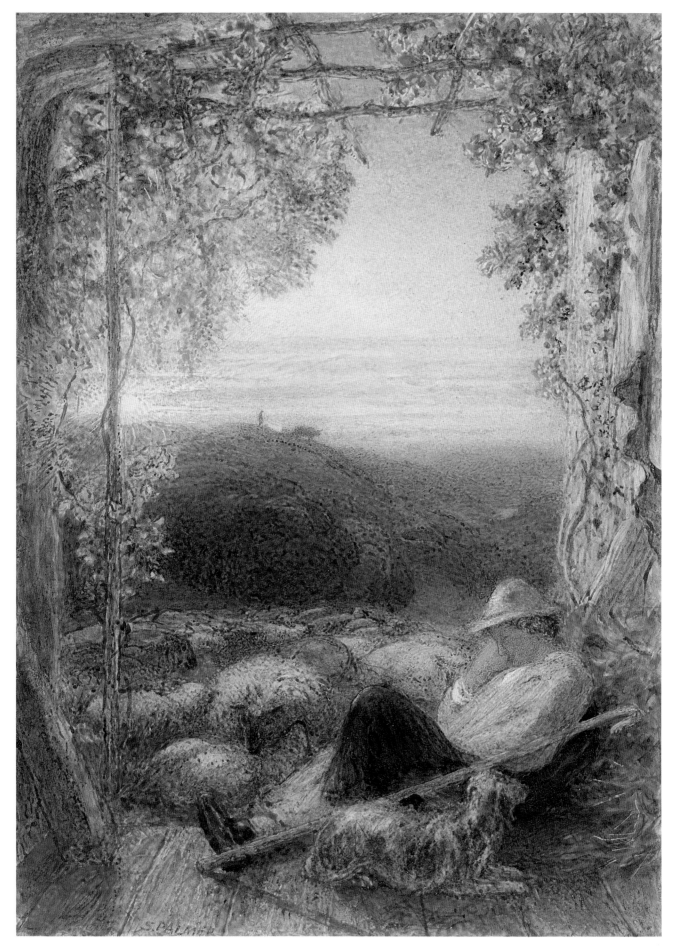

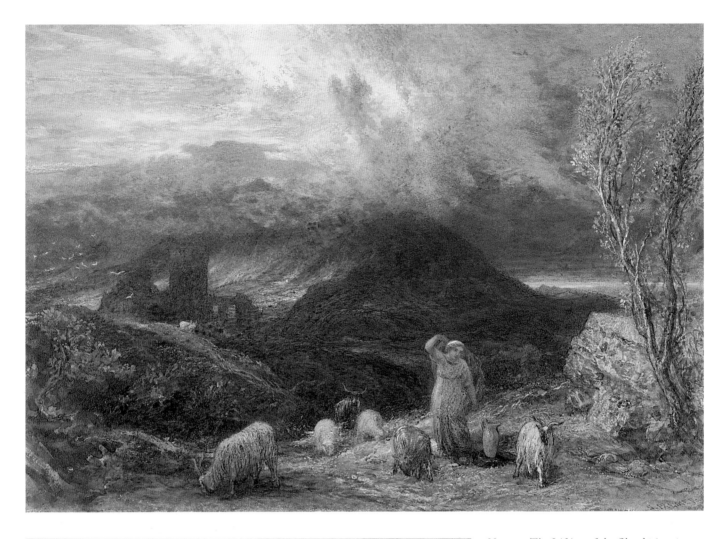

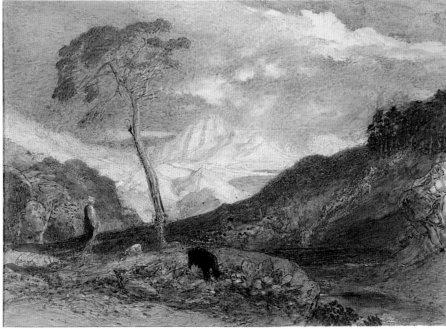

Hope or *The Lifting of the Cloud* (above)
Watercolour and bodycolour on paper
260 × 375 mm
Signed, lower right, with point of the brush:
S. PALMER.
Keynes Family Trust, on deposit at the Fitz-
william Museum
Lister 640

This watercolour was exhibited at the Old
Water-Colour Society in 1865 with the
quotation: 'The day at first was sombre,
like the shadowy turrets we were to
explore. Then there was a distant gleam;
the breeze began to stir, and the rain-cloud
slowly rising, disclosed the mountains.'

Palmer's pictorial subject matter was
frequently literary in inspiration. He drew
subjects from his reading of Virgil, Milton,
Shakespeare and the Bible, and often
appended or inscribed brief quotations on
his watercolours and etchings. At the same

time this was painted, Palmer was much occupied with a commission from Ruskin's solicitor Leonard Rowe Valpy for watercolour illustrations to Milton's *L'Allegro* and *Il Penseroso*, and with a series of etchings based on Virgil's *Eclogues*, published posthumously in *An English Version of the Eclogues of Virgil*, 1883 (see below).

The Goatherd (opposite below)
Watercolour and bodycolour over graphite on paper, squared up in graphite and laid down
204 × 287 mm
Lent by Mr and Mrs G. A. Goyder
Lister 684

This is one of the last watercolours Palmer painted. The predominantly Claudian mood, and the fact that it is squared up for transfer, links this pastoral with a group of drawings which Palmer intended to reproduce as etchings for an illustrated verse translation of Virgil's *Eclogues*. In many cases Palmer made more than one design before arriving at the final version, and it could be that this composition was rejected in favour of one which Palmer considered more successful or relevant.

Virgil's poetry had been an important influence on Palmer's work from the early 1820s. Before he met William Blake in 1824, he had been deeply impressed by his wood engravings for Dr Robert Thornton's *The Pastorals of Virgil ...* (1821), which he considered 'models of the exquisitest pitch of intense poetry' (Palmer, 1892, p.15). Although Palmer had not originally intended to illustrate his translation, he was persuaded to do so by the art critic P. G. Hamerton; in the event only one of the ten etchings for the publication was completed before his death in 1881.

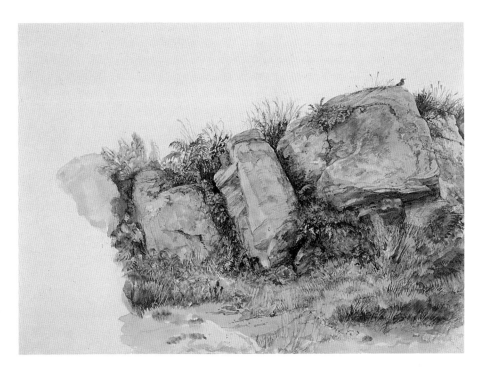

William Dyce 1806–1864

A landscape study of rocks and grasses
Graphite and watercolour on paper
224 × 312 mm
Inscribed in graphite, verso: *Dyce*
Bought, 1969 PD.40–1969

Dyce was not primarily a landscape painter, but the exquisitely painted backgrounds of many of his finest religious and subject paintings of the 1850s and 1860s show that he possessed considerable natural ability in the genre.

An Aberdonian by birth, Dyce studied in Italy, where he came into contact with the German Nazarene painters in 1827. After his return to Britain he worked as Superintendent of the School of Design from 1837 to 1843, and in 1844 was commissioned to execute frescoes in the House of Lords and at Buckingham Palace. He was a polymath of truly Victorian proportions, combining his artistic career with an active interest in science and music. Dyce began to paint watercolour landscapes of the Scottish countryside in the early 1830s, possibly as a diversion from the demands of portraiture commissions in Edinburgh. Apart from a group of watercolours executed during a tour of the Continent in 1832 (most of which are now lost), no further landscapes in oil or watercolour appear to have been painted until the late 1840s. From an inscription on the old mount, it appears that this watercolour was one of a group painted between August and October 1847, when Dyce was working on the decoration of Osborne House. Duncan Robinson has convincingly identified this watercolour with the 'Study of rock and fearns [*sic*], Isle of Wight' which was sold at Dyce's sale (Christie's 5 May 1865 lot 119) on the basis of similarities in style with a view of Osborne House sold in the previous lot, and now in the British Museum (1912–5–13–10) (1982, p.63).

George Richmond 1809–1896

Autumn, near Brasted Chart
Graphite and watercolour with white high-
lights on paper Watermark: J. WHATMAN / ..48
161 × 180 mm
Signed with initials and inscribed in graphite,
lower left: *Autumn near brasted Chart GR*
Accepted in lieu of taxes, and allocated by HM
Treasury, through the Minister of the Arts, to
the Fitzwilliam Museum, from the estate of the
late Sir Geoffrey Keynes, 1985 PD.202–1985

Brasted Chart lies on the River Darent in
Kent, one and a half miles northeast of
Westerham. Richmond painted landscape
sketches in watercolour throughout his
career, mostly as relaxation from his busy
life as a society portraitist. Although he
spent some time at nearby Shoreham in the
1820s, working with his friend Samuel
Palmer and fellow-'Ancients', the majority
of his work of this period is figurative, and
it seems more likely that this view was
painted at the beginning of the 1850s when
Richmond and his family spent holidays in
Sevenoaks (a supposition confirmed by the
date on the watermark). On one of these
visits, Richmond was joined by his friend
Charles West Cope, who recorded that
they 'sketched out of doors in the morning
and played bowls in the afternoon' (Cope,
1891, p.243).

Knole Park
Black chalk, watercolour and bodycolour on
blue paper, laid down on card 135 × 210 mm
Signed in graphite with initials, lower right:
G.R; inscribed and dated in graphite, lower left:
Knole Park 1853
Accepted in lieu of taxes, and allocated by HM
Treasury, through the Minister of the Arts, to
the Fitzwilliam Museum, from the estate of the
late Sir Geoffrey Keynes, 1985 PD.203–1985

The date inscribed on the drawing is
generally thought to have been added later.
A watercolour view of Knole Park in the
Ashmolean Museum is dated 1846.

Miles Edmund Cotman 1810–1858

Norwich from the east
Watercolour with scraping out on paper
190 × 265 mm
Signed in watercolour, lower right: *M E Cotman*
Inscribed in graphite verso: *Norwich Castle*
Given by the Friends of the Fitzwilliam
Museum, 1927 no.1188

Miles Edmund has been called the 'loyal
lieutenant' of his father John Sell Cotman
(Clifford, 1965, p.73). His career was
largely given over to the teaching which
his father despised, working first as the
latter's assistant, and from 1842 to 1852 as
Professor at King's College.

The influence of Cotman senior's style is
unmistakable in his work; on the whole it
lacks his conceptual boldness and clarity of
design. A lithograph after this watercolour
by Day and Haghe was published by William
Freeman in Norwich. As Norma Watt has
pointed out, the state of the castle buildings
suggests that it was painted between 1828
and 1834 (letter to the author, January 1994).

William James Müller 1812–1845

The Valley of the Xanthus
Watercolour with white highlights on paper
374 × 534 mm
Signed, inscribed and dated in watercolour,
lower left: *Valley looking from Xanthus to /
Pinara. W.M.A.M. 1843 – Nov'*.
Given by T. W. Bacon, 1950 PD.100–1950

Müller was especially proud of the 'one or
two hundred' drawings which he made
during a trip to Lycia in southwest Turkey
between 1842 and 1843.

Encouraged to travel there by the
archaeologist Charles Fellows, whom he
met in the spring of 1843, he left England
in September 1842 with his companion
Harry Johnson, and arrived at the mouth

of the Xanthus on 1 November, whence
they proceeded to walk inland for six or
seven miles to the ancient capital of Lycia.
This view looks over the broad river valley
towards Pinara, one of Lycia's most spec-
tacular cities, perched on a table-rock in
the distant mountain range.

According to Johnson, Müller's stamina
during the three months he worked in the
Xanthus valley was extraordinary: 'Neither
climate nor fatigue seemed to have any
effect on Müller, and at the day's close he
never failed to return with one or more of
those powerful watercolour sketches which
have since so powerfully excited the
imagination of the world of art ... I have
known him complete three finished

coloured half-imperial sketches between
breakfast and sundown' (Solly, 1875, p.197).

Müller published an account of his
travels in three long letters published in the
Art Union, in 1844, and exhibited a selec-
tion of his Lycian work to great acclaim at
the London Graphic Society in 1845. A
scheme to produce twenty-six lithographs
based on sketches made during this trip
and advertised in the *Art Union* in 1845
came to nothing, presumably because of
Müller's ill-health after his return from
Bristol to London, where he died the
following autumn.

For a full account of Müller's journey
see Greenacre and Stoddard, 1991,
pp.142–63.

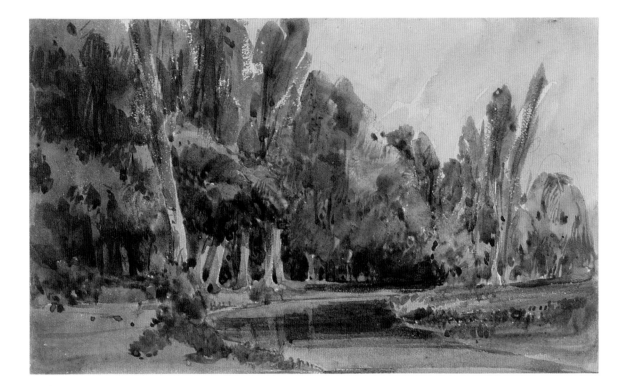

William Callow 1812–1908

In the park at Royaumont
Watercolour over graphite on paper, laid down
on card 146 × 242 mm
Given by Daphne Boulden in memory of her
husband, Dr Peter Boulden, 1993 PD.11–1993

After a brief apprenticeship with Thales
Fielding (1793–1837) in London, Callow
went to Paris in 1829, where he worked for
the successful art editor and publisher J.-F.
d'Ostervald (1773–1850). His initial stay
was brief, interrupted by the turbulent
political events of 1830, but he returned the
following year, and in 1834 began a profit-
able career as drawing master to, among
others, the Duc de Nemours and the
Princesse Clémentine d'Orléans. He was
regularly employed to provide water-
colours for engraving in the popular
landscape annuals, and exhibited exten-
sively both in France and in London,
where he was a stalwart of the Old
Water-Colour Society for over seventy
years.

In his *Autobiography*, Callow records an
excursion on foot in August 1833 to Royau-
mont, twenty miles from Paris in the com-
pany of the painter Baron 'Schweiter', who
from other evidence can be identified as
Ludwig Auguste Schwiter (1805–89), a
portrait of whom by Delacroix is in the
National Gallery, London. They spent
several days with the Vandermere family,
making water-colour studies of the old abbey
and also many of 'the beautiful park with
an ornamental piece of water' (1908, p.23).

Other drawings of Royaumont are in
Eton College, the Victoria and Albert
Museum, and in the Huntington Art
Gallery, San Marino, California (Reynolds,
1980, pp. 167, 204).

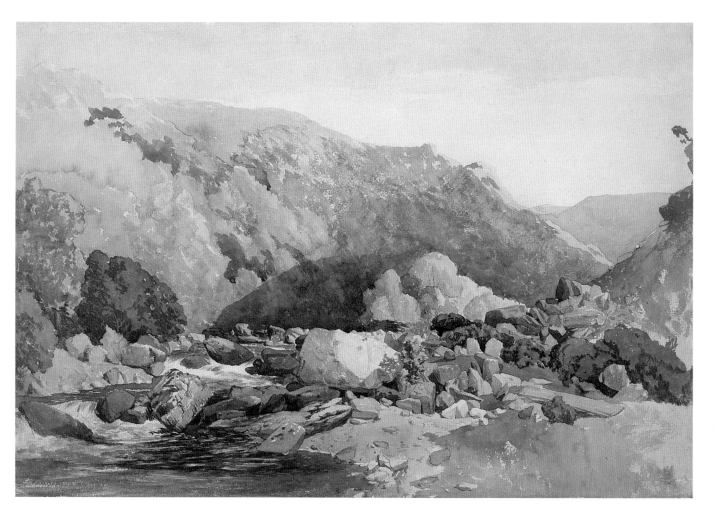

Attributed to **David Hall McKewan**
1817–1873

An Upland Stream
Watercolour over traces of graphite on paper
363 × 538 mm
Given by the Friends of the Fitzwilliam
Museum, 1929 no.1115

Acquired as by W. J. Müller, whose style it closely resembles, this watercolour is characteristic of the boldly painted landscape sketches of McKewan, one of the

most distinguished followers of David Cox. Born in London, McKewan was one of a number of painters working in Cox's circle at Betws-y-Coed during the late 1840s, and may even have been taught by him. In 1848 he joined the New Society of Painters in Water-Colours (as a result of whose formation in 1831 the original society became 'Old'), and was especially known for his paintings of rocky landscapes in Wales.

Like Cox and Müller he felt that 'the

simplest mediums were the best' (Greenacre and Stoddard, 1991, p.11), and preferred transparent watercolours for his work. He was, however, less resistant to new pigments than either of his stylistic progenitors, recommending moist colours in tubes, available from the mid 1840s, as ideal for the 'bold and vigorous touch, so essentially necessary in painting from nature' (*Lessons on Trees in Water Colours*, 1859 unpaginated).

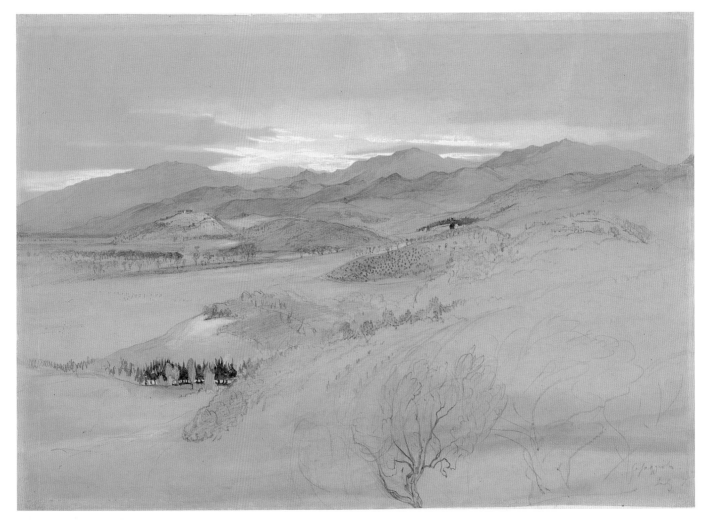

John Ruskin 1819–1900

Caffagiuolo
Graphite and watercolour with white high-
lights on paper 336 × 475 mm
Signed in graphite (partially obliterated), lower
left: */R/uskin*; inscribed and dated in graphite,
lower right: *Caffagiolo / July 7*
Bought, 1968 PD.22–1968

Caffagiuolo lies to the north of Florence
along the road to Bologna at the head of
the Mugello valley.

Ruskin travelled to Italy in 1845 partly
to continue work on the sequel to the first
volume of *Modern Painters*, published in
1843. He left England in April 1845 with
his servant John ('George') Hobbs, and
visited Lucca, Pisa, Pistoia and Florence
before travelling north, where, in the late
summer, he met his former drawing
master, J. D. Harding, at Lago Maggiore.
This was not Ruskin's first trip to Italy (he
made other visits with his parents in 1833,
1835, and 1840), but its effect on his
drawing style was profound. He became
acutely aware of the perilous state of

conservation of Italy's architectural splen-
dours, and, as a result, made numerous
drawings of buildings and monuments
whose focused precision reflect his de-
termination to record their appearance in
the face of imminent deterioration.
Relatively few landscape watercolours
were painted during this trip. As Ruskin
later recognized, his style even in these had
evolved dramatically from the picturesque
manner of his master: 'His sketches are
always pretty because he balances them
together, and considers them as pictures;
mine are always ugly, for I consider my
sketch only as a written note of certain
facts, and those I put down in the rudest
and clearest way as many as possible.
Harding's are all for impression; mine all
for information' (*Works*, III, 201).

In the Pass of Killiecrankie (opposite)
Watercolour and bodycolour on board
287 × 247 mm
Inscribed and dated with the brush in ink on

the verso of the old backboard: *In the Pass of
Killiecrankie / J.R. 1857*
Given by the Friends of the Fitzwilliam
Museum, 1931 no.1589

This extraordinarily intense landscape was
painted at Killiecrankie in Perthshire
during the late summer of 1857. Ruskin
wrote and lectured extensively on geo-
logical subjects – not always very lucidly –
from the 1830s, and as a draughtsman his
interest was stimulated by visits to the
Swiss Alps during the 1840s, and to
Scotland, which he later described as 'one
magnificent mineralogical specimen'
(*Works*, XXVI, 373). The correct observation
of rock formations and their covering
vegetation was in his view essential to
conveying the true character of a locality;
in this case the minutely observed 'honeyed
heathers ... [and] ... scented fern' identify
the scene as the Scottish highlands (*Works*,
IV, 349), the vignette-like distant landscape
acting as a summarized frontispiece to a
visual text more fully elucidated in the
foreground.

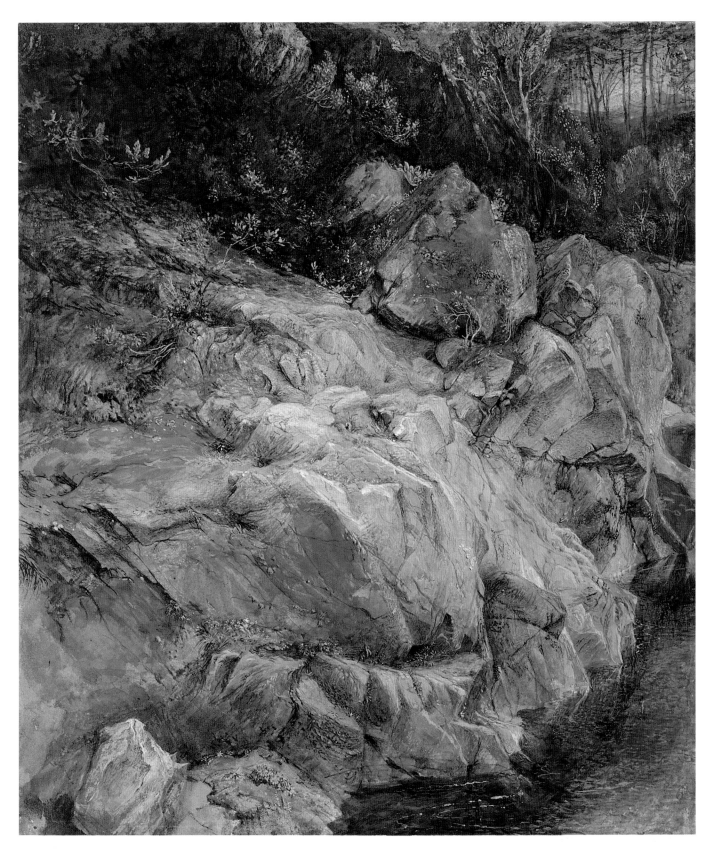

In his *Elements of Drawing*, published in the year this was painted, Ruskin defended the use of bodycolour for landscape painting, describing it as 'infinitely liker Nature than transparent colour', and especially suitable for painting rocks, buildings, solid surfaces, and 'the bloom and mist of distance' (*Works*, xv, 139).

As Christopher Newall has recently pointed out, Ruskin appears to have been particularly proud of this work. It was exhibited twice during his lifetime, in 1881 and 1882, and on at least three occasions in the decade immediately following his death (Wilcox and Newall 1993, p.95).

Study of part of a tree trunk with ivy and another trailing plant
Watercolour and bodycolour on card
308 × 264 mm

Signed, inscribed and dated in ink, lower left:
Kathleen. H. Gordon / with love from her playmate / John Ruskin 29 July 1876
Bequeathed by the Rt Hon. Henry Broughton, 2nd Lord Fairhaven, 1973 PD.922–1973

Ruskin's pursuit of perfection in his own watercolours was paralleled by a strong desire to encourage others in the art. Between 1855 and 1858 he taught a class in landscape painting and drawing at the Working Men's College, and around the same time offered advice to artists whom he considered to show particular promise, such as J. W. Inchbold (1830–88) and John Brett (1831–1902). Although his written instructions are scattered throughout his writings and letters to his pupils, he published only two drawing manuals proper: *The Elements of Drawing* (1857), followed in 1859 by *The Elements of Perspective*. Both differ profoundly from other manuals of the period, in their insistence on the student's ability to master individual details in nature before attempting to progress to formal compositions. This drawing appears to have been executed in exact conformity with his recommendation in *Elements*, that, 'In woods, one or two trunks, with the flowery ground below, are at once the richest and easiest kind of study: a not very thick tree trunk, say nine inches or a foot in diameter, with ivy running up it sparingly, is an easy, and always rewarding subject' (*Works*, xv, 109).

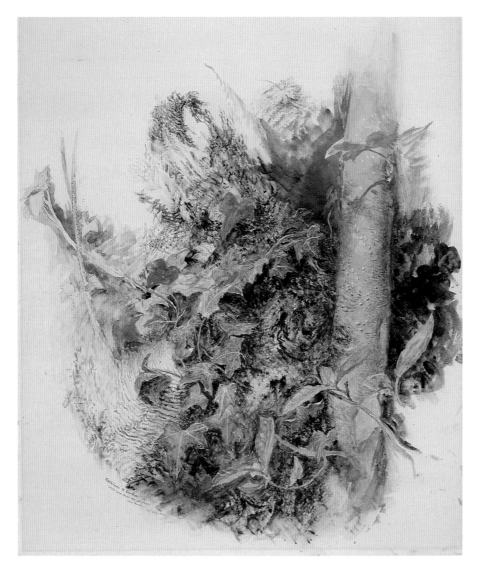

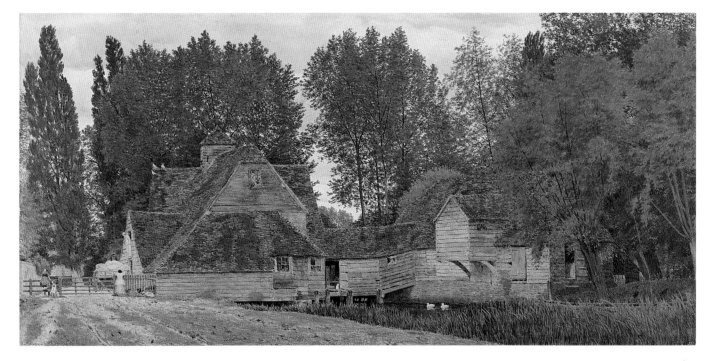

George Price Boyce 1826–1897

The Mill on the Thames at Mapledurham, Oxfordshire, 1860
Watercolour and bodycolour on paper
273 × 568 mm
Signed and dated in watercolour, lower left:
G.P. Boyce. JULY 1860; inscribed in graphite,
verso: *Mill at Mapledurham, Oxfordshire / Boyce
– July 1860 – forenoon*
Bought, 1971 PD.52–1971

Boyce trained as an architect, but decided to devote himself to landscape painting around 1849, after meeting David Cox at Betws-y-Coed. Shortly afterwards he came into contact with Dante Gabriel Rossetti (1828–82), and from the mid 1850s the influence of the detailed naturalism of Pre-Raphaelite landscape painting is prevalent in his work. From the mid 1860s, under the influence of Whistler (1834–1903), with whom he shared an interest in painting nocturnal scenes, his work became looser in handling, and more atmospheric in effect.

Painted in 1860, on one of the artist's many summer excursions in the Thames valley, this watercolour shows Boyce at the height of his powers. As in many of his landscapes of the period, textures of building materials and vegetation – moss-covered roof tiles, red brick, and wea-thered wood – are rendered with the detailed scrutiny of a still life, obscuring at first glance the bustling activity of humans, animals and birds. Tiny, strategically-placed figures introduce accents of strong colour, and draw the viewer into the scene; as if to emphasize the harmony between the landscape and its inhabitants they are blended with the background almost to the point of ambiguity. The presence of a cat – in this case seated in an open doorway, but just as often found prowling along brick walls – is something of a hallmark of Boyce's Pre-Raphaelite style.

Boyce's studies of overgrown vernacular architecture were much admired by the conservation-conscious among his con-temporaries, not only for their meticulous execution, but as records of a countryside and architecture fast disappearing with the industrialization of Britain (see Newall and Egerton, 1987, p.24).

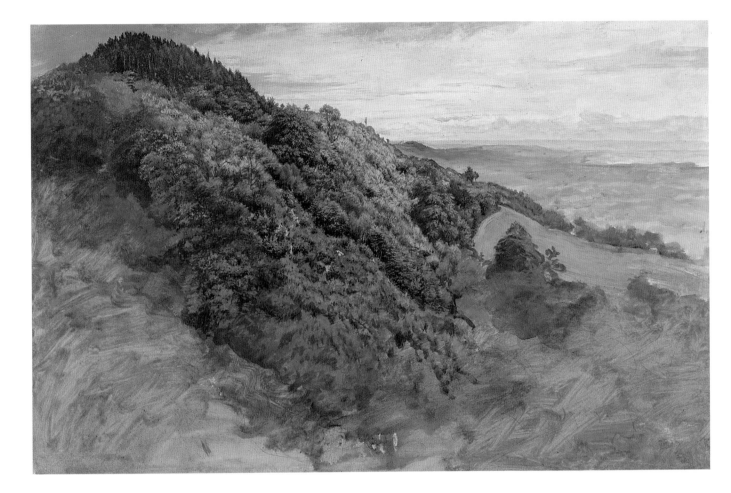

William Linnell 1826–1906

View of Box Hill, Surrey
Oil over graphite on paper 308 × 478 mm
verso: a sketch in graphite, probably for the
same composition
Bought, 1971 PD.47–1971

William Linnell was the fifth of John
Linnell's nine children, and the second to
pursue an artistic career. He became a
student at the Royal Academy and exhibi-
ted there from 1851–91.

Apart from two visits to Italy – the first
from 1851–62, the second, shorter stay

from 1863–5, Linnell spent most of his life
at his home in Redhill, Surrey, near which
this view was traditionally supposed to
have been painted. However, comparison
with a watercolour and unfinished oil
painting of Box Hill by Samuel Palmer,
both painted around 1848 (Lister 435 and
437), suggests that Linnell's oil sketch may
show the same view. Recently, it has been
suggested that the location of Palmer's
views has been misidentified, and in fact
represents the countryside near Under-
river, Sevenoaks, Kent (Lister 371, 372).

Abbreviations

Cormack: Malcolm Cormack, *J. M. W. Turner, R.A. 1775–1851 A Catalogue of Drawings and Watercolours in the Fitzwilliam Museum, Cambridge*, Cambridge, 1975

Girtin and Loshak: Thomas Girtin and David Loshak, *The Art of Thomas Girtin*, London, 1954

Hayes: John Hayes, *The Drawings of Thomas Gainsborough*, 2 vols, London, 1970

Lister: Raymond Lister, *A Catalogue Raisonné of the Works of Samuel Palmer*, Cambridge, 1988

Lister, *Letters: The Letters of Samuel Palmer*, ed. Raymond Lister, 2 vols, Oxford, 1974

Memoirs: A. P. Oppé 'The Memoirs of Thomas Jones', *Walpole Society*, xxxii, 1951

owcs: The Old Water-Colour Society; from 1881 The Royal Watercolour Society

Stainton: Lindsay Stainton, *Turner's Venice*, London, 1985

Travels: Travels in Italy 1776–1783 Based on the 'Memoirs' of Thomas Jones, exh. cat., by Francis W. Hawcroft, Manchester, Whitworth Art Gallery, 1988

Wilton: Andrew Wilton, *The Life and Work of J. M. W. Turner*, London, 1979

Works: E. Cook and A. Wedderburn (eds), *The Works of John Ruskin*, London, 1903–12

Select Bibliography

Exhibition catalogues are listed by author(s)

ADDISON, JOSEPH *Remarks on Several Parts of Italy, &c. In the Years 1701, 1702, 1703*, London, 1736

ALLTHORPE-GUYTON, MARJORIE 'Cotman and Normandy', in M. Rajnai, *John Sell Cotman 1782–1842*, exh. cat., Victoria and Albert Museum, and tour 1982, pp.27–9

ANTIQUE COLLECTORS' CLUB RESEARCH PROJECT *The Royal Watercolour Society: The First Fifty Years, 1805–1855*, Woodbridge, 1992

BAYARD, J. *Works of Splendour and Imagination: The Exhibition Watercolor, 1770–1870*, exh. cat., New Haven, Yale Center for British Art, 1981

BECKETT, R. B. (ed.) *John Constable's Discourses*, Suffolk Record Society, 1970

BECKFORD, WILLIAM *Recollections of an excursion to the monasteries of Alcobaça and Batalha*, London, 1835

BELL, C. F. 'Miles Edmund Cotman 1810–1858', *Walker's Quarterly*, VI, no.21, 1927

BELL, C. F. 'Some Additional Notes to The Walpole Society, Vol. 23', *Walpole Society*, 1947

BELL, C. F. and THOMAS GIRTIN 'The Drawings and Sketches of John Robert Cozens', *Walpole Society*, XXIII, 1934–5

BICKNELL, PETER *Beauty, Horror and Immensity: Picturesque Landscape in Britain, 1750–1850*, exh. cat., Cambridge, Fitzwilliam Museum, 1981

BICKNELL, PETER *The Picturesque Scenery of the Lake District, 1752–1855: A Bibliographical Study*, Winchester, 1990

BICKNELL, PETER and JANE MUNRO *Gilpin to Ruskin: Drawing Masters and their Manuals, 1800–1860*, exh. cat., Cambridge, Fitzwilliam Museum; Grasmere, Dove Cottage and Wordsworth Museum; 1987–8

BOWNESS, ALAN, et al. *The Pre-Raphaelites*, exh. cat., London, Tate Gallery, 1984

BRIGANTI, GIULI, NICOLO SPINOSA and LINDSAY STAINTON *In the Shadow of Vesuvius: Views of Naples from Baroque to Romanticism, 1631–1830*, exh. cat., London, Accademia Italiana delle Arti e delle Arti Applicate, 1990

BROWN, DAVID BLAYNEY *Original Eyes: Progressive Vision in British Water-Colour, 1750–1850*, exh. cat., Liverpool, Tate Gallery, 1991

BROWN, DAVID BLAYNEY *Turner and Byron*, exh. cat., London, Tate Gallery, 1992

BRUYN ANDREWS, C. (ed.), *The Torrington Diaries*, London, 1934

BURY, ADRIAN *Francis Towne: Lone Star of Watercolour Painting*, London, 1962

BUTLIN, MARTIN and EVELYN JOLL *The Paintings of J. M. W. Turner*, revd edn, 2 vols, New Haven and London, 1984

BYRNE, WILLIAM, JOHN SMITH and JAMES EDWARDS *Select Views in Italy*, 2 vols, London, 1796

CASTERAS, SUSAN, RONALD PARKINSON et al. *Richard Redgrave 1804–1888*, exh. cat., London, Victoria and Albert Museum and Yale Center for British Art, 1988

CLARKE, MICHAEL and NICHOLAS PENNY *The Arrogant Connoisseur: Richard Payne Knight, 1751–1824*, exh. cat., Manchester, Whitworth Art Gallery, 1982

CLEGG, JEANNE and PAUL TUCKER *Ruskin in Tuscany*, exh. cat., Accademia Italiana, London, 1992

CLIFFORD, DEREK *Watercolours of the Norwich School*, London, 1965

COHN, MARJORIE B. and R. ROSENFELD *Wash and Gouache: A Study of the Development of the Materials of Watercolor*, exh. cat., Cambridge, MA, Fogg Art Museum, 1977

COPE, A. W. *Reminiscences of Charles West Cope*, London, 1891

CORMACK, MALCOLM *Constable*, Oxford, 1986

CORMACK, MALCOLM *The Paintings of Thomas Gainsborough*, Cambridge, 1991

CROUAN, KATHERINE *John Linnell, Truth to Nature, A Centennial Exhibition*, exh. cat., Martin Gregory Gallery, London, 1982

CROUAN, KATHERINE *John Linnell: A Centennial Exhibition*, exh. cat., Cambridge, Fitzwilliam Museum; New Haven, Yale Center for British Art; 1982–3

CUNDALL, H. M. (ed.) *William Callow RWA FRGS An Autobiography*, London, 1908

DAVIES, RANDALL 'James Holland', *Old Water-Colour Society's Club*, VII, 1929–30, pp.37–54

DAYES, EDWARD *The Works of the late Edward Dayes*, ed. E. W. Brayley, London, 1805

DAYES, J. 'Edward Dayes', *Old Water-Colour Society's Club*, XXXIX, 1964, pp.45–55

EGERTON, JUDY *Wright of Derby*, exh. cat., London, Tate Gallery, 1990

EMMANUEL, FRANK L. 'Edward Duncan R.W.S.'. *Walker's Quarterly*, IV, no.13, 1923

FARINGTON, JOSEPH *The Diaries*, ed. K. Garlick, A. Macintyre & K. Cave, 16 vols, London, 1978–84

FINLEY, GERALD E. 'Turner's Illustrations to Napoleon', *Journal of the Warburg and Courtauld Institutes*, XXXVI, 1973, pp.390–6

FORD, BRINSLEY 'The Dartmouth Collection of Drawings by Richard Wilson', *The Burlington Magazine*, XC, Nov. 1948, pp.337–45

FORD, BRINSLEY (ed.) 'The Letters of Jonathan Skelton written from Rome and Tivoli in 1758', *Walpole Society*, XXXVI, 1960, pp.23–82

FRASER, MAXWELL *Wales, the country*, London, 1952

GAGE, JOHN *A Decade of English Naturalism, 1810–1820*, exh. cat., Norwich, Castle Museum; London, Victoria and Albert Museum; 1969–70

GAGE, JOHN *J. M. W. Turner 'A Wonderful Range of Mind'*, London, 1987

GOETHE, JOHANN WOLFGANG *Italian Journey [1786–1788]*, London, 5th edn, 1987

GOWING, LAWRENCE *The Originality of Thomas Jones*, London, 1985

GRAVES, ALGERNON *The British Institution, 1806–1867: A Complete Dictionary of Contributors and their Work from the Foundation of the Institution*, London, 1908, reprd 1969

GRAVES, ALGERNON *The Royal Academy of Arts: A Complete

Dictionary of Contributors and their Work from its Foundation in 1769 to 1904, 8 vols, London, 1905–6

GREENACRE, FRANCIS *The Bristol School of Artists: Francis Danby and Painting in Bristol, 1810–1840*, exh. cat., Bristol Museums and Art Gallery, 1973

GREENACRE, FRANCIS and SHEENA STODDARD *The Bristol Landscape: The Watercolours of Samuel Jackson (1794–1869)*, exh. cat., Bristol Museums and Art Gallery, 1986

GREENACRE, FRANCIS and SHEENA STODDARD *W. J. Müller* exh. cat., Bristol Museums and Art Gallery, 1986

HALL, WILLIAM (with additions by John Thackeray Bunce) *A Biography of David Cox*, London, 1881

HALSBY, J. *Scottish Watercolours, 1740–1940*, London, 1986

HAMILTON, JEAN *The Sketching Society, 1799–1851*, exh. cat., London, Victoria and Albert Museum, 1971

HARDIE, MARTIN *Water-Colour Painting in Britain*, 3 vols, ed. D. Snelgrove with J. Mayne and B. Taylor: I: *The Eighteenth Century*, London, 1966, revd 1967; II: *The Romantic Period*, 1967; III: *The Victorian Period*, 1968

HARLEY, ROSAMUND D. *Artists' Pigments. c.1600–1835: A Study of English Documentary Sources*, London, 1970

HAWCROFT, FRANCIS *Watercolours by John Robert Cozens*, exh. cat., Manchester, Whitworth Art Gallery and London, Victoria and Albert Museum, 1971

HAWCROFT, FRANCIS *Watercolours by Thomas Girtin*, exh. cat., Manchester, Whitworth Art Gallery and London, Victoria and Albert Museum, 1975

HAWES, LOUIS *Presences of Nature: British Landscape 1780–1830*, exh. cat., New Haven, Yale Center for British Art, 1982–3

HAYES, JOHN *Thomas Gainsborough*, exh. cat., London, Tate Gallery; Paris, Grand Palais; 1980–81

HAYES, JOHN and LINDSAY STAINTON *Gainsborough's Landscape Drawings*, exh. cat., International Exhibitions Foundation, 1983

HERBERT, LORD (ed.) *Henry, Elizabeth and George (1734–80) Letters and Diaries of Henry, Tenth Earl of Pembroke and his Circle*, London, 1939

HERRMANN, LUKE *British Landscape Painting of the Eighteenth Century*, London, 1973

HERRMANN, LUKE *Paul and Thomas Sandby*, London, 1986

HILL, DAVID et al., *Turner in Yorkshire*, exh. cat., York, City Art Gallery, 1980

HILL, DAVID *Turner in the Alps*, London, 1992

HIPPLE, W. *The Beautiful, the Sublime and the Picturesque in Eighteenth-Century British Aesthetic Theory*, Carbondale, 1957

HOLCOMB, ADÈLE *John Sell Cotman*, London, 1978

HUSSEY, CHRISTOPHER *The Picturesque: Studies in a Point of View*, London, 1927

HUTCHISON, SIDNEY C. *The History of the Royal Academy, 1708–1968*, London, 1968, revd 1986

IRWIN, D. and E. IRWIN, *Scottish painters at Home and Abroad, 1700–1900*, London, 1975

ISHERWOOD KAY, H. 'Cotman's Letters from Normandy – II', *Walpole Society*, XV, 1926–7

JAFFÉ, PATRICIA *Drawings by George Romney*, exh. cat., Fitzwilliam Museum, Cambridge, 1977

JAPES, DAVID *William Payne, A Plymouth Experience*, exh. cat., Royal Albert Memorial Museum, Exeter, 1992

KAUFFMANN, C. M. *John Varley 1778–1842*, London, 1984

KITSON, S. *The Life of John Sell Cotman*, London, 1937

KRILL, J. *English Artists' Paper: Renaissance to Regency*, exh. cat., London, Victoria and Albert Museum, 1987

LACK, CHRISTOPHER 'Edward Duncan, R.R.S. 1803–1882', *Old Water-Colour Society's Club*, XV, 1985, pp.1–46

LAMBOURNE, LIONEL 'Richard Redgrave, R.A.: Artist and Administrator' *V&A Album*, 2, 1983, pp.114–22

LAMBOURNE, LIONEL and JEAN HAMILTON, *British Watercolours in the Victoria and Albert Museum: An illustrated Summary Catalogue of the National Collection*, London, 1980

LEWIS, M. *John Frederick Lewis, R.A., 1805–1876*, Leigh-on-Sea, 1978

LISTER, RAYMOND *George Richmond: A Critical Biography*, London, 1981

LISTER, RAYMOND *Samuel Palmer and 'The Ancients'*, exh. cat., Cambridge, Fitzwilliam Museum, 1984

LISTER, RAYMOND *Samuel Palmer, his life and art*, Cambridge, 1987

LIVERSIDGE, M. J. H. 'Canaletto and English Painters', exh. cat., *Canaletto & England*, Birmingham, Gas Hall, 1993, pp.104–17

LYLES, ANNE and DIANE PERKINS *Colour into Line. Turner and the Art of Engraving*, exh. cat., London, Tate Gallery, 1989

MALLALIEU, H. L. *The Norwich School: Crome, Cotman and their Followers*, London, 1974

MAYNE, JONATHAN *Dr Thomas Monro (1759–1833) and the Monro Academy*, exh. cat., London, Victoria and Albert Museum, 1976

MOORE, ANDREW W. *The Norwich School of Artists*, Norwich, 1985

MORRIS, DAVID *Thomas Hearne 1744–1817: Watercolours and Drawings*, exh. cat., Bolton Museum & Art Gallery and tour, 1985–6

MORRIS, DAVID *Thomas Hearne and his Landscape*, London, 1989

MORRIS, SUSAN *Thomas Girtin, 1775–1802*, exh. cat., New Haven, Yale Center for British Art, 1986

MURDOCH, JOHN et al. *The Discovery of the Lake District: A Northern Arcadia and its Uses*, exh. cat., London, Victoria and Albert Museum, 1984

MUNRO, JANE *James Ward 1769–1859*, exh. cat., Fitzwilliam Museum, 1992

NEWALL, CHRISTOPHER and JUDY EGERTON *George Price Boyce*, exh. cat., London, Tate Gallery, 1987

NICHOLSON, BENEDICT *Joseph Wright of Derby*, 2 vols, London, 1968

OPPÉ, A. P. 'Francis Towne, Landscape Painter' *Walpole Society*, VIII, 1919–20, pp.95–126

OPPÉ, A. P. 'John White Abbott of Exeter', *Walpole Society*, XIII, 1925, pp.68–81

OWEN, FELICITY 'Sir George Beaumont and the Old Water-Colour Society', *Old Water-Colour Society's Club*, LXII, 1991, pp.23–9

PALMER, A. H. *The Life and Letters of Samuel Palmer*, London, 1892

PENNANT, THOMAS *Journey to Snowdon*, London, 1781

PIDGLEY, MICHAEL 'Cornelius Varley, Cotman and the Graphic Telescope', *The Burlington Magazine*, CXIV, 1972, pp.781–6

PIGGOTT, JAN *Turner's Vignettes*, exh. cat., London, Tate Gallery, 1993

PIERCE, S. R. 'Jonathan Skelton and his Watercolours – A Checklist', *Walpole Society*, XXXVI, 1960, pp.10–22

POINTON, MARCIA *William Dyce 1806–1864 A Cricial Biography*, Oxford, 1979

RAJNAI, MIKLOS assisted by MARJORIE ALLTHORPE-GUYTON, *John Sell Cotman. Drawings of Normandy in Norwich Castle Museum*, exh. cat., Norfolk Museum Services, 1975

RAJNAI, MILKOS *The Norwich Society of Artists, 1803–1833: A Dictionary of Contributors and their Work*, Norwich, 1976

RAJNAI, MIKLOS (ed.) *John Sell Cotman 1782–1842*, exh. cat., London, Victoria and Albert Museum and tour, 1982

REDGRAVE, RICHARD and SAMUEL REDGRAVE *A Century of Painters of the English School*, 2 vols, London, 1866, revd 1890, repr. 1947

REYNOLDS, GRAHAM *The Later Paintings and Drawings of John Constable*, 2 vols, New Haven and London, 1984

REYNOLDS, JAN *William Callow RWS*, London, 1980

ROBERTSON, BRUCE *The Art of Paul Sandby*, exh. cat., New Haven, Yale Center for British Art, 1985

ROBINSON, DUNCAN *Town, Country, Shore and Sea British Drawings and Watercolours from Anthony van Dyck to Paul Nash*, exh. cat., Queensland Art Gallery and tour, 1982

ROGET, J. L. *A History of the 'Old Water-Colour Society's Club', now the Royal Society of Painters in Water-Colours*, 2 vols, London, 1891

ROMNEY, REVD JOHN *Memoirs of the Life and Works of George Romney*, London, 1830

ROSENTHAL, MICHAEL *British Landscape Painting*, Oxford, 1982

RYSKAMP, CHARLES 'A Cornelius Varley Sketchbook in the Morgan Library', *Master Drawings*, XXVIII, no.3, Autumn 1990, pp.344–59

SCRASE, DAVID *Drawings and Watercolours by Peter De Wint*, exh. cat., Cambridge, Fitzwilliam Museum, 1979

SHANES, ERIC *Turner's Picturesque Views in England and Wales 1825–1838*, London, 1979

SHANES, ERIC *Turner's Rivers, Harbours and Coasts*, London, 1981

SHANES, ERIC *J. M. W. Turner. The Foundations of Genius*, exh. cat., Taft Art Gallery, Cincinnati, 1986

SHANES, ERIC *Turner's England, 1810–38*, London, 1990

SKILTON, CHARLES 'James Duffield Harding 1797–1863: A Centenary Memoir', *Old Water-Colour Society's Club*, XXXVIII, 1963, pp.23–36

SLOAN, KIM *The Poetry of Landscape*, exh. cat., London, Victoria and Albert Museum; Toronto, Art Gallery of Ontario; 1986

SLOAN, KIM *Alexander and John Robert Cozens*, New Haven and London, 1982

SMITH, HAMMOND *Peter DeWint 1784–1849*, London 1982

SOLKIN, DAVID H. *Richard Wilson: The Landscape of Reaction*, exh. cat., London, Tate Gallery; Cardiff, National Museum of Wales; New Haven, Yale Center for British Art; 1982–3

SOLLY, N. NEAL *Memoir of the Life of David Cox*, London, 1873

SOLLY, N. NEAL *Memoir of the Life of William James Müller*, London, 1875

SOMERVILLE, S. *British Watercolours: A Golden Age, 1750–1850*, exh. cat., J. B. Speed Art Museum, Louisville, KY, 1977

SOMERVILLE, S. *Exhibition of Drawings and Watercolours by Corne-lius Varley*, exh. cat., intr. Michael Pidgley; London, Colnaghi & Son, 1973

STAINTON, LINDSAY *British Artists in Rome, 1700–1800*, exh. cat., London, The Iveagh Bequest, Kenwood, 1974

STAINTON, LINDSAY 'Ducros and the British' in *Images of the Grand Tour Louis Ducros 1748–1810*, exh. cat., Iveagh Bequest, Kenwood and tour, 1985

STAINTON, LINDSAY *British Landscape Watercolours, 1600–1860*, exh. cat., London, British Museum, 1985; revd as *Nature into Art: British Landscape Watercolours*; Cleveland Museum of Art and tour 1991

STEVENS, MARY ANNE (ed.) *The Orientalists, Delacroix to Matisse: European Painters in North Africa and the Near East*, exh. cat., London, Royal Academy of Arts, 1984

STOREY, A. T. *Life of John Linnell*, London, 1892

STRICKLAND, WALTER G. *A Dictionary of Irish Artists*, 2 vols, Dublin, 1913

SURTEES, VIRGINIA (ed.) *The Diaries of George Price Boyce*, Norwich, 1980

TAYLOR, BASIL *The Old Water-Colour Society and its Founder-Members*, exh. cat., London, Spink & Son, 1973

THACKERAY, WILLIAM *Notes of a Journey from Cornhill to Grand Cairo*, London, 1846

TONKIN, MORLEY 'The Life of James Holland of the Old Society 1799–1870', *Old Water-Colour Society's Club*, XLII, 1967, pp.35–50

Paintings and Drawings by Francis Towne and John White Abbott, exh. cat., Exeter, Royal Albert Memorial Museum, 1971

UWINS, SARAH (ed.) *A Memoir of Thomas Uwins R.A.*, 1858, repr. Wakefield, 1978

WALTON, PAUL *The Drawings of John Ruskin*, Oxford, 1972

WHITELY, WILLIAM T. *Artists and their Friends in England, 1700–1799*, 2 vols, London, 1928

WILLIAMS, HUGH WILLIAM *Travels in Italy, Greece and the Ionian Islands*, 2 vols, London, 1820

WILLIAMS, IOLO A. *Early English Watercolours, and Some Cognate Drawings by Artists born not later than 1785*, London, 1952

WILCOX, SCOTT and CHRISTOPHER NEWALL *Victorian Landscape Watercolours*, exh. cat., New Haven, Yale Center for British Art and tour, 1992–3

WILCOX, TIMOTHY et al. *Visions of Venice: Watercolours and Drawings from Turner to Ruskin*, exh. cat., London, Bankside Gallery, 1990

WILDMAN, STEPHEN, RICHARD LOCKETT and JOHN MURDOCH *David Cox, 1783–1859*, exh. cat., Birmingham Museum and Art Gallery and London, Victoria and Albert Museum, 1983–4

WILTON, ANDREW 'Turner's Swiss watercolours', *Turner in Switzerland*, ed. Walter Amstutz, Zurich, 1976

WILTON, ANDREW *British Watercolours, 1750–1850*, Oxford 1977

WILTON, ANDREW *The Art of Alexander and John Robert Cozens*, exh. cat., New Haven, Yale Center for British Art, 1980

WILTON, ANDREW *Turner and the Sublime*, exh. cat., Toronto, Art Gallery of Ontario; and tour, 1980–81

WITT, JOHN *William Henry Hunt (1790–1864): Life and Work, with a Catalogue*, London, 1982

WORDSWORTH, JONATHAN, MICHAEL C. JAYE and ROBERT WOOF *William Wordsworth and the Age of English Romanticism*, exh. cat., New York, Public Library and tour, 1987

Index